COLOR

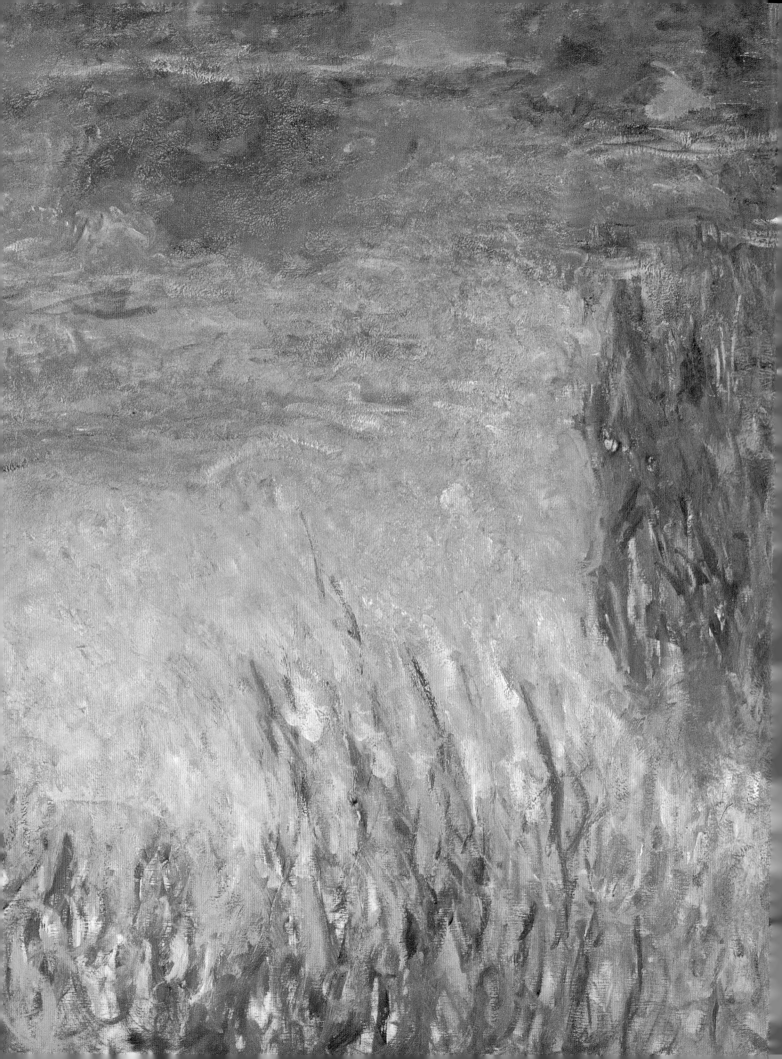

COLOR

Paul Zelanski and Mary Pat Fisher

FOURTH EDITION

Prentice Hall Inc, Upper Saddle River, N.J. 07458

To Josef Albers

and his students

and the students of his students

Published 2003 by Prentice Hall Inc.
A Division of Pearson Education
Upper Saddle River, New Jersey 07458

10 9 8 7 6 5 4 3

ISBN 0-13-098486-8

This book was designed and produced by
Laurence King Publishing Ltd, London
www.laurenceking.co.uk

Every effort has been made to contact the copyright
holders, but should there be any errors or omissions,
Laurence King Publishing Ltd would be pleased to insert
the appropriate acknowledgement in any subsequent
printing of this publication.

Editor: Elisabeth Ingles
Designer: Paul Barrett
Cover Designer: Andrew Shoolbred
Picture Researcher: Maureen Cowdroy
Printed in China

Front cover: Gustav Klimt, *Flower Garden*, c. 1892. Oil on
canvas. Courtesy Narodni Galerie, Prague. Bridgeman Art
Library.

Back cover: Paul Cézanne, *Still life with Pots and Fruit*,
1890-4. Oil on canvas. Courtesy The Art Archive/Private
Collection/Album/Joseph Martin.

Frontispiece: Claude Monet, *Waterlilies, Sunset*, detail.
1914–1926. Oil on canvas, whole painting 79 x 236 ins
(200 x 600 cm). Paris, Musée de l'Orangerie

CONTENTS

PREFACE

Color is addressed to artists and art students in all media, in both fine and applied arts. It provides an informative but non-dogmatic introduction to the many different approaches to understanding color, including aesthetics, science, psychology, and history. Illustrations for the chapters on color concepts are taken from all media. Special aesthetic and practical considerations for color usage in each medium—such as ways that graphic designers use and specify printers' inks—are also explored. The realities of color use are accentuated by direct quotes from working artists. Technical terms are carefully defined in the text and also in a glossary. Those appearing in the glossary are printed in boldface when first introduced in the text.

Special Features of the Fourth Edition

This fourth edition of *Color* reflects the tremendous range of color choices in the studio and the marketplace. There are now millions of colors available through computer graphics, more than the human eye can even distinguish. The section on computer-generated colors includes the complications of color matching when designers are working with both computer and printing technologies. Color choices in such crafts fields as ceramics, glass, and fibers are also mushrooming as they cross the soft boundary between fine and applied arts. Optical color effects continue to be an area of artistic experimentation, and these are illustrated and discussed in detail.

In the midst of these burgeoning choices, students are given a clear and solid foundation for understanding uses of color. Some 35 lively new images have been added to this edition, from cave paintings to twenty-first century virtual reality installations. Illustrations of points under discussion reflect the great variety in color applications, including historic and contemporary paintings, sculpture, installation pieces, crafts, photographs, advertisements, cartoons, commercial design, computer art, video, architecture, landscape design, interior design, and clothing. The work of women and multicultural art are naturally interwoven throughout the text.

For this edition, new visual demonstrations have been added, such as the effects of different lighting sources, reflective qualities of different surfaces, the Bezold Effect, and the phenomenon of color constancy. There is new material on the emotional and physiological effects of different hues, and on the spatial effects of colors. Cutting-edge virtual reality and video installations are illustrated and discussed. Website design and current printing technologies are included in updated discussions of computer-based art. Technical sections have been modified for greater clarity and ease of understanding. Technical material is provided in ways that can form take-off points for artists' own explorations of the intriguing world of color.

A special characteristic of this book is its extensive use of artists' own words about their use of color. More such quotations have been incorporated into this edition, and a new feature has been added: artists' quotations introducing each chapter.

Another special new feature of this edition is an appendix of Studio Color Problems. These comprise a great treasury of practical experiments with color based on the experiential teaching methods of the great colorist Josef Albers. Those using his experiential method might like to

assign the first two chapters of the text to develop a general orientation and a basic vocabulary before launching into studio work, and then continue with the more theoretical and practical material introduced later in the book once students have made some discoveries on their own. Professor Zelanski is a former student of Albers and has found this method highly successful in four decades of teaching.

Acknowledgements

Among the many artists in various media with whom we have worked in preparation of this book, we would like to pay a special tribute to the late Arthur Hoener. His pioneering work in optical color mixtures is still ahead of its time. We are also grateful to Frank Noelker, the late John Roy, and Janet Cummings Good for their help in cutting-edge color technologies and for supplying outstanding illustrative material.

We are grateful to those professors who reviewed the earlier editions of this book; their suggestions have benefited all editions. Ruth Zelanski and Ron Lambert have helped in locating and providing images.

At Laurence King Publishing, Elisabeth Ingles has served as the enthusiastic and intelligent editor for this edition, and photo researcher Maureen Cowdroy has worked hard to track down new images. Our dear friend Laurence King has been steadfastly supportive. Norwell F. Therien, our American editor at Prentice Hall, has firm conviction of the value of this book in helping students understand and make full use of the complexities of color.

Annette Zelanski has been of great help, as ever, and we want to express to her our love and appreciation. We owe her a very special debt of gratitude.

Paul Zelanski
Mary Pat Fisher
March 2002

PHOTO CREDITS

The authors, the publishers, and Laurence King Publishing wish to thank the artists, museums, collectors, and other owners who have kindly allowed works to be reproduced. In general, museums have supplied their own photographs; other sources, photographers, and copyright holders are listed here. Every effort has been made to contact all the copyright holders; should there be any errors or omissions, the publishers would be happy to make the necessary corrections in any future editions of this book.

1.1 © Succession H. Matisse/DACS 1999; photo John Webb. **1.2** Space Telescope Science Institute/NASA/Science Photo Library, London. **2.2** From *Webster's Third International Dictionary of the English Language*, Springfield, MA: Merriam 1976. **2.7** Artwork by David Kemp. **2.8** From Heinz-Otto Peitgen and Peter H. Richter, *The Beauty of Fractals*, Berlin: Springer Verlag. **2.11** Photo Dana Salvo. **2.12** The Georgia O'Keeffe Foundation; © ARS, New York and DACS, London 1999. **2.14** From Binney and Smith, "How to Mix and Use Color with the Liquitex Acrylic and Oil Color Map," Easton, PA. **2.14** © Tintometer Ltd. **3.3** Artwork by Technical Art Services, Stansted Abbotts, Great Britain. **3.5** © DACS 1999; from "Interaction of Color," New Haven, CT: Yale University Press. **3.6** Photos Ruth Zelanski. **3.8** Courtesy of Jack Shainman Gallery, New York. **3.10** John Theodore Deifert IV. **3.11** © DACS, London/VAGA, New York 1999; photo Geoffrey Clements, New York. **3.12** Photo M. Routier/Studio Lourmel, Paris. **3.13** Service Photographique de la Réunion des Musées Nationaux. **3.15** Kimbell Art Museum; photo Michael Bodycomb. **3.16** © 1986 House and Garden, New York. **3.18** Photo © 2001 by Kay Chernush. **4.3** Photo David Glomb. **4.4** Giraudon/Bridgeman Art Library, London/New York. **4.5** Andy Warhol Foundation for the Visual Arts, Inc. ARS, New York, and DACS, London, 2002/Bridgeman Art Library, London. **4.6** Commissioned by the Museum of Contemporary Art, Los Angeles, for the exhibition "Individuals: A Selected History of Contemporary Art, 1945–1986"; photograph by Squidds and Nunns. **4.7** Photo Sean Ellis, ad Matt Roach. **4.8** © Nolde-Stiftung Seebüll. **4.9** Eben Ostby: modeling, rendering, design, and textures; Bill Reeves: modeling, rendering, design, and lighting; © 1987 Pixar. **4.10** © DACS, London/VAGA, New York 1999. **5.1** © Christo 1962, photo Jean-Dominique Lajoux. **5.6** The Overlook Press, New York. **5.7** © Studio Quattrone, Florence. **5.8** Stedelijk Museum A7681. **5.9** © King Features Syndicate. **5.10** Christie's Images Ltd, London. **5.12** Thames and Hudson Ltd, London. **5.13** AKG Photo, London. **5.14** Photo Philippe Migeat. **6.7** From Johannes Itten, "The Elements of Color," © Otto-Maier Verlag, Ravensburg, Germany. **6.9** From A Color Notation, 2nd edition, Boston: George H. Ellis Co.; photo Beverly Dickinson. **7.8** Artwork by Technical Art Services, Stanstead Abbotts, Great Britain. **7.9, 7.11, 7.12** Binney and Smith, op. cit. **7.15** From Susan Peterson, *The Craft and Art of Clay*, 2nd edition, Englewood Cliffs, NJ: Prentice Hall, 1995. **7.16** Photo Claire Garoutte. **7.18** Hennegan, Cincinatti, OH. **7.20, 7.21** Pantone, Inc., Moonachie, NJ. **7.22** Courtesy of the artist. **7.23** Courtesy of the artist. **7.25** Courtesy of the artist. **7.26** Reproduced from The Color Index, 3rd edition, Pigments and Solvent Dyes volume, published in 1982 jointly by the Society of Dyers and Colorists. **7.27** Photo Beverly Dickinson. **7.28** Courtesy of Pro Chemical and Dye, Inc., Somerset, MA; swatches by Nancy MacLennon, Binghamton, NY, and Claire deRoos, Johnson City, NY. **7.29** Courtesy Stefan Stux Gallery, New York. **8.1** Courtesy of the artist. **8.4** J. Baker Collection. **8.6** (last frame) © Studio Quattrone, Florence. **8.7** Photo Douglas Kirkland. **8.9** Photo © Linda Burgess, London. **8.10** Artwork by Technical Art Services, Stanstead Abbotts, Great Britain. **8.12** From Igildo G. Biesele, Experimental Design, Zurich, Switzerland: ABC Verlag. **8.13** Courtesy of the artist. **8.15** Photo Ellen Labenski, © The Solomon R. Guggenheim Foundation, New York. **9.1** Photo Frank Noelker. **9.2** © ARS, New York and DACS, London 1999; photo Richard Stoner. **9.3** Photo Jannes Linder from the exhibition "Century '87: Today's Art Face to Face with Amsterdam's Past," August 7th to September 14th 1987. **9.8** © Allen Carter. **9.13** Photo Frédéric Delpech. **9.14** Metropolitan Life Foundation Purchase Grant. **9.15** © Succession H. Matisse/DACS 2001; photo Bridgeman Art Library, London. **9.16** © DACS, London/VAGA, New York 1999. **9.17** Noemi Zelanski. **9.18** © Mary Franks 2000, courtesy of the artist. **9.19** Artwork by David Kemp. **9.20** Noemi Zelanski. **9.21** © DACS 1999; photo Beverly Dickinson. **9.22** © DACS 1999; photo David M. Thum. **9.23** Photo David Caras. **9.25** © ADAGP, Paris and DACS, London 1999. **9.26** Photo Liz Dowling. **9.27** © 1998 The Barnes Foundation™, All Rights Reserved; photo Bridgeman Art Library. **9.28** Courtesy of the artist. **10.3** Photo Mary Pat Fisher. **10.5** © V &A Picture Library, London. **10.8, 10.9** Photographs courtesy of Vatican Museums. **10.12** © Photo RMN—R. G. Ojeda. **10.16** © ADAGP, Paris and DACS, London 1999. **10.17** Photo © 1980 Buffalo Fine Arts Academy. **10.18** AKG Photo, London. **10.19** Photo Mali Olatunji. **10.21** © Kate Rothko Prizel and Christopher Rothko/DACS 1999; photo Lee Stalsworth. **10.22** Photo Robert E. Mates Studio, New Jersey. **10.23** Collection British Council. **10.24** Alan J. Kegler, University at Buffalo, New York. **10.25** Courtesy of the artist. **10.26** © Museum of Modern Art, New York/photo Charles Duprat. **11.2** Photo Frank Noelker. **11.3** Leslie Caldwell/Bernie Guild, art directors; Mike Koelker, writer/creative director; Steve Neely, producer; Leslie Dektor, director; Peterman/Dektor, production company; Foote, Cone Belding (San Francisco), agency; Levi Strauss and Co., client. **11.4** Milton Glaser and The Overlook Press, New York. **11.6** Luminaire®, designed by G. Benedini. **11.7** William Low, illustrator; John Morton, art director; Dan Glassman, copywriter; Compaq Computer Corporation, source holder/publisher: © 1997. **11.8** Michael Tracy, designer; James Rome, architect; photo Hickey and Robertson. **11.9** Photo M. Courtney-Clarke. **11.10** Sonia Halliday Photographs. **11.11** Photo Adam Bartos. **11.12** Photo John Foley. **11.13** Photo Richard Bryant/Arcaid. **11.14** Photo Mick Hales. **11.15** Photo Victoria Hyde. **11.16** Philip Moulthrop. The authors and publishers would also like to thank Tim Imrie for his photography.

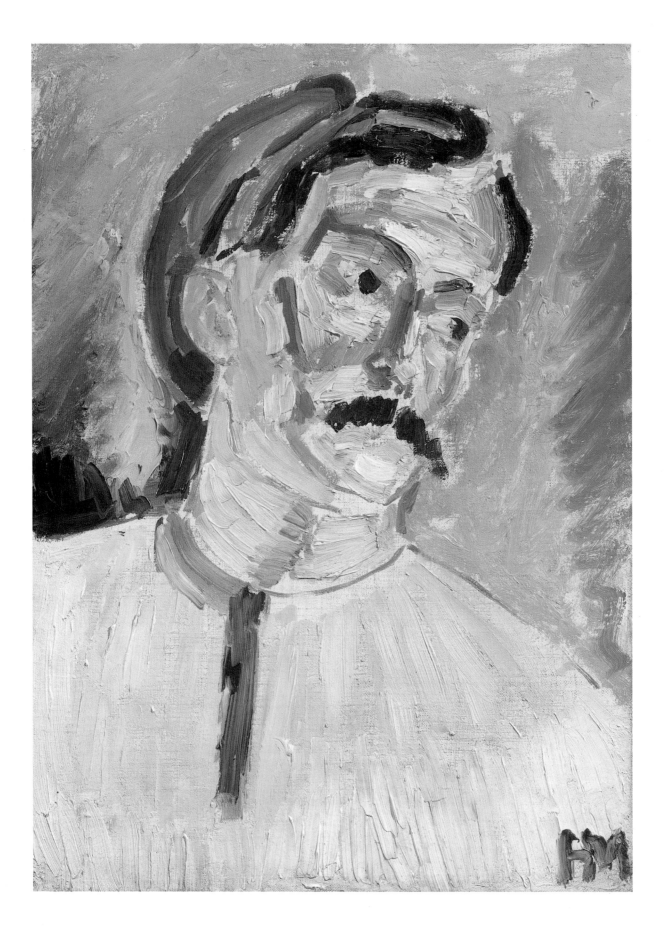

1

Why Study Color?

Color is an expressive force in itself—a language in itself.

HANS HOFFMAN

Color is perhaps the most powerful tool at the artist's disposal. It affects our emotions beyond thought and can convey any mood, from delight to despair. It can be subtle or dramatic, capture attention or stimulate desire. Used more boldly and freely today than ever before, color bathes our vision with an infinite variety of sensations, from clear, brilliant hues to subtle, elusive mixtures. Color is the province of all artists, from painters and potters to product designers and computer artists.

Used masterfully, color can elicit strong responses. The great colorist Henri Matisse took extreme liberties with the natural colors of the head of Derain (an early twentieth-century colorist who was in his time considered notorious for his vibrant color choices). The blue-green shadow on the left side of his face in Figure **1.1**, the pink nose and ear, the purple eye shadows and outlines, and the green eyebrow all transcend nature. And yet we have now become so accustomed to brilliant use of color that in the twenty-first century we can readily understand Matisse's interpretive use of bold color.

In fact, color is now being extensively used in everyday life to help us grasp information. Signs in airports and supermarkets may be color coded to help us find our way amidst a barrage of visual stimuli. Businesspeople at their computers now routinely add color to their charts and diagrams to emphasize the differences between the factors they are analyzing. Colors are assigned to the details in Magnetic Resonance Images to help doctors spot and track tumors, for we can see contrasts more clearly in color than

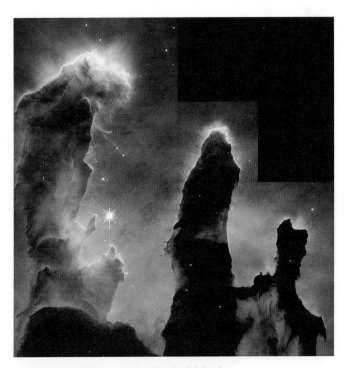

▲ **1.2** *Gas Pillars in the Eagle Nebula*
Hubble telescope photograph.
Colors have been manipulated to help distinguish the gases.

◀ **1.1** Henri Matisse, *André Derain*, 1905
Oil on canvas, 15½ x 11⅜ ins (39.4 x 28.9 cm).
Tate Gallery, London.
The French artists Matisse and Derain were leaders in an early twentieth-century trend toward bold color choices.

in black and white. And in the astonishing views of the cosmos revealed by the Hubble telescope, colors are assigned to invisible gases so that scientists can better see and distinguish them. In the star-forming nebula shown in Figure **1.2**, which has been named "Eagle Nebula," sulfurous gases have been represented as red, hydrogen as green, and oxygen as blue, resulting in a coherent visual image of this otherwise "fuzzy" area of the cosmos which is 7,000 light-years away from our planet.

In art, color is a vehicle for expressing emotions and concepts as well as information, and it is a very powerful element of design. Its possibilities are limitless. For an artist, color is like notes for a musician and words for a speaker. A single note, a single word, can have infinite shades of meaning and expression, depending on how it is used, what surrounds it, and who is its audience.

The art of using color well is an open-ended, complex discipline which incorporates many different points of view and poses many questions. Scientists have tried for centuries to understand what creates colors in our world, and how we see them; yet we still have no absolute answers to these questions. Theories put forth by those studying the physics of light and the anatomy and physiology of vision still lie in the realm of hypothesis. Color theorists have tried to condense the infinite number of visible color variations into a few basic colors and to form theories about their relationship. But no one color theory has been generally adopted as satisfactorily explaining all color phenomena. Psychologists are studying the impact of various colors on our emotions and health, but they find that individuals tend to differ in their responses. Art historians analyze the different ways in which color has been created and used in different times and places. Those interested in design try to discern how colors affect compositional factors, such as unity, emphasis, balance, contrast, and spatial awareness. Other specialists offer suggestions and attempts at standardization in the realms of mixing colors with lights and pigments, for there is a special science of color creation for each discipline.

To tap into the tremendous potential of color, artists must explore all of these intellectual approaches. But beyond these very important perspectives lies direct experience with color. Interestingly, Leary and Alpert's studies of hallucinogens during the middle of the twentieth century revealed that most people's responses to color were accentuated by taking hallucinogens. However, artists on the whole were little affected—because artists are already high on color most of the time. A layperson has to be told to look for an after-image effect, for instance, but artists are always alert to color experiences.

Actually working with color, exploring its characteristics and potentials, carefully observing how colors work together, will teach you in ways that no theory can. The theories are useful ways of narrowing the field of exploration. Intellectual information provides a general map so that you do not have to wander randomly through the myriad halls of color. Beyond the intellect, one works intuitively, experimentally, with all senses alert. Only in this way can you discover the realities of color—and the journey is endless.

2
Color Basics

Color is the probity of art. ... Color gives the appearance of life.
EUGÈNE DELACROIX

To develop a vocabulary for talking about colors, we must delve briefly into the physical properties of what we see as colors. While this vocabulary is useful, it is not always precise, for much of it is based on theoretical or scientific observations that do not necessarily hold true in artistic practice. And although the same terms are often used for describing colored lights and colored pigments, such as paints, they are quite different phenomena. When talking about colors, it must be made quite clear to which of these one is referring.

The Physics of Light

Physicists explain color as a function of light. A current theory is that energy from the sun consists of a series of separate energy packets, or quanta, traveling as continuous electromagnetic waves. They stimulate color sensations in our visual perception when they strike objects.

In the seventeenth century, the great physicist and mathematician Sir Isaac Newton (see Chapter 6) conducted a series of experiments demonstrating, among other things, that sunlight contains all the colors of the rainbow. He admitted a ray of daylight into a darkened room through a hole in a window shade and placed a glass prism where the ray would pass through it. As it did so and then came out the other side, the ray of white light was bent, or **refracted**, breaking it down into its constituent colors which could be seen on a white wall beyond, as shown in Figure **2.1**.

Newton identified seven basic colors in the breakdown: red, orange, yellow, green, blue, indigo, and violet. Each hue is now thought to correspond to a certain portion of the range of wavelengths of radiant energy that can be distinguished by the human eye, called the **visible spectrum**. A **wavelength** is the distance between crests in a wave of energy. Wavelengths in the visible spectrum are measured in **nanometers**, each of which is only one-billionth of a meter. Differences between colors involve tiny differences in wavelengths. Figure **2.2** shows the designation of **spectral hues**, or the colors that can be seen in a rainbow, in terms of the wavelengths indicated by each hue name. "Red," for instance, is the name given to everything from about 625 to 740 nanometers, although we can distinguish

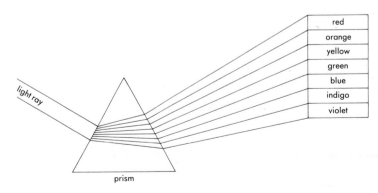

▲ **2.1** A modern rendition of Newton's experiment, breaking white light into the hues of the spectrum by passing it through a prism.

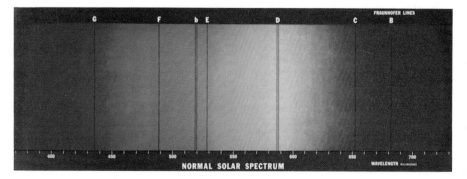

◀ **2.2** Colors of the visible spectrum are here identified as regions of certain wavelengths, measured in millimicrons (nanometers). The dark "Fraunhofer" lines represent some of the fine dark lines seen in a pure spectrum, revealing wavelengths that are missing in the light sample.

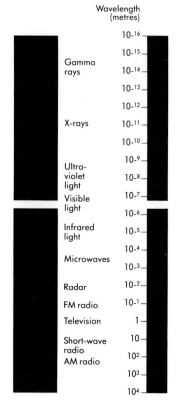

◀ **2.3** In the electromagnetic spectrum, only a very small portion of all radiant energy can be seen by humans.

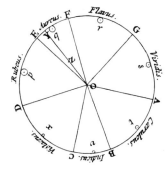

◀ **2.4** Newton's proposed color wheel, created by joining the two ends of the visible spectrum. Although this model does not correspond to the linear array of wavelengths, it is useful for analyzing relationships among colors.

many differing reds within that range, some of them merging into the area we call "orange." Red has the longest wavelengths; violet has the shortest.

Beyond red and violet at each end of the visible spectrum lie wavelengths of radiant energy that humans cannot see, from infrared and ultraviolet outward. As illustrated in Figure **2.3**, the electromagnetic spectrum comprises radiations from the universe ranging from gamma rays to radio waves. The greatest portion of this spectrum is invisible to human sight.

Light Colors

Although red and violet are quite different in terms of wavelengths, they are visually similar at their outer extremes and can be mixed to produce purples that cannot be seen in the spectrum itself. Newton therefore proposed that the straight band of spectral hues could be bent into a circular model with the two ends joined (**2.4**). At its center was white—the result of mixing lights of all colors, as Newton had demonstrated by reconverging the colors of the spectrum through a second prism into a single ray of white light (**2.5**).

This was the first **color wheel**—an attempt to illustrate visual relationships among hues. Newton's color circle was adopted by many later aesthetic theorists as a way of explaining relationships between different colors.

Color theorists often speak of the colors in light as **additive**: the more they are mixed with other colors, the lighter they become. White light can even be recreated by mixing only three carefully chosen colored lights: green, blue-violet, and orange-red. These same colors can be used to mix most of the colors that humans can distinguish, but cannot themselves be mixed from other colors. They are there-

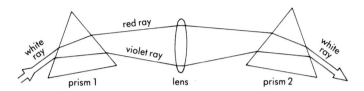

▲ **2.5** Newton demonstrated that white light is the composite of all spectral hues by breaking it down into the visible spectrum, then converging these rays through a second prism back into white light.

▼ **2.6 Light colors**

If colored lights in the light primaries red-orange, green, and blue-violet are projected in overlapping circles, they mix to form the light secondaries yellow, magenta, and cyan. In additive mixtures, the secondaries are paler than the primaries. Where all three primaries overlap, they produce white.

2.7 (below right) **Pigment colors**

In subtractive, or pigment, mixtures, the primaries are traditionally said to be red, yellow, and blue. If two primaries are mixed, they theoretically produce the secondaries orange, green, and purple. If all three are mixed, they theoretically produce black. However, in paint mixing, it is not possible to mix all colors from any three primaries.

fore known as **primary colors**. As illustrated in Figure **2.6**, where the primaries orange-red and green overlap, they create yellow; green and blue-violet can be mixed to form indigo (known as "cyan" in printing and photography); and blue-violet and orange-red overlap to form magenta. The yellow, cyan, and magenta formed by mixing two primaries are called **secondary colors**; in light mixtures, these are more luminous than primary colors. White, as we have seen, results from mixing all three primaries together at the proper intensities, and black is the absence of all light.

Light mixtures can be created by superimposing lights of different colors, by showing two different colors in rapid succession, or by presenting small points of different colors so close to each other that they are blended by our visual apparatus. In the past, experiments with light mixing had to be done by projecting and overlapping colored lights on a wall. However, the advent of computer graphics has opened a vast world of instantaneous and mechanically precise light mixing for aesthetic exploration. Cathode ray tubes used in video receivers and computer graphics monitors have three electron guns corresponding to the light primaries: red-orange, green, and blue-violet. When the beams from these guns strike the light-sensitive **phosphors** on the surface of the screen in varying combinations and intensities, they can create a great array of luminous color sensations.

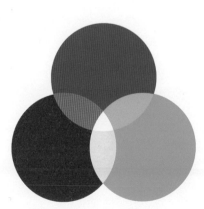

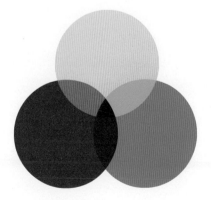

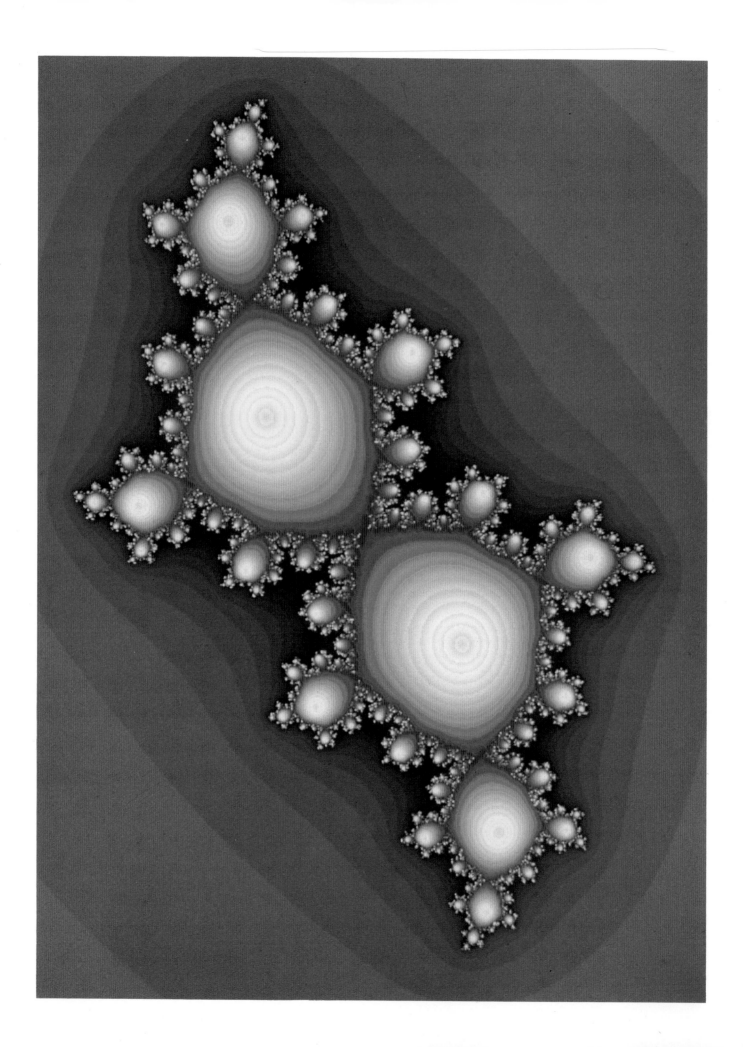

In the fractal computer image shown in Figure **2.8**—the beautiful visual expression of a mathematical formula—the lightest areas occur where the rays are most concentrated and the darkest areas where the rays are least concentrated. The stunning yellows are entirely mixed; there is no yellow gun in a cathode ray tube. If you examine a yellow image on a television or computer screen very closely, you can see that it is formed by the juxtaposition and overlapping of orange-red and green bits of light.

Pigment Colors

Colors seen on the surface of objects operate in a very different way from those seen in beams of light. When daylight or some other kind of incident light strikes a surface, certain wavelengths may be absorbed and others reflected by its **pigments**, or coloring matter. The **reflected** wavelengths blend to form the color "seen" by the viewer. To cite a simple example, the surface of an apple absorbs all wavelengths except those which create the sensation of red; these are reflected into the eye of the viewer. An object that appears black absorbs almost all wavelengths (in the darkest of pigments, carbon black, 97 percent of the incident light is absorbed). In theory, a surface that appears white absorbs no wavelengths; all are reflected and mixed. This ideal is never met in practice; the closest one can come is absorption of only two percent of the incident light.

In traditional color theory, there are three pigment colors—red, blue, and yellow—that cannot be mixed from other colors and from which all other colors can be mixed (see **2.7**; more on this in Chapter 7). These characteristics would define them as primary colors.

Mixtures of the pigment primaries red, blue, and yellow theoretically yield the pigment secondaries orange, green, and purple (sometimes called violet). When these secondaries are mixed with their adjacent primaries, they yield **tertiary colors**: red-purple, red-orange, yellow-orange, yellow-green, blue-green, and blue-purple. If one starts with three primaries, one gets three secondaries and six tertiaries, giving a total of twelve colors, as shown in Figure **2.9**.

◀ **2.8 Heinz-Otto Peitgen and Peter H. Richter, Fractal image based on the process x → x² + c**

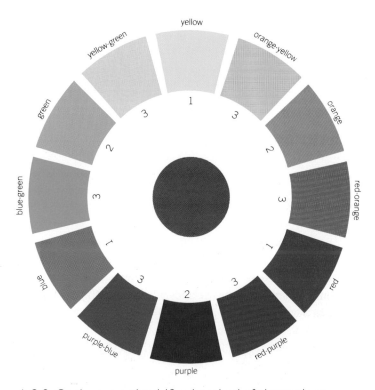

▲ **2.9** On the conventional 12-color wheel of pigment hues, the primaries are red, blue, and yellow; the secondaries are orange, green, and purple; and the tertiaries are mixtures of adjoining primaries and secondaries. If colors are mixed with their complement (the hue lying opposite on the wheel), a neutral gray should be created, as indicated in the center.

However, with pigments, the ability to mix all other colors from only three primaries is possible only in printers' inks and color photography. Transparent inks or photographic dyes in chrome yellow, magenta, and cyan, plus black, and the white of the paper can be used to approximate most colors that the eye can see. Even then, despite advances in printing technology and our efforts to render colors precisely, the colors in the figures in this book or any other book may still be slightly inaccurate.

In paint mixing, it is not possible to mix all colors from any three basic primaries. Some theories would therefore add green to the list of paint pigment primaries to make more mixtures possible. In 1905 the color standardist Albert Munsell (1858–1918) proposed five pigment primaries: green, blue, purple, red, and yellow (which he called **principal hues**). We recommend that new students use

ten paint colors and mix all others from them. These pigment mixing issues will be dealt with in detail in Chapter 7; the point here is that the concept that only three primaries exist is more true of light mixtures than of paint pigments.

Saturation, Hue, Value

Between each of the hues on a 12-point pigment wheel (2.9) are many more possible gradations as adjacent colors are mixed. It is also possible to mix colors that are not adjacent to each other. Mixing those that lie opposite each other on the color wheel, for example, tends to yield a chromatic gray. Two colors that are opposite each other on the color wheel are called **complementaries**. By definition, complementaries are two hues which when mixed form a neutral gray. Another and opposite effect of complementaries, as we will see in Chapter 9, is that when placed side by side rather than mixed, they tend to intensify each other optically.

The degree to which colors are grayed by being mixed with their complementaries is called **saturation**, also known as "intensity." In their purest, most brilliant state, colors are at maximum saturation; as they become more and more neutral, they are said to be lower in saturation.

The matching of complementaries is not a precise science, however. The 12-point three-primary wheel shown in Figure 2.9 is only one of many suggested models for color relationships. Drawing a line through the center of this wheel shows yellow and purple, red and green, and orange and blue to be pairs of complementaries. But the 10-point color wheel that results from Albert Munsell's five primaries (**2.10**) yields slightly different results: Yellow is the complement of purple-blue, green of red-purple. Only the pairing of blue and yellow-red (orange) remains the same as on the 12-point wheel. The medium being used will also have a bearing on complementary relationships; fabric dyes and ceramic glazes do not produce exactly the

▶ **2.11 Maria Lewis, *Shvetashvatara Upanishad*, 1995**
From the *Upanishad* series. Acrylic paint on canvas, 29 × 29 ins (74 × 74cm).
Three-dimensional forms lend themselves to a variety of value changes, even if the object is itself created in a single uniform color.

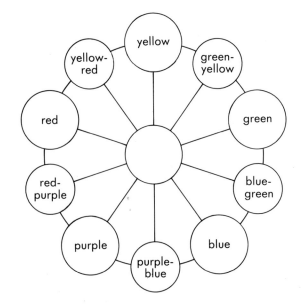

▲ **2.10** Color theorists have proposed other color models, including this one by Albert Munsell, which is based on five principal colors and the intermediate colors that can be obtained by mixing them. The result is a 10-point wheel, as opposed to the traditional 12-point wheel shown in Figure 2.9.

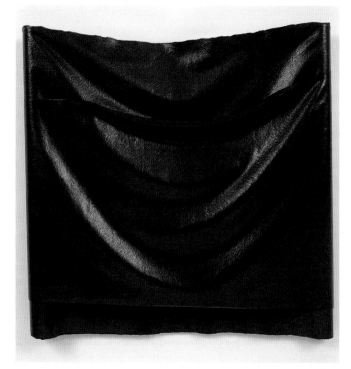

◀ **2.12 Georgia O'Keeffe, *Light Coming on the Plains II*, 1917**
Watercolor on paper, 11⅞ × 8⅞ ins (30.2 × 22.5 cm).
Amon Carter Museum, Fort Worth, Texas (1966.32).
The subtle color variations in this painting are based on value gradations in a single hue, plus transparent mixtures of the blue watercolor with the yellow of the groundsheet.

same mixtures as paint pigments. Because the mixtures and intensifying interactions between complementaries are of great importance in some approaches to color usage, artists must experiment and observe carefully to see which combinations best produce the effects they seek.

In describing the variations among colors, **hue** is the quality we identify by a color name, such as "red" or "purple." It corresponds to the wavelength of a color. Saturation is a measure of the relative purity or intensity of a color. A third property of colors is **value**, sometimes known as "brightness" when light mixtures are being discussed. Value is the degree of lightness or darkness in a color.

Value changes across a three-dimensional surface as it reflects or curves away from a light source. Maria Lewis's three-dimensional piece *Shvetashvatara Upanishad* (**2.11**) is a piece of canvas painted solid ultramarine blue with a

glossy texture like a leather hide. She has wrapped it around rollers and draped it to create imagery suggesting this commentary from Hindu scripture:

> When you or I are able to "roll up the sky like a piece of hide," in that moment when the impossible then becomes possible —and only then—
> will you or I be able to end our pain and misery without the help of God.

Surrounding light is reflected to varying degrees from the surface of Lewis's sculpture, creating optical impressions ranging from very light to very dark blues.

In pigment mixtures, value can be adjusted by the addition of black or white or by thinning the mixture so that a lighter ground shows through. The potential gradations are infinite, though there is a finite limit to the number of differences in value humans can distinguish. In *Light Coming on the Plains II* (**2.12**), Georgia O'Keeffe uses a dark blue watercolor, mixed with black for lower values and also thinned to create increasingly higher values as they reveal and mix with the high yellow of the groundsheet. The lightest values are referred to as "high," the darkest as "low."

When pigments of equal value are mixed, the resulting color is darker rather than lighter, since more wavelengths are absorbed. Because this process subtracts from the light reflected, pigment mixing is called **subtractive color mixing**. This darkening, which occurs during actual paint mixing, is not demonstrated in the traditional theoretical color wheel of pigment relationships shown in Figure 2.9.

One way of introducing variations in value into the diagram showing color relationships is to make a three-dimensional model. Albert Munsell's color "tree" represents value gradations along a vertical axis, with variations in hue indicated by changes around the perimeter, and variations in saturation presented as horizontal steps from the vertical axis (**2.13**). Any color along the vertical axis—from white at the top, through grays, to black at the bottom—is called a **neutral**. Colors close to this axis and thus of low saturation are also commonly called "neutral." Colors horizontally further outward from this axis can be called **chromatic hues**. A colored version of the model is shown in Figure **2.14**. Note that the model is not symmetrical. If saturation is measured in equal steps, each hue is found to have a different number of potential steps and to reach maximum saturation at a different point along the value scale. Yellow,

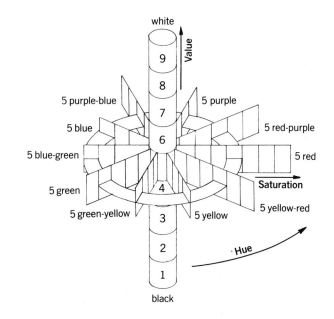

▲ **2.13** In Munsell's three-dimensional model of color relationships, hues are presented around a central axis that represents value changes. Saturation is measured outward from this axis, from the grays of the central pole to the highest saturation possible for each hue. The degree of saturation at the fifth step of value is shown here.

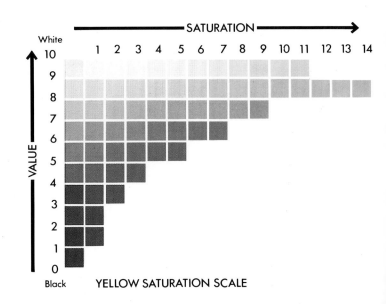

▲ **2.14** Sample representation of change in value and saturation for the hue yellow.

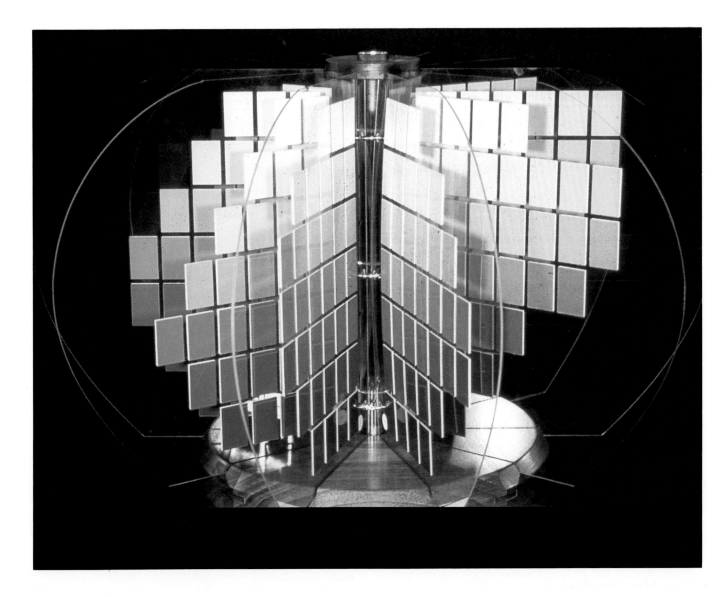

▲ 2.15 The Munsell Color Tree
Albert Munsell's model attempted to show gradations in saturation horizontally without changing value, which was represented along the vertical axis. Gradations in saturation were presented as mixtures of hues with their complements, based on the opposite hues in a 10-point color circle.

which is a light color in its purest form, reaches its maximum saturation at the eighth step of value (**2.15**). Blue, a darker hue in its pure form, reaches maximum saturation at the fourth step of value. For purple, of which the purest form is a dark color, maximum saturation occurs even lower on the value scale, at the third step.

Although many terms commonly used in describing colors are obviously subject to question—some theories even find fault with the terms "additive" and "subtractive"—the concepts of wavelengths, light mixtures, pigment mixtures, primaries, secondaries, hue, value, saturation, and complementaries will be useful as we pursue our study of color.

3
Perceiving Colors

Color is the subjective perception in our brain of an
objective feature of light's specific wavelengths.

LEONARD SHLAIN *Art and Physics*

The colors we see are not simply a function of differing wavelengths; they are actually our response to visual stimuli via complex processes that occur in our perceptual apparatus. These involve the way our eyes register colors, classify the inputs, and transfer them to the brain, and the way the brain decodes the signals. At our present state of scientific knowledge, much of the process of color perception can be described only theoretically. We simply do not yet know how we see colors. Furthermore, the brain may override what the eyes tell it. The more research is done, the more reluctant scientists are to make generalizations about this complex subject. And some of us are able to perceive colors with senses other than our vision, such as hearing and feeling.

The Human Eye

Light, varying in wavelength and brightness, enters the human eye through its transparent outer covering, the cornea. The muscles of the iris contract and expand to admit less or more light through the pupil, depending on the amount of light available. The light which has been admitted is then focused on the back surface of the eye by three refracting media: the aqueous humor, the crystalline lens, and the vitreous humor (**3.1**).

The back of the eye is covered by the **retina**, which consists of many specialized cells arranged in layers. The layer most important to color vision consists of the photorecep-

tors called **rods** and **cones**. They are so named because of their differing shapes. Rods allow us to distinguish forms in dim light, but only with black and white vision; cones function under brighter lighting to allow us to perceive hues. Thus we cannot perceive hues well at night. It appears that rods function in light as well as darkness, for stimulation of the cones also excites the rods.

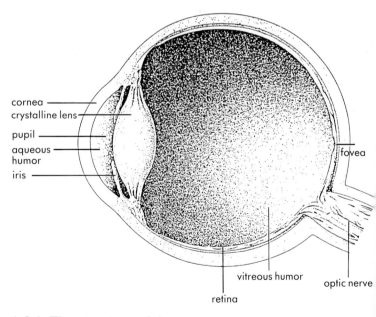

▲ **3.1 The structure of the eye**
Discrimination of colors begins when light entering the pupil reaches the retina, which lines the inside of the eye.

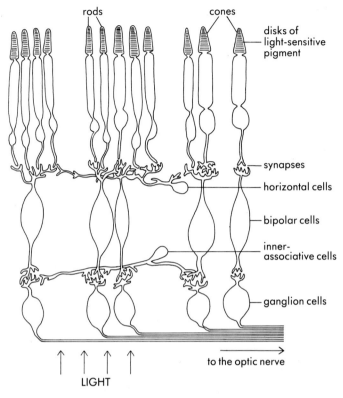

rods

cones

disks of light-sensitive pigment

synapses

horizontal cells

bipolar cells

inner-associative cells

ganglion cells

to the optic nerve

LIGHT

▲ **3.2 Rods and cones**
After light excites the light-sensitive pigments in the rods and cones, electrochemical messages are relayed to the visual cortex in the brain across a network of nerve cells.

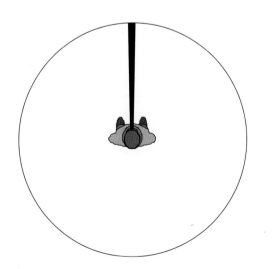

▲ **3.3** We see colors most clearly in the 2-degree area of the visual field that lies directly in front of our eyes.

Before light reaches the rods and cones, it must also pass through layers of nerve cells, as indicated in Figure **3.2**. Only about 20 percent of the light that reaches the retina actually registers in the photoreceptive rods and cones. The rest is simply unseen.

At the center of the back of the eye is an area about one millimeter in diameter known as the **fovea**. It contains only cones. Light falling on this small area gives the sharpest color definition. When we are examining details in an image, we automatically move our eyes until what we want to see is centered on the fovea.

We see colors most accurately in a very narrow field of view—only about 2 degrees directly in front of our eyes, out of the 360-degree field surrounding us (**3.3**).

The approximately 100 million rods and 6 million cones in each eye communicate with the brain via the optic nerve. The photoreceptors send their electrochemical messages to the optic nerve across synapses (gaps) in a complex network of optic nerve fibers. The bipolar and ganglion cells are thought to gather and pass on signals from the rods and cones; the horizontal and inner associative cells seem to integrate activities across the retina. In the fovea, each cone is connected with a single bipolar cell and a single ganglion cell, whereas signals from rods and cones on other parts of the retina are bundled together.

Information from the two eyes is transmitted to various areas on both sides of the brain, where it is somehow re-integrated to form a single image. Almost one-third of the gray matter of the cerebral cortex is involved in this complex process.

Seeing Colors

After centuries of analyzing the anatomy and physiology of color vision, scientists still have no definite proof of how the cones work. They do know that the rods contain disks of a light-sensitive pigment called visual purple, or **rhodopsin**. When light strikes this pigment, it bleaches, reducing the electrical signals for darkness otherwise transmitted by the rods. In the dark, our rods have large amounts of unbleached rhodopsin, allowing us to perceive forms with very little light present. The rods can function at light levels up to one thousand times weaker than the visual system based on the cones.

Like rods, cones also contain light-sensitive pigments, called **iodopsins**, but their nature and functions are still matters of conjecture. Of the many theories advanced, the one in current favor is that there are three general kinds of cone pigments: one for sensing the long (red range) wavelengths, one for the middle (green range) wavelengths, and one for the short (blue-violet range) wavelengths. These primary levels of response are thought to mix to form all color sensations, just as additive mixtures are made from colored lights. Yellow, for instance, is a sensation triggered by activation of the green- and red-sensitive cones. Red-sensitive and green-sensitive cones predominate in the retina, with relatively few blue-sensitive cones. The idea of three basic kinds of cones is called the **Trichromatic Theory**. It was first advanced in 1801 by the English physicist Thomas Young and developed in the mid-nineteenth century by the German physicist Hermann von Helmholtz.

This theory, however, only explains what happens in the photoreceptors under direct light stimulation. It is now thought that electrochemical signals transferred from these receptors to the brain are handled somewhat differently. In this second stage of a process that may actually have other unknown stages, colors may perhaps be discerned in pairs of opposing colors. According to the **Opponent Theory**, some response mechanism—perhaps specialized cells in the visual cortex—registers either red or green signals, or either blue-violet or yellow. In each pair (red/green, blue-violet/yellow) only one kind of signal can be carried at a time, while the other is inhibited. These pairs correspond roughly to the complementary colors on color wheels. Another set of cells responding to variations between white and black is thought to operate in a non-opponent fashion, yielding a range of values.

After-images

The opponent theory, which has been supported by electrical analysis of nerve cells in various animals, helps to explain why we do not perceive a reddish-green or a bluish-yellow. It can also be used to explain phenomena such as **after-images**, visual sensations that occur briefly after a color stimulus is gone. When we stare at a highly saturated color for some time and then at a neutrally-colored area, we "see" an illusory image in the color complementary to the one at which we had been looking. It may be that when the signalling mechanism for one color is fatigued, its opponent color is no longer inhibited. You can verify this effect by first staring at the dot in the center of the red turtle in Figure **3.4** and then transferring your gaze to the dot on its right. What you will see is the "opponent" of red: a greenish light in the same shape. This after-image effect is also called **successive contrast**. After-images occur in our visual perception all the time, but most of us

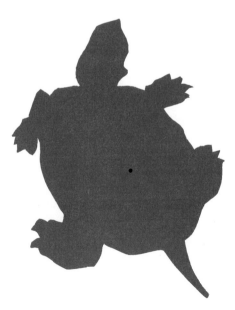

◀ **3.4** Stare at the black dot in the center of the red turtle for 15 to 30 seconds. Then transfer your gaze to the black dot to the right. The luminous blue-green after-image "drawn out of" the white is a successive contrast phenomenon.

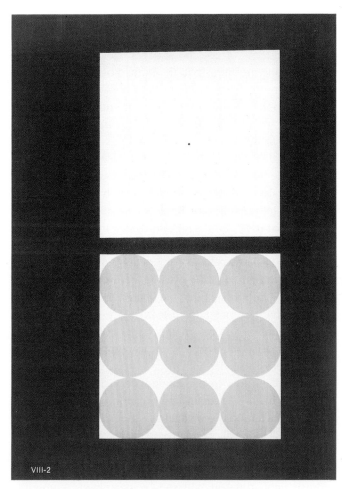

▲ **3.5 Josef Albers, *Color Diagram VIII–2***
Stare at the dot in the center of the yellow circles for 30 seconds. Then quickly look at the dot in the white square above. Note everything you see in each case.

are not usually aware of this phenomenon. If you spend some time looking at a person with brightly colored clothing and then look away, you can perceive an after-image of the person in complementary colors.

After-images cannot be explained simplistically, however. Consider Figure **3.5**, created by Josef Albers, whose work centered on what happens visually in the interaction between object, eye, and brain. If you stare at the black dot in the center of the yellow circles for quite a while and then suddenly transfer your gaze to the black dot on the white square, you will see not only a luminous blue-violet after-image of the circles but also, and even more conspicuously,

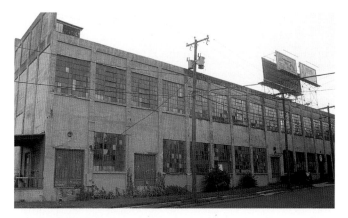

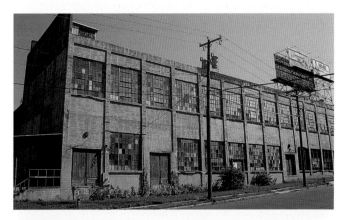

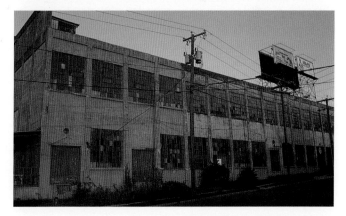

▲ **3.6** Ruth Zelanski, old factory building photographed in the early morning, at noon, and in late afternoon sunset, 2001. Photographs reveal that changes in natural light throughout the day bring a great shift in surface color, from blue-gray to almost gold. But unless people consciously pay attention to such shifts—as many artists do—they tend to interpret the colors as being constantly the same as those in the noon photograph.

yellow diamonds corresponding to the spaces between the circles. We can only guess at what is happening in our perceptual apparatus to create this effect. In fact, nobody yet knows how we see the simplest of color phenomena, let alone the extremely complex array of colors that we perceive every waking moment.

Color Constancy

One unusual scientific discovery has cast doubt on attempts to discover structures in the eye and brain corresponding directly to wavelengths of light. It was described in 1959 and 1977 by E. H. Land, the developer of the Polaroid instant photograph process. In his original work, Land projected two black-and-white slides taken of the same scene from two projectors in such a way that they overlapped exactly. One slide was taken with a red filter and projected through a red filter; the other was taken with a green filter but projected with white light. When projected on top of each other, they nonetheless reproduced an approximation of the hues of the original scene, including blues, yellows, oranges, and greens. Land's discovery also worked when yellow and red lights were used in the projectors. Neither traditional wavelength theories nor trichromatic theories can explain this phenomenon, for Land's research subjects discerned colors with much less information than was ever thought possible. No blue wavelengths needed to be present for people to "see" blue, for instance.

One explanation for Land's results would be that higher structures in the brain were interpreting the colors of fami-liar objects rather than "seeing" them. But in Land's later experiments, people successfully perceived the hues in abstract patterns of colored squares. Land proposed that there is some mechanism in the human brain that makes it work differently from a camera. A camera will reveal that a building looks bluish in the morning and reddish in late afternoon, because of different lighting effects. By contrast, humans tend to perceive the building as if its color were constantly that which is perceived in white midday sunlight (the middle image in Figure **3.6**). This strange but familiar phenomenon by which colors subjectively seem to remain the same under different kinds of illumination is called **color constancy**. Land suggested that it must be the result of some perceptual apparatus in the visual cortex of the human brain that works in conjunction with the color perceptors in the retina of the eye. His **retinex**—"retina" plus "**cortex**"—theory has been vindicated by neurobiological research that demonstrates the existence of a network of tiny peg-shaped "blobs" in the visual cortex at the back of the human skull. These seem to compare visual information from an object with what is seen immediately surrounding it. Colors in the immediate vicinity seem more important in these mental computations than colors at a distance. If a lemon is seen against a green leaf at sunset, the fruit will still look yellow relative to the leaf because the ratio of wavelengths coming from the fruit and the leaf remains the same. Even though the environment is totally bathed in reddish light, the leaf will still be perceived as green—rather than brownish—in comparison to the lemon (**3.7**).

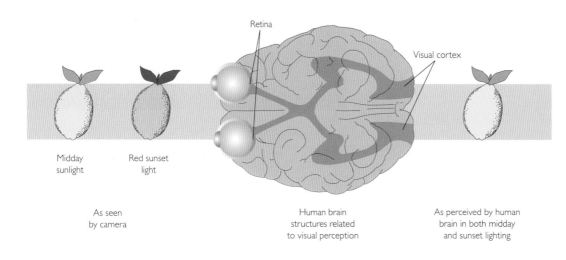

Retina

Visual cortex

Midday sunlight

Red sunset light

As seen by camera

Human brain structures related to visual perception

As perceived by human brain in both midday and sunset lighting

◀ **3.7** Because of the human tendency to perceptual color constancy, studied by E.H. Land, a lemon which appears yellow in white midday sunlight but more reddish at sunset will still be perceived as a yellow lemon at that time of day because all its surroundings also shift equally toward red.

Variables in Color Perception

It seems safe to say that color sensations occur in the responses of our perceptual apparatus. They are not inherent properties of objects. In fact, few animals other than humans even seem to see the world through trichromatic color vision. And humans may differ in their color responses. Given our individual differences in all other physiological areas, it is highly likely that we also differ in color vision.

Genetic and Cultural Differences

Recent research in molecular biology reveals that a minimal genetic difference between two people in terms of a particular amino acid affects their cone cells and thus the way they see colors. Two people looking at the same red object, for instance, may see its color differently. In fact, these studies indicate that there may be an almost infinite variety of ways that people see what is known as "red."

Major variations from the norm can be discovered as forms of color blindness. These are genetic defects found most often in men, some 7 percent of whom cannot distinguish red from green. But even those who are not color blind have no way of knowing whether they are seeing precisely the same red when looking at the same Coca-Cola label, even though the input to both sets of eyes will be of the same wavelength.

Cultural differences also come into play, to a certain extent. We have learned different ways of categorizing color, and these influence what we "see." The indigenous people of the Ituri Forest in Africa refer to dark values of all hues as "black" but have many different labels for white and brown, referring to subtle distinctions that those from cultures who simply say "white" or "brown" may not notice.

Emotions

It is likely that our emotional state influences our color perception. When people are depressed, they may perceive colors as being dimmer than when they are happy. As severe depression sets in, people often describe a visual sensation of darkness. Scientific research shows that our pupils open wider when we look at something we like, thus allowing more light to enter. They narrow when we look at something we do not like, thus decreasing the amount of light that enters. We speak of "seeing red" when we are angry, and of "feeling blue" when we are sad.

Perhaps these statements are also linked to empirical realities in our neurobiological processes.

Design Factors

Little is known of these individual emotional variations in color perception, but scientists and artists have identified some design variables which can be manipulated to influence color perception. Among them are the size of the colored area and its surroundings.

All other things being equal, a large expanse of color will generally appear brighter than a very small area of the same color. Zwelethu Mthethwa's huge C-print shown in Figure **3.8** presents a startlingly large field of highly saturated blue—a most unexpected color for an interior—in a nearly life-sized format that almost fills the viewer's field of vision if he or she is standing near it. If a color field is very small or far away, it will tend to dull and lose the sharpness of its edges. In Figure **3.9**, the same colors appear different, depending on the amounts used and what is next to them.

Thus in some cases, a small area of a color appears darker than a larger area. However, the effect will also depend heavily on the color of the background. The only hard and fast rule that can be applied is that *all colors are affected*

▲ **3.8 Zwelethu Mthethwa,** *Untitled,* **2000**
C-print, 70½ × 95 ins (179 × 214 cm). Jack Shainman Gallery, New York.
Size plays an important role in our perception of colors: a large color field will appear brighter than a small one.

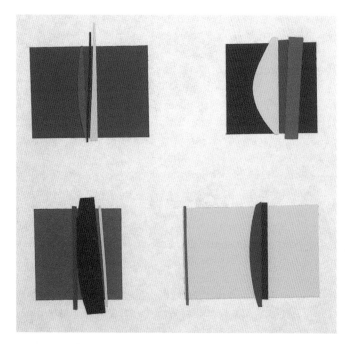

by the colors around them. Consider the apparent shift in value of a uniform gray strip in Figure **3.10**. The strip is actually a uniform color, but as its surroundings become darker, it appears much lighter; as its surroundings become lighter, it appears much darker. The only way to convince yourself that the strip is of uniform color is to cover its surroundings with pieces of paper, so that you can see it in isolation.

Adjacent colors can also change each other's apparent hues. In *All Things Do Live in Three* (**3.11**) by Op Artist Richard Anuszkiewicz, the background is actually a uniform red; the light blue, medium green, medium blue, and

◄ **3.9** The same four colors have been used in these collages, but if you look closely at them, you will perceive differences in their hues and saturation depending on the size of each color's area and what is next to it.

▼ **3.10** The line through the center is actually a solid, uniform gray, but next to darker grays it appears light and next to lighter grays it appears dark.

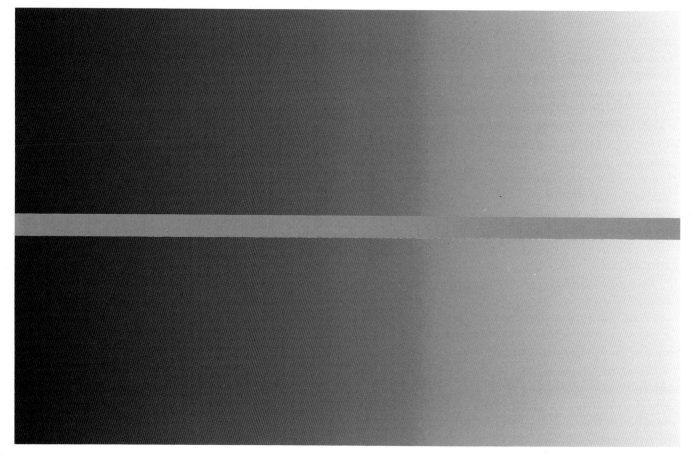

yellow dots on it change its appearance considerably. The only way to see the "true" color of the red would be to cover the dots, so powerful are they in affecting our perception.

Lighting

A third important variable in color perception is the light in which we see an object. Typical fluorescent light has a blue cast; incandescent light is reddish-yellow. The color of daylight continually varies as the sun's angle changes in relationship to the earth; clouds and particles in the atmosphere also cause variations in light diffraction. In general, with some particulate matter in the air, daylight will shift in color from blue in the early morning through white to red in the late afternoon. These changes in turn affect the colors reflected from objects.

We nonetheless tend to perceive colors as unchanging, because of our visual memory. A white card will still look white to us, whether we see it under a yellow candlelight or "white" daylight. Because of this tendency, introduced

▲ **3.11 Richard Anuszkiewicz, *All Things Do Live in Three*, 1963**
Acrylic on masonite, 21⅞ × 35⅞ ins (55 × 91 cm).
Private collection.
Stare at this Op Art painting for a while. How many different reds do you perceive? The only way to see that a single red has been used throughout is to cover the dots upon it.

earlier as color constancy, we might say that our house "is" the medium brown that it appears at midday under a slightly overcast sky, even though its color, early in the morning, is a dark blue-brown, and, late in the afternoon, a reddish brown, and even though the areas in shadow are much darker than those in direct sunlight. As indicated earlier, something in our brains compensates for the actual changes, allowing us to generalize our color perceptions and therefore recognize familiar objects so that we do not, for example, think we have come home in the evening to

the wrong house. E. H. Land, in noting that we will compensate for the extra redness in tungsten filament lights without believing that the objects illuminated have changed in color, suggested that

> the eye, in determining color, never perceives the extra red because it does not depend on the flux of radiant energy reaching it. The eye has evolved to see the world in unchanging colors, regardless of always unpredictable, shifting and uneven illumination.[1]

Although this mental process is automatic, protecting us from visual chaos, those who choose to be more observant can override it. In search of visual truth, the French Impressionist Claude Monet (1840–1926) observed and painted the exact same scenes—haystacks, poplars along a canal, the face of a cathedral—under many different lighting conditions, documenting the great changes that actually occurred. Discarding the idea that objects possess a certain color, Monet trained his eye to see each moment in its freshness. He stated:

> This is what I was aiming at: first of all, I wanted to be true and accurate. For me, a landscape does not exist as landscape, since its appearance changes at every moment; but it lives according to its surroundings, by the air and light, which constantly change.[2]

To observe the effects of light on Rouen Cathedral, Monet rented a room opposite the cathedral and spent months there working at paintings on different easels corresponding to the different times of day. Of the twenty canvases in the completed series, the two shown in Figures **3.12** and **3.13** illustrate the great differences he observed even in the color of stone. In full midday sunlight, the façade is awash with gold, with slight blue shadows, and some surfaces are bleached almost white by the brightness of the sun. At sunset, by contrast, Monet saw the surface as a pale bluish pink, with rich oranges and reds in the building's recesses.

Lighting is important to artists not only in observing the world around them but also in creating and displaying their works. Paintings and frescoes created hundreds of years ago were painted by natural light or artificial light from candles or oil lamps. Under stronger lighting in modern museums, their hues may look brighter than they did to their creators, if the surfaces have not faded. In the northern hemisphere, some artists seek natural northern lighting

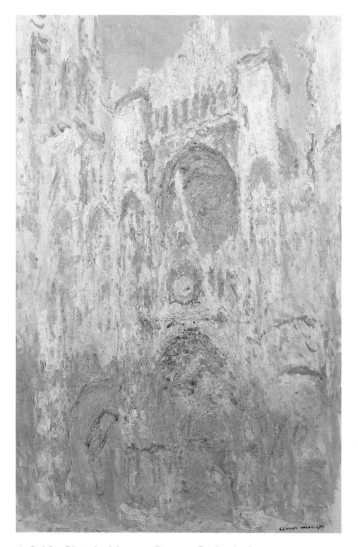

▲ **3.12 Claude Monet, *Rouen Cathedral, Effect of Sun, End of Day,* 1894**
Oil on canvas, 39²/₅ × 25³/₁₀ ins (100 × 64.3 cm).
Musée Marmottan, Paris.
Monet overruled the human optical tendency to color constancy, recognizing and portraying the actual color shifts that occur with changing lighting.

▶ **3.13 Claude Monet, *Rouen Cathedral, The Portal and the Albane Tower. Full Sunlight. Harmony in Blue and Gold,* 1894**
Oil on canvas, 42¹/₁₀ × 28¹/₂ ins (106.9 × 72.3 cm).
Musée d'Orsay, Paris.

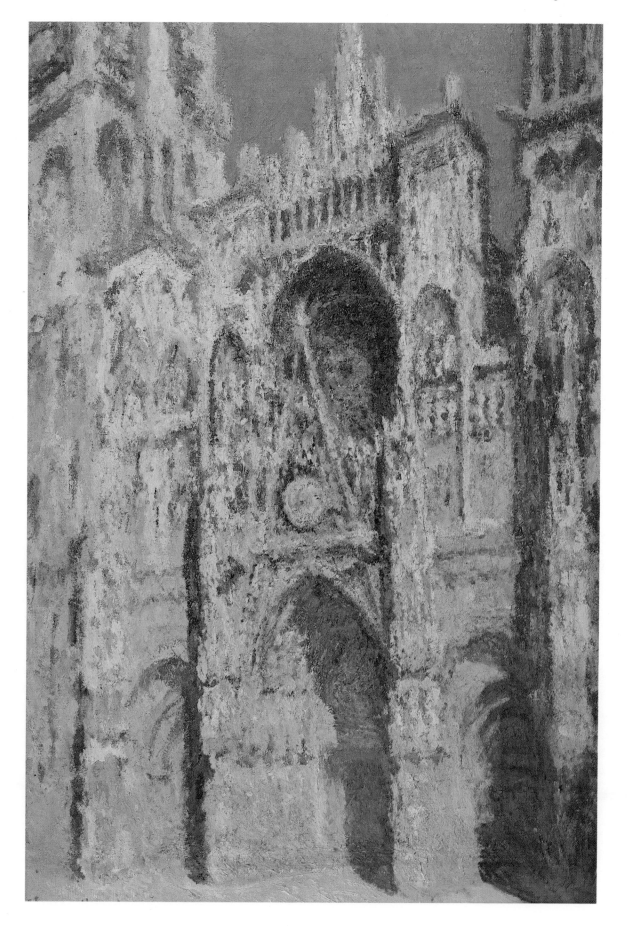

for their studios because this light changes the least during the day as the sun moves through the sky from east to west; in the southern hemisphere, a southern exposure is more unchanging. Artificial lighting is preferred by others because it does not change at all, assuming that no natural light comes in at the window, and because works are ultimately most likely to be seen under such lighting. These lights do affect color sensations, however. Familiar incandescent tungsten lights are typically redder than midday daylight. The light given by fluorescent tubes usually depends on the fluorescent chemicals that coat the tubes. Figure **3.14** shows the great differences in the same collage photographed with daylight film under daylight, incandescent tungsten light, and ordinary fluorescent light. Since regular fluorescent lighting is bluish, a warm pink fluorescent tube may be paired with a bluish one to give a more even white light. More expensive "full-spectrum" fluorescent tubes are color-corrected to approximate sunlight. Colors created under yellow incandescent lighting may appear more brilliant when taken outside under natural light.

The effect of natural lighting on works of art is strikingly apparent at the Kimbell Art Museum in Fort Worth, Texas (**3.15**). It was designed by Louis Kahn, who once said that "you cannot make a building unless you are joyously engaged." Colors really come alive in this museum, where works of art hanging on the off-white travertine walls are lit by natural daylight coming through long skylights in vaulted ceilings. Because the ultraviolet light in sunlight can be destructive to paintings, the light is screened and reflected off the concrete ceiling. Light itself almost becomes the subject of this architectural environment, an effect that is in keeping with Kahn's philosophy:

> All material in nature, the mountains and the streams and the air and we, are made of Light which has been spent, and this crumpled mass called material casts a shadow, and the shadow belongs to Light.[3]

Surface Qualities

In addition to size, surroundings, and lighting, the color we perceive depends, in the case of pigments, on the characteristics of the surface from which it is reflected. A shiny three-dimensional surface will not reflect light uniformly. As in Figure 2.11, many optical color variations will seem to play across its surface, even if the object is actually of a uniform color. Reflection of light from its outermost contours will be strongest, making them appear optically very light, even if the material is actually of dark color. A rough or porous matte surface will reflect light in a more diffuse manner. It will appear lighter or darker as it curves away from the light source, but without the extreme highlights characteristic of a glossy surface.

Materials have different reflective qualities. The same hue will appear different if it is on wood, metal, canvas, paper, ceramics, or cloth. The black plastic parts of the water tap in Figure **3.16** have a certain sheen and therefore develop slight highlights, but are not nearly so reflective as the chrome body of the tap.

A shiny surface will also reflect the colors around it. The chrome finish of Davide Mercatali and Paolo Pedrizzetti's

◄ **3.14** The same collage photographed (a) with daylight film in daylight, (b) with daylight film under incandescent tungsten light, (c) with daylight film under fluorescent light. Daylight film in daylight is a fairly accurate reproduction of the actual colors. Incandescent tungsten light gives a reddish cast to the colors; ordinary fluorescent light gives a blue-green cast.

◀ **3.15 Louis Kahn (architect), Interior of Kimbell Art Museum, Fort Worth, Texas (detail)**

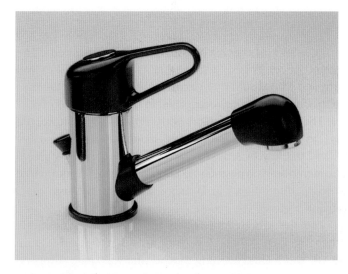

▲ **3.16 Davide Mercatali and Paolo Pedrizzetti, *Hi-Fi Tap/mixer***
The shiny chrome of this faucet is so reflective that its own color is difficult to distinguish from those of reflected surrounding colors.

water tap carries a complex array of reflections, including a variety of yellow values that develop as it picks up the solid yellow of its surroundings, reflected to various degrees as it curves through space, plus the black of its own fittings, and even its own highlights, re-reflected. Figure **3.17** indicates ways that light will be reflected, refracted, or absorbed by differing surfaces.

Nonvisual Color Perception

A final limitation of scientific theorizing on the artist's use of color perception phenomena is the fact that many of us perceive colors through senses other than our vision. The ability to feel colors with our hands is not uncommon among blind people. Try it yourself: Take several sheets of silkscreen colored papers in different hues, close your eyes, and run your hands over them. Can you feel any differences? Yellow, for instance, may feel much clearer and "faster" than red.

Some people perceive colors when hearing sounds. Associations between colors and musical keys, notes, or instruments are so common that a body of research exists surrounding this kind of **synesthesia** (the combining of two forms of perception). The composer Scriabin, for instance, associated musical keys with colors. He experienced the key of C as red, G as orange, D as yellow, A as green, E as light blue, B as whitish blue, and so on. Scriabin even composed a special symphony, *Prometheus*, with a part for projected colored lights as "a powerful psychological resonator for the listener."[4] Scriabin's vision, never fulfilled, was to use

> … a great white hall with a bare interior dome having no architectural decorations. From this dome the shimmering colors would rush downwards in torrents of light.[5]

People with synesthetic perception tend to experience rising pitch or quickening tempo as lighter colors; somber passages are readily perceived as dark colors. As the

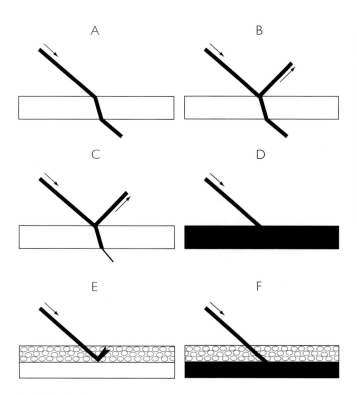

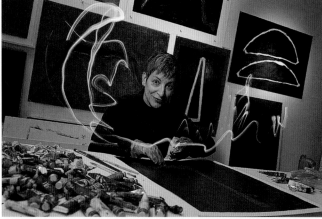

▲ **3.18** Carol Steen using light to display the colors she perceives while hearing music. Photograph by Kay Chernush.

▲ **3.17 Reflective qualities of surfaces**

a) Refraction—a ray of light passing through a transparent surface is refracted (bent) and then transmitted onward.

b) Reflection and transmission—some light may also be reflected from a transparent surface, depending on its surroundings and the angle from which it is seen. If the surface is shiny but non-transparent, light is reflected from the surface but not transmitted through it.

c) Translucence—a translucent or semi-opaque surface transmits only a little light. Some light is reflected, and some absorbed.

d) Absorption—the least reflection occurs when light strikes a dark matte surface. The light is instead absorbed. In opaque materials, a bright white surface reflects the most light and absorbs the least.

e) White ground—in painting, if a translucent layer of pigment and medium is spread over a white ground, some light is reflected back upward through the paint, giving brilliance and luminosity to its colors. The more opaque the paint, the less this effect occurs.

f) Dark ground—a dark ground beneath a layer of translucent paint absorbs rather than reflects light rays, so there is no appearance of brilliance or luminosity.

painter and art theorist Wassily Kandinsky asserted: "The sound of colors is so definite that it would be hard to find anyone who would try to express bright yellow in the bass notes, or dark lake [a red-purple] in the treble."[6]

The association of colors with certain sounds, however, is, on the whole, a subjective matter. Rimsky-Korsakov "saw" the key of A as "rosy," rather than Scriabin's green. Contemporary synesthetic composer Michael Torke wrote "Bright Blue Music" in D major, and "Green Music" in E major.

Females are far more likely to experience synesthesia than are men. When New York artist Carol Steen (Figure **3.18**) was a child learning to read, she was quite surprised to discover that her friends did not experience "A" as pink, as she did. Tastes trigger color sensations for her as well: "I see the most brilliant blue after I eat a salty pretzel." And for her, pain is definitely orange. Acupuncture also evokes such clear sensations of colors and shapes that she paints them. This heightened world of color experience was previously viewed as a kind of mental illness. But scientists now have extensive documentation that what synesthetes experience are real perceptual phenomena, although they still are not certain how they occur. Carol Steen says:

"It's the only way I know of perceiving. If someone said they were going to take it away, it would be like saying they were going to cut off my leg."[7]

4
Psychological Effects of Color

By trial and error, color can be used to evoke a visceral reaction antecedent to words.

PAUL GAUGUIN

It is universally accepted that colors affect us emotionally. Bright reds, oranges, and yellows tend to stimulate us, while blues and greens often make us feel more peaceful. Colors can therefore be used to express emotions and even to evoke them. Here again, however, we must beware of simplistic assumptions, for very slight differences in colors can produce quite different effects.

Warm and Cool Colors

We associate the colors of fire—reds, yellows, oranges—with warmth. This is not just an abstract notion, for physiological research indicates that under red lighting our bodies secrete more adrenalin, increasing our blood pressure and our rate of breathing, and actually raising our temperature slightly. Imagine how warm you would feel in the sitting room designed by David Hicks shown in Figure **4.2**. Yellows and oranges have a similar effect, though they are not as warming as strong reds.

By contrast, feel the coolness of the greens and blues in the poolside area of a Los Angeles house designed by Luis Ortega (**4.3**). We associate blues and greens with the cooling qualities of water and trees, and physiological research shows that green or blue lights will slow our heartbeat, decrease our temperature, and relax our muscles.

Hues in the red area of the color wheel are therefore often referred to as "warm," while those in the blue and green range are called "cool." These terms are relative

rather than absolute. Notice how the intensity of the red walls and floor in Figure 4.2 makes the oranges, yellows, and pinks of the painting over the sofa seem cool by contrast; the "hot" pinks in the easel painting on the left seem positively icy.

In addition to the influence of surroundings, it is possible to discern warmer and cooler variations on a single hue. As the value of a hue becomes lighter, it generally appears cooler. And the addition of a small amount of a cooler hue to a red or a warmer hue to a green will create what could be called a "cool red" or a "warm green." In Figure **4.1**, which compares colors mixed by printers' ink formulas numbered according to the Pantone Mixing System (PMS), a single unit of yellow has been substituted for one of the eight units of Rubine Red in PMS 219 to create PMS 205. Does PMS 219 feel warmer or cooler to you than PMS 205? Surely PMS 217, which has only one part of Rubine Red to 31 parts of white, is cooler than either of the darker reds.

▲ **4.1 PMS 217, 205, 219**
Do you experience any subjective difference in warmth between these colors?

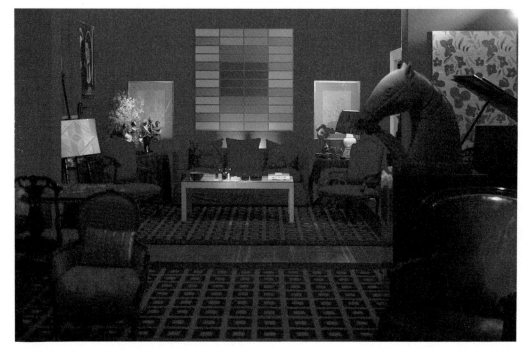

◀ **4.2 David Hicks, Sitting room of a house in Oxfordshire, England, 1970s**
Red is usually experienced as a warming color.

Physiological Effects

Mystics have long held that we emanate a colored glow, or aura. Some feel that its presence has been verified by Kirlian photography, a special process for capturing the usually invisible energies that radiate from plants and animals. The color of the aura, as seen by clairvoyants, is thought to reflect the state of a person's health and spirituality. According to the mystic Corinne Heline, gold is the auric color of spiritual illumination, clear blue or lavender indicates a high spiritual development, orange a predominantly intellectual nature, clear green a sympathetic nature, and pure carmine or rose-red an unselfish, affectionate quality. Duller colors are associated with materialistic, fearful, or selfish qualities. A dark gray aura with brown and red in it accompanies depression.

According to physiological research with the effects of colored lights, red wavelengths stimulate the heart, the circulation, and the adrenal glands, increasing strength and stamina. Pink has a more gently stimulating quality and helps muscles to relax. Orange wavelengths stimulate the solar plexus, the immune system, the lungs, and the pancreas, and benefit the digestive system. Yellow light is stim-

ulating for the brain and nervous system, bringing mental alertness and activating the nerves in the muscles. Green lights affect the heart, balance the circulation, and promote relaxation and healing of disorders such as colds, hay fever, and liver problems. Blue wavelengths affect the throat and thyroid gland, bring cooling and soothing effects, and lower blood pressure. Deep blue lessens pain. Blue-green light helps to decrease infections, soothe jangled nerves, and correct weakness in the immune system. Indigo light helps to counteract skin problems and fevers. Violet light affects the brain, has purifying, antiseptic, and cooling effects, balances the metabolism, and seems to suppress hunger.

Given these apparent physiological effects of colored lights, there is a science of healing with colors, or **chromotherapy**. People are bathed with colored lights, placed in colored environments, or asked to meditate on specific colors thought to stimulate particular glands. This form of treatment dates back thousands of years to the "color halls" of the ancient Egyptians, Chinese, and Indians.

Although color healing has remained largely an occult science, chromotherapy is being taught in some nursing schools and alternative medical centers, and the medical

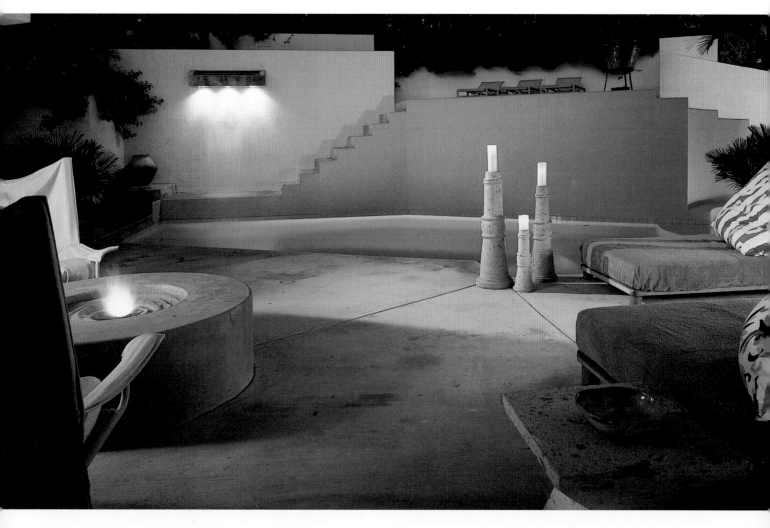

▲ **4.3 Luis Ortega, House and pool designed for Duke Comegys, Los Angeles**
Blues and greens are considered cooling.

profession as a whole makes use of color in certain treatments. For example, premature babies with jaundice are cured by exposure to blue light.

A more prominent use of color therapy occurs in interior design. Psychological literature is full of attempts to determine how specific colors affect human health and behavior and how best to put the results into effect. Bright colors, particularly warm hues, seem conducive to activity and mental alertness and are therefore increasingly being used in schools. Cooler, duller hues, on the other hand, tend to sedate. Henner Ertel studied the effects of environmental color among schoolchildren in Munich. The interior design colors with the most positive intellectual effects in Ertel's study were yellow, yellow-green, orange, and light blue. Surrounded by these colors, children's IQ scores rose by up to 12 points. In white, brown, and black environments, IQ scores fell. In addition, Ertel found that an orange environment made the children more cheerful and sociable and less irritable and hostile.

In some institutional situations, a calming environment is beneficial. In a study conducted by Harry Wohlfarth and Catharine Sam of the University of Alberta, the color environment of 14 severely handicapped and behaviorally disordered eight-year-olds was radically altered. It was

changed from a white fluorescent-lit classroom with bright orange carpeting and orange, yellow, and white colored walls and shelves to one with full-spectrum fluorescent lighting and brown and blue walls and shelves. The children's aggressive behavior diminished and their blood pressure dropped. As one nurse reported:

> I found the children and myself considerably more relaxed in the new room. The afternoons seemed less hectic and instead of running out of time for our activity, we ran out of activities.
>
> I also found at lunch I was more relaxed and was able to eat something without feeling sick.... The noise level really went down in the Phase II room, which seemed to keep everyone from getting upset as the day went on.[1]

When the environment was then experimentally changed back to the way it had been before, aggressive behavior and blood pressure returned to their previous levels.

Interestingly, the same effects were found in both blind and sighted children in Wohlfarth and Sam's study, suggesting that we are affected by color energies in ways that transcend seeing. One hypothesis is that neurotransmitters in the eye transmit information about light to the brain even in the absence of sight, and that this information releases a hormone in the hypothalamus that has numerous effects on our moods, mental clarity, and energy level. In what Wohlfarth calls the science of "color-psychodynamics," colors that seem to increase blood pressure and pulse and respiration rates are, in order of increasing effect, red, orange, and yellow. Those decreasing these physiological measures are green (minimal effect), blue (medium effect), and black (maximum effect).

The legendary Notre Dame football coach Knute Rockne attempted to use awareness of the physiological effects of colors competitively. To stir up his own players, he painted their locker room red. He had the visiting team's locker room painted in blue-greens, thus sedating them both before the game and when they returned to relax at half-time. Similarly, the influence of environmental color was demonstrated in one factory where workers were complaining about feeling cold. Rather than raise the thermostat, management decided to paint the blue-green walls coral. The complaints stopped.

Lest we hasten to repaint everything in attempts at behavior modification, we should note that physiological color responses are complex. The precise variation of a hue

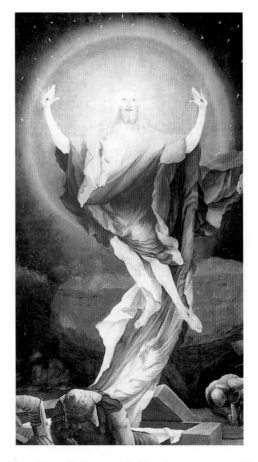

▲ **4.4 Matthias Grünewald, *The Resurrection* (detail), right wing of *The Isenheim Altarpiece*, c. 1510–15**
Oil on panel, full painting 8 ft 10 ins × 4 ft 8 ins (2.7 × 1.4 m). Musée d'Unterlinden, Colmar, France. The risen Jesus is often shown dressed in red, symbolizing vibrant life.

has a major impact, but one that is rarely addressed by psychological research. One shade of pink may be calming, while another may be stimulating. Although mystics find certain blue-violets conducive to a very high spiritual state, a group of college students said that a blue-violet they were shown tended to make them feel sad and tired. These same students found that a color described by the researchers as "cool green" made them feel angry and confused.

Furthermore, initial responses to a color environment may be reversed over time as our body adjusts to the new stimulus. It is known that some time after blood pressure is

raised by red light it drops below the normal level; after blood pressure is lowered by blue light, it eventually rises to a higher-than-normal level.

Color Symbolism

Our responses to colors are not just biological. They are also influenced by color associations from our culture. In societies where most adults drive cars and are familiar with stop lights, there is an automatic association of red with "stop" and green with "go." In cultures where cars are rare this clear-cut association does not exist.

In Western industrial cultures, black is associated with death; mourners wear dark clothes and the body is trans-ported in a black limousine. In ancient Egypt, however, statues of Osiris were painted black to indicate the period of gestation when seeds are sprouting beneath the earth; black was associated with preparation for rebirth rather than with an ending of earthly life. People in the West Indies use bright colors to commemorate deaths, in cele-bration of the soul's departure for a happier existence. In China and India the color used for mourning is white— because of the humility of wearing undyed cloth and the association of white with peace and coolness. In some Native American tribes, black is associated with introspec-tion; white is seen as the color of winter, of purification and renewal.

Despite regional differences, red is associated with vig-orous life in many cultures, probably because it is the color of blood (**4.4**). The earliest humans were buried with red ocher pigments. Maybe it was hoped that the color would help the deceased to live on in another plane. Highly satu-rated blood reds are often linked with women's sexuality or fertility, while light values of red-pinks may be used to express affection and sweetness. The exaggerated dark pink skin of Andy Warhol's *Marilyn* (**4.5**) suggests sweet-ness and sensuality at the same time.

Variations on the same hue may have different symbolic associations. In Catholic religious art, the blue of a clear sky is often used to symbolize heaven. The Virgin Mary's robe is usually a blue, often a more saturated version of the color, symbolizing the quiet power of her serenity. If she is dressed in a darker blue-black, this color may be interpreted as an expression of her sorrow over the death of her son.

▲ **4.5 Andy Warhol, Mint Marilyn Monroe, 1962**
Oil and silkscreen enamel on canvas, 20½ x 16½ ins (52 x 42 cm). Jasper Johns Collection 2000, Andy Warhol Foundation for the Visual Arts, New York.
Andy Warhol has exaggerated Marilyn Monroe's normal coloring to emphasize the sexual associations of red, and of blonde hair.

Personal Color Preferences

Not only have we inherited cultural associations, but we also respond to colors in individual ways. Imagine that you are standing in Larry Bell's neon-lit installation piece (**4.6**). How do these particular blues affect you personally? If you compare your responses with those of other people, you may find some significant differences.

Psychological research has revealed some variables that help explain individual differences in color responses. To wit: We are most responsive to the pleasure of sheer color as children. From early infancy, babies respond to brightly colored objects. Among adolescents, the sensation-seeking prefer red, while the more reserved prefer blue. Elderly people have a significant preference for light over dark

colors, but yellow is the color they like least. People with certain mental illnesses—particularly schizophrenia—show a preference for nonchromatic, neutral colors (white, black, brown, gray) while "normal" people and manic-depressives generally prefer chromatic hues. Extroverts tend to prefer warm hues; introverts like cool hues. However, people may be drawn toward colors representing qualities they lack, for balance. Red, for instance, is usually the preference of vibrant, outgoing, impulsive people, but timid people may also be drawn to it. Those who are feeling frustrated or angry may be repelled by red.

Individual color preferences are so distinctive that they have been used for purposes such as personnel selection, treatment of the elderly, medical diagnosis, and therapy since the middle of the twentieth century, when the Swiss psychologist Dr. Max Luscher developed his Luscher Color Test. He proposed that a person's selections and rejections of specific colors reveal information about his or her psychological characteristics. In the Luscher Color Test, subjects are given colored cards to line up from most to least favorite. The full test involves 73 color cards; the more commonly used version has dark blue, blue-green, green, orange-red, yellow, brown, black, and gray as choices. A person who prefers blue, according to Luscher's conclusions, tends to be passive, sensitive, tender, and loving; a person who prefers orange-red tends to be active, aggressive, competitive, and lusty. Dr Luscher also proposes that a proper inner balance of the four "psychological primaries" red, green, blue, and yellow yields a happy, well-adjusted person (**4.7**). The samples used for Luscher testing are not always uniform in color, nor is there general agreement about the direct correlation of color preferences with personality traits, but color choices are nonetheless of interest to artists, particularly in applied design.

Not only personality but also geography may influence our color preferences. According to the work of the psychologist E. R. Jaensch, people from strongly sunlit countries tend to prefer warm, bright colors, while those from countries with less sunlight tend to prefer cooler, less intensely saturated colors. Jaensch speculated that in

◀ **4.6 Larry Bell, *Leaning Room II*, 1970**
Sheet rock, paint, and fluorescent light installation based on leaning room, artist's studio, Venice. Collection of the artist.

▲ **4.7 Advertisement for Patrick Cox shoes in *Wallpaper* magazine, September 2000.**
All the spectral hues have been employed here to suggest a well-rounded, successful personality—to help sell his shoes.

brighter environments, people's eyes have adapted to protect them from sunlight so there is a physiological bias toward these warm colors. In areas where the sun is not so bright, people's eyes are more accustomed to drawing ambient light from the sky and are thus biased toward cool colors. Scandinavians tested showed a preference for blue and green, while Mediterranean people preferred red.

Our own color preferences are important to us. A study of six- to eleven-year-olds wearing goggles with colored eyepieces while doing a pegboard test (imagine this situation!) showed that they completed the test much faster and more accurately when they were wearing goggles of their favorite color.

◀ **4.8 Emil Nolde,** *Autumn Sea XVI*, 1911
Oil on canvas, 29 x 34½ ins
(73 x 88 cm).
© Nolde-Stiftung, Seebüll, Germany.
Yellow is commonly used to evoke
a happy mood, but it may also be
associated with fear.

Unconscious color prejudices are also sometimes apparent in artists' works. However, to use a musical analogy, it is limiting to try to play everything on the violin when a whole orchestra of instruments is at one's disposal. Artists can explore the entire range of hues, at all levels of value and saturation, in order to create any effect they desire.

Emotional Effects

Given their physiological effects, different hues seem to create different emotional responses in those who see, wear, or live with them. Although there are no hard and fast rules about the effects of different colors, color therapist Suzy Chiazzari specifies these associations between emotions and particular hues:

> *Red:* vitality, strength, warmth, sensuality, assertion, anger, impatience
> *Pink:* calmness, nurturance, kindness, unselfish love

> *Orange/peach:* joy, security, creativity, stimulation
> *Yellow:* happiness, mental stimulation, optimism, fear
> *Green:* harmony, relaxation, peace, calmness, sincerity, contentment, generosity
> *Turquoise:* mental calmness, concentration, confidence, refreshment
> *Blue:* peace, spaciousness, hope, faith, flexibility, acceptance
> *Indigo/violet:* spirituality, intuition, inspiration, contemplation, purification
> *White:* peace, purification, isolation, spaciousness
> *Black:* femininity, protection, restriction
> *Gray:* independence, separation, loneliness, self-criticism
> *Silver:* change, balance, femininity, sensitivity
> *Gold:* wisdom, abundance, idealism
> *Brown:* nurturance, earthiness, retreat, narrow-mindedness[2]

Such associations are rather common, but on the other hand cannot be considered absolute. Consider the heated comments of color specialist Faber Birren about the seemingly innocuous color white:

◀ **4.9 Still from the film**
***Red's Dream*, produced by**
Pixar on Pixar Image
Computer, 1987
"A Night in the Bike Store" is
computer-rendered in local
color, complete with shadow
effects.

A prominent decorator once told me that "white is the best thing for walls. It is neutral and it blends with everything!" This is preposterous. If you've read *Moby Dick*, you may remember the hair-raising description of white as the most portentous, desolate and heinous of all visual sensations.

White is terrible when you get too much of it. It hurts the eyes. Worse than this, it makes you feel sterile and naked and as vacant as shadow. Neutral? It puts restaurants out of business and hospitals out of patients.[3]

Although psychologists have conducted experiments to see how people respond to certain colors in isolation, in everyday life we see hundreds of thousands of colors in infinite combinations and unique contexts. The actual emotional effect of a specific color in an artwork depends partly on its surroundings and partly on the ideas expressed by the work as a whole. To be surrounded by blue, as in the Larry Bell installation (4.6), is quite different from seeing a small area of blue in a larger color context, such as the blue covers on the poolside chaises shown in Figure 4.3. And to illustrate the importance of thematic context, consider the use of yellow in Emil Nolde's *Autumn Sea XVI*

(**4.8**). This highly saturated yellow is often associated with happy, uplifting emotional effects, but Nolde has used it in such a way that it evokes feelings of terror and turmoil. For one thing, he has used it to fill the sky, broken by streaks of red-purple and black. No sunset ever looked like this. Spatially, the black regions seem to be advancing over our heads, getting darker and darker as they approach us. Nolde has placed our point of view almost down in the roiling water itself, as if we are drowning in it, with the sky pressing down menacingly above. Nolde (1867–1956) was a leader in the German Expressionist movement, using colors to express inner psychological states rather than outer realities.

Local and Expressive Color

There are two opposite ways of using color in representational art. At one extreme is **local color**—the color that something appears from nearby when viewed under average lighting conditions. We think of the local color of a banana as yellow, for example. Thinking in terms of local

◀ **4.10 George Segal,**
Depression Bread Line
(detail), 1991
Plaster, wood, metal, and
acrylic paint, full work
108 x 108 x 36 ins
(274.3 x 274.3 x 91.4 cm).
FDR Memorial, Washington,
D.C. Courtesy, Sidney Janis
Gallery, New York.

▶ **4.11 George Chaplin,**
***Turner*, 2001**
Oil on canvas, 66 x 78 ins
(168 x 198 cm).
When color is used without
any figurative imagery, it may
nonetheless evoke emotional
responses. What do you feel
when looking at these floating
colors? Why has the artist
compared this work with that
of J.M.W. Turner (see 9.11)?

color can, however, be deceptive. Many colors can be perceived across the surface of a banana. In the realistic scene from the computer-generated film *Red's Dream* (**4.9**), the artists have programmed the computer to take into account the light from five different light sources; two of them cast shadows that affect both value and hue in accurate local color.

At the other extreme is the **expressionistic** use of color, whereby artists use color to express an emotional rather than a visual truth. Human skin comes in many colors, but never in green. Nonetheless, George Segal has expressively used green for the faces as well as figures of men standing silently waiting for the dole during the Depression (**4.10**). If they had pink faces, we might think them drunk, but the green cast creates a sickly, depressing impression of their solitude, social embarrassment, and unaccustomed poverty.

Expressive use of color may dispense altogether with representational imagery, as in George Chaplin's *Turner* (**4.11**). This is a painting which does not even look like a painting, for it is impossible to see how the colors were applied to the canvas, or which was applied first and which last. The colors just float there, sometimes in the background, sometimes in the foreground, ephemeral, unbounded presences that shift during the day with changes in natural lighting. Chaplin explains:

Color is both the subject and object of my painting, and I celebrate it for its emotional and spiritual impact. Each work develops as an intuitive and sensory experience through subtle transitions of varying amounts of color. These combine to produce a kinetic illusion of light and space. I feel my way of working is directly aligned with the process of change in nature. A temporal analogy is the chromatic shifting of atmosphere apparent in the minutes of a sunrise.[4]

5

Compositional Effects of Color

Art is harmony. Harmony is the analogy of contrary and similar elements of tone, of color, and of line, conditioned by a dominant key, and under the influence of a particular light.

GEORGES SEURAT

Analyzing color use from a strictly design-oriented point of view, we find that in addition to its emotional influence, color can strongly affect the composition of a work. Color choices may be based as much upon their influence on perceptions of space, unity, and emphasis as upon the artist's desire for realism or psychological suggestion. Shapes and textures are part of this organizational process, but color also plays a major compositional role. In this chapter, we will be analyzing the effects of color irrespective of the ways artists have used shapes and textures; in reality, however, all elements of design are interrelated.

Spatial Effects

Colors can influence our spatial perceptions in many ways. For one thing, hues that are lighter at maximum saturation (yellows, oranges) appear larger than those that are darker at maximum saturation (blues, purples). According to the Munsell system of classifying colors, yellow reaches maximum saturation at step 8 of value, whereas blue does so at step 4, and purple at step 3. And highly saturated colors tend to appear larger than those that are less saturated.

In Christo and Jeanne-Claude's installation *Wall of Oil Barrels: Iron Curtain* (**5.1**), in which oil barrels piled twelve feet high completely blocked traffic between the Rue de Seine and Rue Bonaparte in Paris for several hours, all the barrels are of the same standard size. But of the ends

▲ **5.1 Christo and Jeanne-Claude, *Wall of Oil Barrels—Iron Curtain,* Rue Visconti, Paris, June 1962.** © Christo 1962.
In addition to being a provocative and even obstructive political statement, the Christos' oil barrels allow us to compare the apparent visual size of colors whose actual size is identical.

▶ **5.2 Beverly Dickinson, Greek landscape**
Photograph. Color contrasts are greatest in areas that are closest to the viewer; distant areas lose color contrast and may be tinged with a blue atmospheric haze.

that we can see, those painted white or yellow seem visually larger than those colored dark blue or brown, which is of lower saturation than pure yellow.

When a color expands visually, it may also seem closer to the viewer than those that seem to contract. Look again at the oil barrels in 5.1. Do the white ones seem to pop forward optically? A related perceptual phenomenon is the observation that warm colors seem to advance while cool colors seem to recede. But in practice, artists can bring any color forward or push it back, depending on what other spatial devices they use.

Nevertheless, an awareness of these color effects is often useful. Interiors that are physically small can be made optically larger through avoidance of large areas of highly saturated warm colors, which tend to fill the space visually. In David Hicks' room (4.2), red seems to be advancing into the room from all sides—walls, floor, and furniture—creating a cozy atmosphere. A high ceiling can be made to appear lower by painting it in a color that advances optically. In landscape design or painting, spatial planes can be set up by using colors that advance visually and colors that recede visually.

Spatial advancing or receding also results from contrasts between colors. Through our experiences in the world, we have learned that hue and value contrasts are greatest in things close to us, and less apparent in things seen at a great distance. This effect is called **atmospheric perspective**. In areas where there is particulate matter in the air, distant forms also appear bluish because of the scattering of short blue wavelengths in sunlight. In Beverly Dickinson's photograph of a Greek landscape (**5.2**), the greens get progressively bluer as distance increases. The monasteries are made of the same materials but the furthest one does not appear as bright. The apparent blueness of the landscape beyond almost merges with that of the sky. Automatically our brain assigns different spatial planes to these decreasing contrasts.

Representational artists have long used atmospheric perspective as one means of creating the illusion of deep space on a two-dimensional surface. So well established is

◄ **5.3 David Bomberg,**
North Devon Sunset—
Bideford Bay, 1946
Oil on canvas, 24 × 30 ins
(60.9 × 76.2 cm).
Laing Art Gallery, Newcastle upon Tyne, England. How has Bomberg used color to push the far reaches of the bay back into distant space?

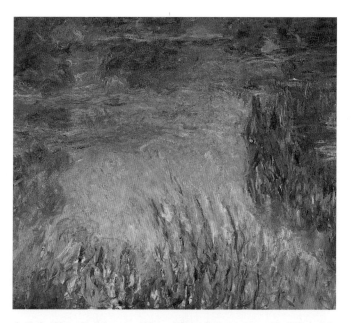

▲ 5.4 Claude Monet, *Waterlilies, Sunset*, detail, 1914–26
Whole painting 79 × 236 ins (200 × 600 cm).
Musée de l'Orangerie, Paris.
In the maze of color sensations which may come from below, on, or above the surface of the water, how do you interpret the spatial position of the more subdued colors at the top of the picture plane?

this convention—and the real-life experiences on which it is founded—that contemporary artists can evoke sensations of three-dimensional space through use of color alone. The scene in David Bomberg's somewhat abstract painting of sunset over Bideford Bay (**5.3**) appears to recede into very deep space without sacrificing lushness of color, largely because the blues of the water and the oranges and pinks of the sky both lighten in value across the centre of the canvas. Because the upper part of the canvas becomes dark again in contrast to the light area in the distance, it appears to advance over our heads, making the whole work appear to narrow vertically toward a distant horizon from the areas below and above our point of view.

Spatially, water presents a highly interesting surface, because it is both transparent and reflective. Thus the colors one sees in looking at water may lie on the surface, beneath the surface, or above, reflected from the surface. Claude Monet devoted many years to this mysterious subject, painting the water in his garden at Giverny again

and again, in endless permutations. In paintings such as the detail from a sunset version of *Waterlilies* (**5.4**), we are at a loss to sort out the spatial mysteries of what we see. We are apparently looking down and across the surface, seeing grasses beneath, reflections of overhanging trees, reflections of a brilliant gold and pink sunset, and floating waterlilies all intermingling. The same greens and blues come forward here, recede slightly into the distance there. Poet Paul Claudel explains:

> Claude Monet, at the end of his long life, after having studied all the different motifs that nature creates with color effects in reply to light, has addressed the most docile, the most penetrable element—water—which is at the same time transparent, iridescent, and reflective. Thanks to water, he has become the painter of what we cannot see. He addresses that invisible spiritual surface that separates light from reflection. Airy azure captive of liquid azure. ... Color rises from the bottom of the water in clouds, in whirlpools.[1]

In nonobjective as well as representational art, we interpret contrasts in hue and value as having spatial meaning. In contemporary nonobjective art, some areas appear to pop forward, while others seem to recede into the background. Gene Davis's *Diamond Jim* (**5.5**) is painted in stripes that continually vary in degrees of hue and value contrasts. At first glance it appears totally flat, but as you continue to stare at it without trying to hold it flat mentally, it will quickly develop a spatial pattern that goes in and out. Analyzing how each area works is very instructive. But Davis warns that he himself has used no color theories in creating his stripe paintings. He says:

> My whole approach to color is intuitive. If a certain color seems called for, I tend to use the reverse. Actually, I'm interested in color to define intervals. ... I'll put a red here on the right and, let us say, three feet away I will use another red. Now, that's going to define the interval between those two stripes in a way it would not do if I made this other stripe green, because then there would not be a dialogue established between those two stripes. ... My work is mainly about intervals, that is, like in music. Music is essentially time interval, and I'm interested in space interval.[2]

When colors are held to a consistent value and saturation level, even highly contrasting hues will appear quite flat. Milton Glaser, in designing the Aretha Franklin poster

(**5.6**), claimed that the flat shapes refer back to Art Deco and the work of Matisse. All except the yellow areas are consistently high in saturation; the yellows are lower in value than the high light of a highly saturated yellow, and thus correspond to values similar to those of the other hues. For the most part, the shapes lock together two-dimensionally like pieces of a jigsaw puzzle. They do not appear to overlap, a visual clue that would suggest three-dimensional space, because the uniformity of value and intensity holds them all on the same plane.

The only area of the Aretha Franklin poster that appears three-dimensional is the singer's face. By adding areas in a single lighter value, Glaser gives us the impression of a more rounded form in three-dimensional space.

▲ **5.5 Gene Davis, *Diamond Jim*, 1972**
Acrylic on canvas, 6 × 8 ft (1.83 × 2.44 m).
Courtesy Gene Davis estate.
If you stare at Davis's painting, it will lose its flatness and become a complex series of intervals which seem to exist on different planes in space.

▶ **5.6 Milton Glaser, Fold-out poster of Aretha Franklin**
With the exception of Aretha's face, Glaser's flat shapes appear to be lying side-by-side across a two-dimensional plane. Economical use of highlights gives the face a three-dimensional appearance.

◀ **5.7 Leonardo da Vinci, *Mona Lisa*, 1503–6**
Oil on panel, 30 ¼ × 21 ins
(76.8 × 53.3 cm).
Musée du Louvre, Paris.
Leonardo was a master at
using subtle gradations of
color to create softly
rounded forms and the
illusion of deep space.

When transitions between lighter and darker values are developed more gradually to depict three-dimensionality, the effect is called **chiaroscuro**. Developed to a high art by Renaissance painters, chiaroscuro (literally, "light and shade") is the portrayal of the effects of light and shadow across a three-dimensional form. Areas facing a light source are executed in lighter values, while those curving away from the light are depicted in darker values. The mind of the viewer immediately interprets this information as evidence of three-dimensionality. An example that is famous for its subtlety is Leonardo da Vinci's *Mona Lisa* (**5.7**).

Leonardo shared his observations about some subtleties of chiaroscuro effects in real life, such as the effects of deep shadows:

> Colors seen in shadow will display less variety in proportion as the shadows in which they lie are deeper. The evidence of this is to be had by looking from an open space into the doorways of dark and shadowy churches, where the pictures which are painted in various colors all look of uniform darkness. Hence at a considerable distance all the shadows of different colors will appear of the same darkness.[3]

Balance and Proportion

In addition to suggesting spatial concepts, colors also give a visual suggestion of a certain weightiness or lack thereof. Generally speaking, highly saturated or busily detailed areas will draw attention and therefore seem to carry more weight than less saturated or visually simpler areas.

Artists may manipulate colors more for the sake of balance in a composition than to establish a certain mood or to give a true representation of the external world. In a graphically brilliant cartoon strip of "Krazy Kat" (**5.9**), the artist George Herriman begins with a black sky in which floats a red and green moon, a fittingly isolated and eerie backdrop to Krazy Kat's statement, "I are illone." The sky and earth then change hues throughout the remaining panels, setting up blocks of color that are satisfyingly varied but yet visually balanced. The large rectangle of black sky on the bottom anchors the whole work and repeats the visual theme stated in the first panel. This repetition invites the viewer to compare the two, reinforcing the discovery that Krazy Kat's assumption of solitude is not at all true.

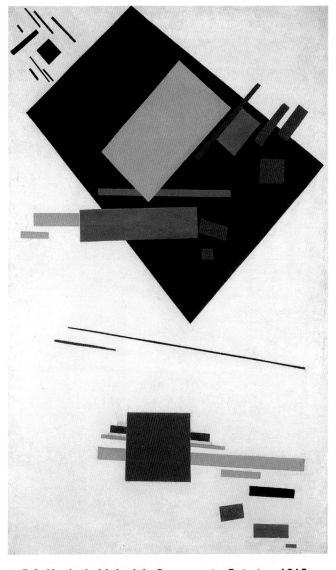

▲ **5.8 Kazimir Malevich,** *Suprematist Painting,* **1915**
Oil on canvas, 40 × 24½ ins (101.5 × 62 cm).
Stedelijk Museum, Amsterdam.
Malevich expected viewers to bring their own interpretation to his work, but surely the question of balance is involved in the content of this painting. Does the red square in the bottom seem visually weighty enough to serve as the fulcrum for the teetering black shape above, or does this composition seem intentionally out of balance? Do the colored shapes superimposed on the black rectangle seem to add to or subtract from its visual weight?

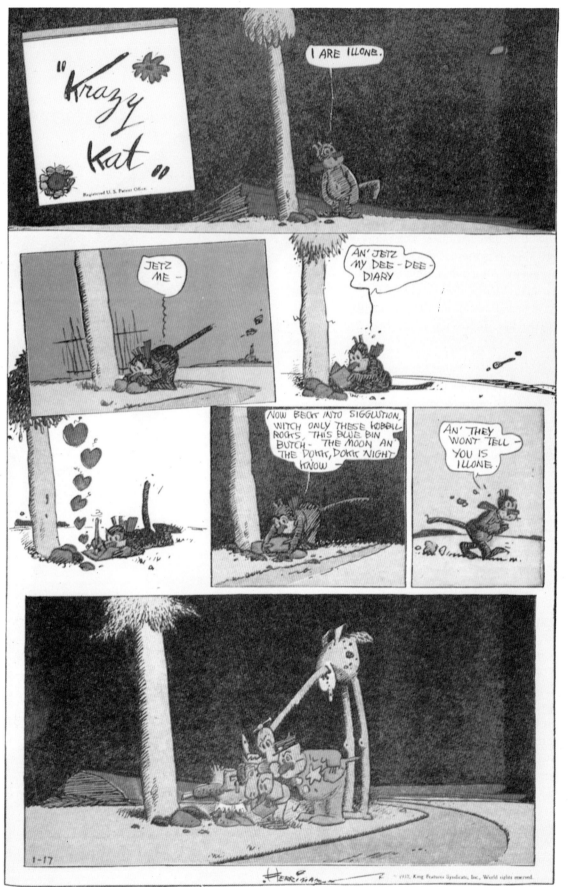

◄ **5.9 George Herriman, "Krazy Kat" strip, January 17, 1937**
How has Herriman used colors to achieve visual balance in this cartoon strip?

▲ **5.10 Jacob van Hulsdonck (1582–1647),** *Plums and Peaches,* **early 17th century**
Oil on copper, 11¼ × 13¾ ins (28.5 × 35cm). Private collection. Compare the total area covered by "warm" and "cool" colors in this composition. Do you think they are intentionally balanced against each other?

In some cases, artists create a feeling of imbalance with the help of color, but they do so in intentional violation of the principle of balance. Russian Constructivist painter Kazimir Malevich insisted on working solely with relationships among colored geometrical forms. Naturalistic repre-sentation thus set aside, one can clearly see the sense of imbalance in his *Suprematist Painting* (**5.8**). He expected viewers to read their own feelings into such works. Here the red square at the base seems to belong to a different world from that of the tilted black rectangle that looms above it. The unsaturated red square seems quietly alive and stable, like an established peasant culture, whereas the tilted, skewed rectangles of more saturated colors above might be suggestive of an industrializing culture that is increasingly out of balance. The red square is complete; other color fragments are nearby but do not intrude on it. By contrast, the weighty but teetering black rectangle is cut

◀ 5.11 Advertisement for Deneuve perfume by Parfums Stern and Bloomingdale's
The surprise and visual contrast of the red nose catches our attention; the yellow of the perfume is also accentuated by contrast.

across again and again by contrasting color shapes. It even seems to have "lost" some pieces of itself, black scraps which have become detached at the upper left.

The sense of balance or imbalance is usually achieved largely through intuitive manipulation of the elements and principles of design (such as symmetry, light-and-dark contrast, and emphasis). Colors affect each other so strongly that no absolute statements about relative visual weight can be made that would apply to all cases.

In contrast to balancing lighter and heavier visual weights, another kind of color balancing is designed to satisfy the viewer's sense of aesthetic proportion. In every work of more than a single color, areas of light, dark, and medium values exist in a certain mathematical relationship to each other, as do more and less saturated colors and warm and cool colors. These relationships have been translated by some color theorists into rules for proper color use. Some theorists feel that warm and cool hues should cover approximately equal areas in a work, thus creating a satisfying symmetry of hues. There is an approximately equal ratio of reds and yellows to greens and blue-purples

in Jacob van Hulsdonck's *Plums and Peaches* (**5.10**). The composition is apparently carefully worked out with reference to balancing of hues, despite the seemingly innocent informality of the scattered fruits. Other recommendations about color balancing will be discussed in Chapter 6, where we examine color theories. It must be noted, however, that many successful works do not conform to any theory of color balance.

Emphasis

A stronger consideration for many artists is the desire to emphasize certain areas of a work, drawing them immediately to the viewer's attention. This objective is particularly crucial in advertising art, for the viewer's attention must initially be seized and then guided in such a way that the product name and image will be noticed, despite all the visual distractions of modern life. One strategy involves visual understatement of everything surrounding the product so that it will stand out better, by contrast. In the two-

page advertisement for Catherine Deneuve's perfume (**5.11**), everything on the right-hand page is neutral grays and black except for the elegantly sensual bottle of perfume. It is yellow and consequently appears extremely luscious and desirable in contrast with the neutrality of its setting. The real attention grabber is on the left-hand page of the spread: the lipstick-colored red nose on Deneuve's beautiful but grayed face. The red captures our attention and immediately makes us wonder why. To find out, we must slow down enough to read the handwritten message on the right-hand page: "Inside every woman is another woman. I designed this perfume for the other woman in you." As we finish reading the message, we are back at the perfume bottle and the product name.

Sometimes a whole work calls attention to itself by contrast with its surroundings. Brightly colored sculptures stand out vigorously in dull-colored urban environments. When an artist uses an **open palette**—that is, choosing hues from all parts of the color wheel—at high saturation, as Milton Glaser did in his Aretha poster (5.6), we cannot help but notice the work. However, when an open palette is used with hues at very high or low values, rather than at maximum saturation, the effect will be much quieter, much subtler.

Unity

There are many principles of design that can subtly unify a work of art. Use of color to unify a composition often revolves around repetition of a certain color theme. One possibility is a very **limited palette**. The artist chooses only a few non-contrasting hues, perhaps combined with neutral whites, browns, grays, or black. The result is usually coherent because nothing pulls away from the central colors. A surprising use of a limited palette is *Wooden Door with Window* by Vera Lehndorff and Holger Trulzsch (**5.12**). Vera has been painted to look like a continuation of the door, in browns, whites, and blues that largely eliminate her natural skin tones. Where the transformation is successful, she almost blends optically with the building. We can hardly distinguish her arm against the white plaster, for there is very little contrast in value and hue between the two. Edges of shapes and forms become soft and nebulous when there is little color contrast between them, whereas

▲ **5.12 Vera Lehndorff and Holger Trulzsch, *Wooden Door with Window* (detail), 1975**
Cibachrome photograph, 19 ¹/₂ × 19 ¹/₂ ins (49.5 × 49.5 cm). With a limited palette, there may be variations in value but little variety in hue. Vera's natural coloring has been painted to match the limited palette of her surroundings.

▲ **5.13 Salvador Dalí, *The Christ of St.-Jean-de-la-Croix*, 1951**
Oil on canvas, 80 × 45½ ins (205 × 116 cm).
Glasgow Art Gallery and Museum.

▲ **5.14 Ben Vautier, *Ben's Store*, 1958–73**
Installation. Musée National d'Art Moderne, Paris.
In this mad collection of found objects, statements about art and life, and references to the artist himself (e.g. "Ben is a genius"), does the repetition of a few main colors help to bring unity to the chaos?

edges of highly contrasting hues, as in the Aretha poster (5.6), are "hard," or sharply defined.

It is also possible to repeat colors throughout a composition when a more open palette is used. One way of doing so is actual repetition of the same color note throughout the composition. In the cacophony of Ben Vautier's installa-

tion, *Ben's Store* (**5.14**), red pops out again and again, with black as a persistent foil. Another approach is to mix a little of a single main color into everything else, giving that color a subtle prominence in the work, such as the yellow ocher light that plays across Salvador Dalí's *The Christ of St.-Jean-de-la-Croix* (**5.13**). Another painterly method is to allow the color of a single undertone to show through and thus influence all areas of the work.

Although unity is a traditional objective in art, many contemporary artists have departed from tradition to create works that do not look or feel unified. Even Gene Davis, whose paintings are clearly unified by the repetition of color stripes (5.5), muses:

> One of the things that really interests me a great deal is the idea of shattering the unity of a work of art. In other words, who says a work of art must have unity? Why not something that's fragmentary? … Fragments are often very interesting. … When is a work finished? … Oftentimes when a work is just a fragment, it's better than it is when it's finished.[4]

This iconoclastic, intuitive approach is a counterpoint to heavily theoretical, intellectual approaches to color theory, which will be explored in some detail in the next chapter.

6
Theories of Color Relationships

Color is the final art, which is, and will always remain, a mystery.

PHILIPP OTTO RUNGE *Color Theorist*

In order to work with colored lights and particularly with colored pigments, artists have long sought a framework for understanding the great variations among colors—how desired colors can be mixed from materials at hand and how these mixtures relate to each other visually. Specifics of color mixing will be covered in the next two chapters. In this chapter we will look at a number of attempts to devise a systematic framework for explaining the similarities and differences among colors.

Few artists have ever worked exclusively from a single color model. Each of the color theorists discussed in this chapter has contributed useful observations about optical color phenomena and relationships among colors. Color is such a mysterious phenomenon that even opposing theories may each be correct, to a certain extent.

Early Theories

The ancient Hindu *Upanishads*, the early Greek philosophers and physicians, and the Arab physicist Alhazen all developed theories about color vision—what colors are and how we see them—to help explain the world around them. Aristotle's ideas drew particular attention. He explained similarities among colors by "the common origin of nearly all colors in blends of different strengths of sunlight and firelight, and of air and water" and recognized that "darkness is due to privation of light." To Aristotle, all variations were the result of mixtures of darkness and light.

Crimson, for example, was a combination of a certain amount of blackness with firelight or sunlight.

For many centuries after Aristotle, colors were explained according to his theories. The reds seen at sunrise and sunset were thought to result from the mixture of white sunlight with the darkness of night that was just departing or approaching; the red seen in fire was a mixture of the white light of the fire and the darkness of the smoke. Green was more shadow than light, and blue was more shadow still. These ideas followed Aristotle's procedure: "Verifications from experience and observation of similarities are necessary," he wrote in his *De Coloribus*, "if we are to arrive at clear conclusions about the origin of different colors."[1]

Leonardo da Vinci

Ever curious, always combining his dual passions for science and art, the great Renaissance artist Leonardo da Vinci (1452–1519) included color theorizing in his explorations. Although earlier philosophers had not treated white and black as colors, Leonardo included them among the "simple" colors that are the artist's basic tools: white, yellow, green, blue, red, and black. He observed the phenomenon later known as **simultaneous contrast**, which demonstrated that complementary hues intensify each other if juxtaposed:

Of different colors equally perfect, that will appear most excellent which is seen near its direct contrary: a pale color against

red; a black upon white; … blue near a yellow; green near red: because each color is more distinctly seen when opposed to its contrary, than to any other similar to it.[2]

In the compilation of Leonardo's notes, published post-humously in 1651 as the *Treatise on Painting*, he devoted considerable attention to his observations on blueness in the atmosphere. He concluded that we only see this blue by contrast with black.

> I say that the blueness we see in the atmosphere is not intrinsic color, but is caused by warm vapour evaporated in minute insensible atoms on which the solar rays fall, rendering them luminous against the infinite darkness of the fiery sphere which lies beyond and includes it…. As an illustration of the color of the atmosphere I will mention the smoke of old and dry wood, which, as it comes out of a chimney, appears to turn very blue, when seen between the eye and the dark distance. But as it rises, and comes between the eye and the bright atmosphere, it at once shows of an ashy gray color; and this happens because it no longer has darkness beyond it, but this bright and luminous space. … Colors will appear what they are not, according to the ground which surrounds them.[3]

In addition to carefully noting the optical effects of color combinations, Leonardo also described atmospheric per-spective and shadow effects in considerable detail. He used his observations of color to improve his own paint-ings, developing to a fine art the subtly graded values and hues of chiaroscuro modeling and the softly blended, smoky quality known as **sfumato**, hauntingly represent-ed in the hands, face, and hazy background landscape of his famous *Mona Lisa* (5.7).

Newton

In contrast to Leonardo's careful observations of color phenomena in real-life situations, the British physicist Sir Isaac Newton (1642–1727) turned color theory into a laboratory study of the properties of light, in an attempt to derive some systematic, logical framework for under-standing color. As we noted in Chapter 2, Newton demon-strated that all the spectral hues are present in white light. He made from them the first color circle representing color relationships (2.4). The segments of his circle stood

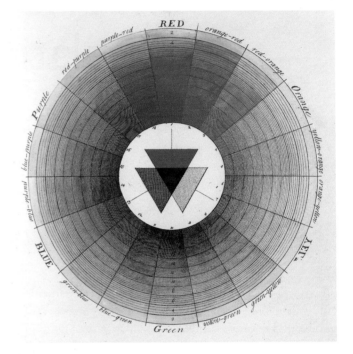

▲ **6.1 Moses Harris, Color circle from *The Natural System of Colors*, c. 1766**
Royal Academy of Arts, London.
From an initial set of three primaries, Harris derived a color circle with 18 hues, shaded with black as they approached the center.

for the seven hues he distinguished in the spectrum (although the choice of seven seems to have been mysti-cally based on the seven Musical Tones and the seven Heavenly Spheres). He called these "primary colors," and noted their "best" aspect falling on the circumference of the wheel midway between the lines dividing the hues. Newton did not present his model in color, but he envi-sioned that hues would be most "intense and florid" on the circumference, becoming gradually "diluted" with whiteness as they approached the center. The center of his color circle was white, the mixtures of all hues in light. Newton noted that if only two hues lying opposite each other on the wheel were mixed, the result would not be white but "some faint anonymous Colour." He suggested the possibility of producing white by mixing three light primaries but was unsuccessful in his experiments:

I could never yet by mixing only two primary Colours produce a perfect white. Whether it may be compounded of a mixture of three taken at equal distances in the circumference I do not know, but of four or five I do not much question but it may. But these are Curiosities of little or no moment to the understanding of the Phaenomena of Nature.[4]

Moses Harris

Working with pigments rather than lights, an English entomologist and engraver named Moses Harris developed the first model of pigment primaries. Following the discovery by a French printer, J. C. Le Blon, in 1731, that all hues could be reduced to mixtures of red, yellow, and blue pigments, Harris created a beautiful illustration of the theory. In his *Natural System of Colors* (c. 1766), a highly influential though extremely rare volume, he offered a detailed color circle in hand-tinted color (**6.1**). In its center are the three pigment primaries, which he called "primitives"—red, blue, and yellow—from which all other colors could theoretically be mixed. From them he derived the secondary or "compound" hues: orange, purple, and green. Mixtures of primitives and compounds yielded two intermediate stages, in which the hue less represented in the mixture was named first ("orange-red" for instance, is more red than orange). The eighteen colors so derived were then graded into **shades** (darker values—cleverly created here by optical mixing with ever more closely placed black lines) and **tints** (lighter values, commonly created by adding white to a color or thinning the medium to allow the white of the support to show through, but here developed by wider spacing between the black lines).

Goethe

Johann Wolfgang von Goethe (1749–1832), the great German poet, thought his color theory would be of greater historical importance than his poetry. In 1810 he published his book *Zur Farbenlehre*, or *Theory of Colors*. In it he vigorously attacked Newton's theories of the physics of light, which were still controversial, and returned to the observational tradition of Aristotle and Leonardo. Contrary to Newton, Goethe concentrated on color as a visual pheno-

▲ **6.2 Roger Crossgrove, *Study in Colored Shadows*, 1987**
Photograph.
The cast shadows seen here are the complementaries of the lights used to make them, true to Goethe's observations.

menon happening in the eye, rather than as an aspect of light. "The waking eye reveals itself as a living organism," he wrote. "The eye is not capable of remaining—cannot bear to remain—for even a moment in a state which is determined by the object looked at." It was Goethe who gave us extremely detailed descriptions of visual pheno-

▲ **6.3 Vincent van Gogh, *Still-Life with Drawing Board and Onions*, 1889**
Oil on canvas, 19 1/2 × 25 1/4 ins (45 × 64 cm).
State Museum Kröller-Müller, Otterlo, The Netherlands.
Van Gogh's use of brilliant colors included color shadows in this painting, following Goethe's observations that a colored light will create shadows in its complementary color.

mena that are still of interest to artists, such as colored shadows, simultaneous contrast, and successive contrast.

With reference to colored shadows, Goethe observed that strong midday sunlight produces a black or gray shadow on white—or a darker value of the surface—but that under other conditions, shadows will be the hue complementary to the hue of the light. These other necessary conditions were that the light be of some hue other than white and that the shadow be somewhat illuminated by a secondary light source. The stronger the colored light, the paler the shadow; thus the most brilliant-colored shadows result from the palest-colored lights. Roger Crossgrove's photographic study of colored shadows (**6.2**) employs a bank of red, green, blue, and yellow lights with rheostats for dimming the lights to increase the saturation of the shadows. Where the shadows overlap, you can see secondary mixtures, such as orange and purple.

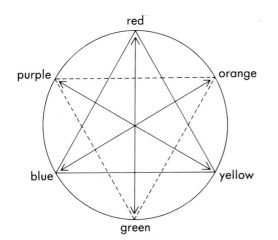

▲ 6.4 Goethe's color circle
Triangles join the triads of primaries and secondaries and, in this reconstruction, arrows link complementary hues.

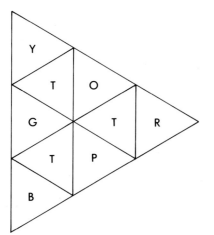

▲ 6.5 Goethe's color triangle
Goethe offered an alternative model in which the primaries red, blue, and yellow were the corners of a triangle, secondaries the sides, and tertiaries ("T") the mixtures of the three surrounding colors. The tertiaries were therefore probably of low saturation, but we do not have an actual colored sample of what Goethe envisioned.

Although Goethe gives instructions for producing colored shadows experimentally, he also describes their natural occurrence in scenes like the following, which took place in snow- and frost-covered mountainous terrain:

During the day, owing to the yellowish hue of the snow, shadows tending to violet had already been observable; these might now [at approaching sunset] be pronounced to be decidedly blue, as the illumined parts exhibited a yellow deepening to orange. … But as the sun at last was about to set, and its rays, greatly mitigated by the thicker vapours, began to diffuse a most beautiful red colour over the whole scene around me, the shadow colour changed to a green, in lightness to be compared to a sea-green, in beauty to the green of the emerald. The appearance became more and more vivid: one might have imagined oneself in a fairy world, for every object had clothed itself in the two vivid and so beautifully harmonising colours, till at last, as the sun went down, the magnificent spectacle was lost in a grey twilight, and by degrees in a clear moon-and-starlight night.[5]

The Impressionists and Postimpressionists acknowledged these observations, adding color shadows to the bright hues of some of their work, as in Monet's paintings of Rouen Cathedral (3.12 and 3.13) and van Gogh's *Still-Life with Drawing Board and Onions* (**6.3**). Here the shadows of plate and book are indigo, rather than simply a darker yellow as one might expect, and reflection off the gold borders of the book creates a secondary shadow of the complementary purple.

Goethe also described complex color sensations such as the "catotropical" colors seen when colorless light strikes a colorless surface, such as a spider's web or mother-of-pearl, and the colors seen in haloes around the moon. He suggested two models for relationships between colors. One was a circle with lines linking complementary hues superimposed on two triangles delineating primary and secondary triads (**6.4**). The second was a triangle (**6.5**) with red, blue, and yellow at its outermost points and the secondaries green, orange, and purple in the middle. Dividing primaries and secondaries were further triangles denoting the less saturated, lower-value tertiaries that would theoretically result from mixing two secondaries with the adjacent primary.

Runge

The same year that Goethe published his *Zur Farbenlehre*, the German painter Philipp Otto Runge (1777–1810) published *Die Farbenkugel* (*The Color Sphere*)—the first

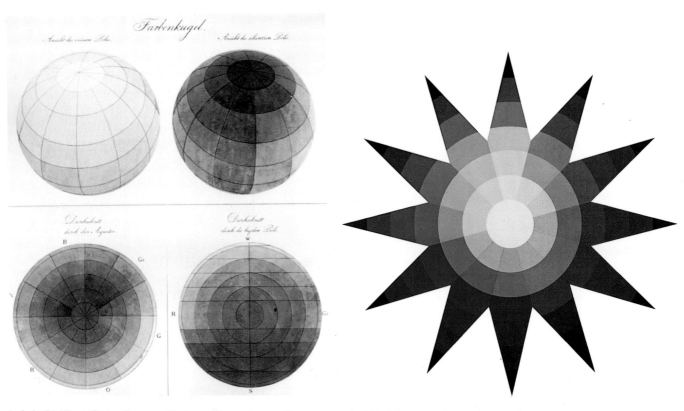

▲ **6.6 Philipp Otto Runge, Color sphere from *Die Farbenkugel*, Hamburg, 1810**
Collection Faber Birren.
Runge presented his pioneering model of a color sphere from various angles to show its three-dimensional relationships.

▲ **6.7 Johannes Itten, Runge's color sphere presented as a star**
In Itten's version of Runge's model, certain color relationships—such as complementarity, value gradations, and close harmonies (analogous colors)—can readily be seen.

attempt at a three-dimensional model of color. Runge presented color relationships as a sphere (**6.6**). Pure hues were displayed around its equator. Through the central axis was a gray value scale, from black at the bottom to white at the top. Across the surface of the sphere, the colors were graded from black to the pure hue to white, in seven steps. Intermediate mixtures theoretically lay inside the sphere.

One hundred and fifty years later, Johannes Itten, a great German teacher of the art of color, adopted and adjusted the same model, considering it "the most convenient for plotting the characteristic and manifold properties of the color universe."[6] Itten displayed the outer surface of the whole sphere at once by opening it into a twelve-pointed star, with the white top as its center (**6.7**).

Chevreul

Interest in codifying and understanding color relationships was so strong in the early nineteenth century that another major contribution soon appeared: *The Principles of Harmony and Contrast of Colors* by Michel Eugène Chevreul, a renowned chemist and director of the dye house for Gobelins tapestries in Paris. Chevreul (1786–1889) developed a finely graded two-dimensional color circle. His work with liquid dyes verified the usefulness of red, yellow, and blue as primaries and orange, green, and violet as secondaries. His greater contribution to the art of color, however, was his elucidation of the laws governing the visual effects of colors upon each other: simultaneous contrast, succes-

sive contrast, and optical color mixtures. From these he derived certain suggestions about how colors should best be used: the principles of harmony.

Chevreul noted that colors with little contrast, such as hues adjacent to each other on a color circle (**analogous hues**), will tend to blend optically. Highly contrasting colors (such as complementary colors lying opposite each other on the color circle) used in sufficiently large quantities will make each other appear more brilliant, without any optical change in their hue. If small areas of opposite colors are presented together, on the other hand, they will tend to blend visually and thereby create a duller overall color sensation, "want of vigor," as he wrote. These effects, to be explored in Chapter 9, led Chevreul to recommend that highly contrasting colors be used in large juxtaposed areas, whereas analogous colors should best be used in small, diffused amounts. He stated: "The contrast of the most opposite colors is most agreeable. … The complementary assortment is superior to every other."[7] When using analogous hues, Chevreul asserted that combinations worked best when the key hue was a primary.

Chevreul's book is full of such prescriptions. While they were of great interest to many painters of the times, such as the Impressionists and Postimpressionists, few consciously followed his recommendations for proper color harmonies. Monet rejected theories; Pissarro read Chevreul's work but claimed there was no intellectual basis for what he was trying to do in his paintings. Georges Seurat, however (9.27), attempted to apply the laws of color theory precisely to the craft of painting. In doing so he relied not only on Chevreul but also on his successor, Ogden Rood.

Rood

Trained as an artist as well as a scientist, the American Ogden Rood (1831–1902) performed extensive research into the optics of color, declaring it to be "a sensation existing merely in ourselves" rather than an absolute fact of the physical world. He identified the three major variables that determine the differences between colors as purity (saturation), luminosity (value), and hue. Through painstaking experiments with spinning disks and other equipment, he demonstrated that pigment hues can be mixed optically to

▲ **6.8 Ogden Rood, Circle of complementaries from *Modern Chromatics*, 1879**
Rood's experiments with optical color-mixing contraptions enabled him to develop this precise matching of complementary hues.

form the sort of luminous mixtures one would get when mixing lights.

Such optical mixtures would be blended by the eye if lines of color or "a quantity of small dots of two colors very near each other" were viewed from a certain distance. "For instance," he wrote in his 1879 classic, *Modern Chromatics*,

> Lines of cobalt-blue and chrome-yellow give a white or yellowish-white, but no trace of green; emerald-green and vermilion furnish when treated in this way a dull yellow; ultramarine and vermilion, a rich red-purple, etc. This method is almost the only practical one at the disposal of the artist whereby he can actually mix, not pigments, but masses of coloured light.[8]

Rood felt that it was important for artists to know exactly which colors were directly complementary to each other, so that they:

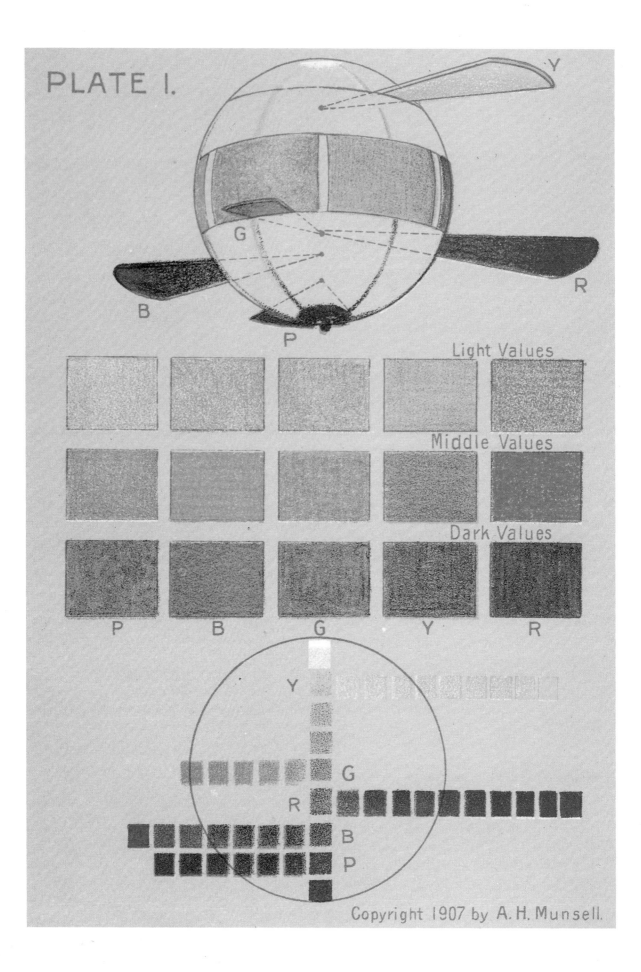

PLATE I.

Light Values

Middle Values

Dark Values

... are made to glow with more than their natural brilliancy. Then they strike us as precious and delicious, and this is true even when the actual tints are such as we would call poor or dull in isolation. From this it follows that paintings, made up almost entirely of tints that by themselves seem modest and far from brilliant, often strike us as being rich and gorgeous in colour, while, on the other hand, the most gaudy colours can easily be arranged so as to produce a depressing effect on the beholder.[9]

From his experiments, Rood developed the circle of contrasting colors shown in Figure **6.8**.

Rood's work has been highly influential among artists, beginning with **Pointillist** techniques of optical blending. Yet he himself deplored the ways his theories were used, considering the results most unattractive. His son, an enthusiastic student of the Impressionists, described Rood's reaction to an exhibition of their paintings:

"... by a lot of Frenchmen who call themselves 'Impressionist,' some are by a fellow called Monet, others by a fellow called Pissarro, and a lot of others."

"What do you think of them?" I ventured.

"Awful! Awful!" he gasped.

Then I told him what these painters said of his theories.

This was too much for his composure. He threw up his hands in horror and indignation, and cried—

"If that is all I have done for art, I wish I had never written that book!"[10]

Munsell

For all his painstaking experiments, Rood himself was unable to devise a "scientifically accurate color-system," as he admitted to Albert Munsell. Working with reference to Rood's experiments to devise a system simple enough for school-children to understand, Munsell himself developed

◄ **6.9 Albert Munsell, Diagram of equal steps to maximum saturation**
Munsell noted that different hues reach maximum saturation at different steps of value, and that they also differ in the number of equal steps from neutral gray to maximum saturation.

the standards for color notation still used as the basis for pigment specifications in the United States, Great Britain, Germany, and Japan. These were first published in 1905 in his book *Color Notation*.

Munsell used three dimensions for describing color variations: hue, value, and chroma (saturation), each graded in equal steps, as measured by a photometer. These dimensions form an irregular three-dimensional "tree" (see Figures 2.13 and 2.15) rather than the perfect sphere proposed by earlier theorists, for the hues reach maximum saturation at different steps of value and also vary in the number of steps from neutral gray to maximum saturation (**6.9**). Munsell gave each step in each direction a distinctive number reflecting the three dimensions: vertical (value), horizontal (saturation), and around-the-circumference (hue). His numbers replaced the imprecise vocabulary of popular color names, such as "hellish blue" and "celestial blue." As we noted in Chapter 2, Munsell departed from tradition by using five primary hues—red, yellow, blue, green, and purple—instead of three, thus placing rather different hues opposite each other as complementaries. Whereas Rood had emphasized the truth of visual sensations, without being able to derive a mathematically logical system from his observations of color realities, Munsell sought an objective standard for precise pigment specifications.

Ostwald

Another early twentieth-century color theorist, the German scientist Wilhelm Ostwald (1853–1932), won the Nobel Prize in 1909 for his work in chemistry, and his color model bears the stamp of a highly scientific mind. To quantify color variations, Ostwald based them on mathematical steps from black to white, in geometric rather than arithmetical progression, and on an analysis of the light apparently reflected or absorbed by a surface. Arithmetical progression, in increments of one—1, 2, 3, 4, 5, 6, and so on—does not give the visual appearance of equal distance between steps. This effect is obtained instead by increasing the value geometrically—1, 2, 4, 8, 16, and so on. Both are illustrated in Figure **6.10**.

Ostwald's system of color specification was portrayed as a three-dimensional series of triangular cross-sections. White formed the upper pole or top of the triangles, black

Arithmetical gray scale

Geometric gray scale

◄ **6.10** Following the work of Gustave Fechner, Ostwald made use of the visual fact that to achieve optically equal steps in value gradation, one must use geometrically rather than arithmetically changing pigment percentages.

▼ **6.11 A generic slice through the Ostwald solid**
Ostwald's notation gives the mathematical percentages of "pure color" (C), white (W), and black (B) used as a basis for his model.

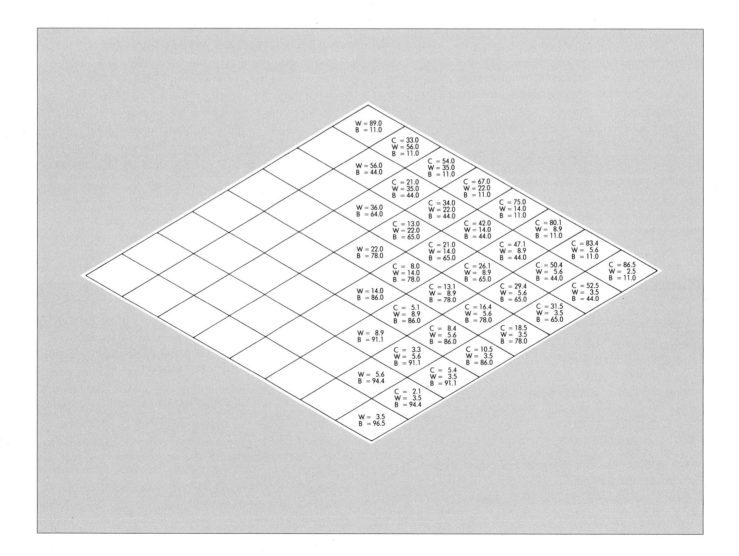

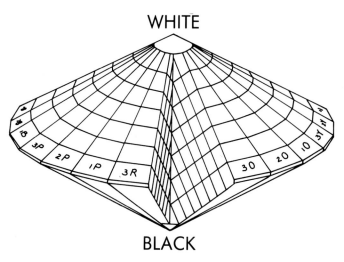

WHITE

BLACK

▲ **6.12 Wilhelm Ostwald, Color solid from**
Color Science, 1931
Ostwald's double pyramid model is based on a series of double triangles in which pure hues form the equator, and black and white the poles. Within this framework, mixed colors are derived in quite a different manner than in Munsell's model.

White

Tint

Color Tone Gray

Shade

Black

▲ **6.13 Faber Birren's Color Triangle**
Like Ostwald, the color theorist Faber Birren did not analyze colors in terms of hue, value, and saturation. Rather, as in this simplified diagram, he claimed that "there are only seven forms in the world of color—pure hue (red, yellow, etc.), white, black, gray, tint, shade, tone. … All colors seen in the world will find classification on this chart."[11]

the lower pole, and 24 pure hues circled the equator (**6.12**). To create the 12 double triangular charts from which the solid is constructed, Ostwald mixed the fully saturated hues with measured amounts of black and white and gave each sample a notation with percentages of color (C), white (W), and black (B). Moving diagonally toward white from the equator, the amount of black is held constant as white increasingly takes the place of the original hue, which Ostwald called the "full color." This process is called **tinting**. The opposite process, called **shading**, adds black and decreases the full color while white is held constant. Moving directly toward the center is called **toning**; here both white and black increase while the full color is decreased, thus graying it. Colorist Faber Birren devised a simplified diagram to show these relationships (**6.13**).

Ostwald's addition of black and white is a quite different procedure from Munsell's system of graying hues by mixing them with their complement. In practice, different white pigments vary in tinting power, so no standard Ostwald chart can be used with accuracy unless one uses exactly the same pigments as those used in preparing the chart. Moreover, some artists have rejected Ostwald's model as being too scientific to use in the actual creation of art or to represent the dynamic realities of color. The colorist Adolf Holzel was strongly opposed to the limitations of trying to make all color differences fit into variations of black and white content. Holzel himself held that colors contrasted with each other in seven ways: hue, saturation, area, value, complementarity, warmth and coolness, and simultaneous contrast. The artist Paul Klee was particularly disturbed by what he considered Ostwald's "negative reaction to color."[12] Nevertheless, Ostwald's symmetrical system well suited certain rational approaches to art, such as the Bauhaus attempt to merge technology with the arts and crafts.

Ostwald originally provided for 30,000 graded colors, but upon recognizing that the distinctions between one and the next were so slight that he thought people could barely distinguish them, he devised an abridged version of his color model with 680 "psychologically equidistant" colors, which he thought would be sufficient for most artists. His system has been useful in grading colors for printing processes, one of the subtractive methods of color mixing to be explored in the next chapter.

7

Subtractive Notation and Mixing

Do you know a painter who has invented a color different
from those that compose the Solar Spectrum?

ANDRÉ DERAIN

One of the most complex aspects of contemporary color use is the mixing and specification of precise colors. Until the nineteenth century, painters and dyers mixed their own colors from private recipes. However, with the growth of industry and the availability of premixed oil paints, the need arose for precise means of communication between suppliers and users of pigments. "Cadmium red medium" from one paint company differed from another company's "cadmium red medium." Furthermore, industrial processes brought expectations that colors could be precisely replicated in printing and dyeing or matched exactly to a sample. To standardize ways of specifying and mixing colors, a number of systems have been developed. None is as sophisticated as the human eye. Under optimal lighting conditions, an average human being can distinguish up to seven million different colors. But matching colors by eye is a subjective matter, for different people see colors somewhat differently. Nonetheless, standardization of prepared pigments diminishes the amount of guesswork in pigment mixing, which remains a complex art.

Dye and Pigment Sources

The major subtractive colorants—those whose apparent color depends on the wavelengths they reflect—are dyes and pigments. **Dyes** are coloring materials dissolved in a liquid solvent; **pigments** are bits of powder suspended in a medium such as oil or acrylic. Materials to be colored absorb dyes, whereas pigments sit on the surface. Lakes are pigments made from dyes, extending the range of pigment colors.

Since the end of the Ice Ages, humans have used natural plant and animal materials to form dye solutions into which fabrics were dipped. Berries, fruits, leaves, lichens, and roots were found to have different coloring properties. The root of the indigo plant was for centuries the only source of blue dye. The stigma of the crocus yielded a yellow dye called saffron. Cochineal, a brilliant red dye, was created from the dried bodies of certain female scale insects that fed on cactus plants, and were once exported on a large scale from huge cactus plantations in Mexico. And royal purple dye used in Greek and Roman courts was derived from the glandular mucus of a certain sea snail.

Synthetic dyes first appeared in 1856, with the discovery that the addition of alcohol to coal-tar yielded a purple that could dye silk. These synthetically-derived dyes are called **aniline dyes**. They rapidly became popular for their range of colors, potentially high saturation, even consistency, and convenience. A few years later, a more colorfast, vivid, multihued family of dyes called **azo dyes** was developed synthetically from petroleum. Farms producing precious natural dyestuffs, such as madder roots in Europe and indigo in India, were largely put out of business by these new discoveries. Experimentation with synthetics continues apace. Over three million synthetic dyes have been discovered and several new ones are announced every week.

The colors produced by pigments and their mixtures are more difficult to predict than dye colors, for light is

reflected from the surfaces of the pigment particles. While natural dyes were substances that would dissolve in water, those used as pigments were usually insoluble. The earliest pigments were minerals extracted from the earth, used by cave dwellers for unsaturated yellows, browns, reds, and black (**7.1**). As early as 40,000 B.C., however, some were heated to increase the range of colors available. Yellow ocher, for instance, was heated to obtain red. Over the millennia, color palettes were extended by the creation of the deep blue of ultramarine from lapis lazuli, the Romans' bright cinnabar red from a sulfide of mercury, the cadmium yellows and oranges from greenockite, and green from malachite.

The next major progression in the pigment palette available occurred during the Middle Ages, when pigments were chemically combined or changed to form new colors. The green of verdigris was the result of hanging copper plates over vats of vinegar to form a green crust on the copper. Certain blues were copper-ammonia compounds made from this verdigris. Zinc white is an oxide of zinc.

As in dyes, modern laboratory experimentation with petroleum has yielded a vast array of artificial pigments whose saturation, purity, and durability often exceed those of natural pigments. This was not necessarily so at first. The bright pink lakes used by Van Gogh in 1888 and 1889 have turned blue, as have rose lakes used by Gauguin. Countless works by Postimpressionists and Fauvists in the late nineteenth century have thus changed in color. Only in the early twentieth century did the fragile synthetic lakes give way to more costly synthetic pigments which were more resistant to light, humidity, and temperature fluctuations. These are now available to painters in premixed tube colors, some of which are labeled to reflect their resemblance to natural pigments, as in the sample palette of paint pigments shown in Figure **7.2**.

Today, the same pigments are used in many forms—oils, acrylics, chalks, egg tempera, watercolors. Only the media, binders, and range of pigments used differ among these forms. We will explore the complexities of pigment mixing in two popular media—oils and acrylics—below,

▲ **7.1 Main hall ("Hall of Bulls"), Lascaux, France, c.15,000–10,000 B.C.**
Early cave-dwelling humans in the Lascaux area apparently painted with pigments from natural materials such as red earths, red and yellow sandy ochers, manganese oxide for browns and blacks, and calcite for white.

Cadmium Yellow · Cadmium Red · Alizarin Crimson · French Ultramarine · Cerulean Blue · Viridian

Burnt Sienna · Raw Sienna · Yellow Ochre · Burnt Umber · Ivory Black · Purple Lake

◄ **7.2 Contemporary paint pigments**
The original tube colors are at the top of each strip, with progressively lighter tints below.

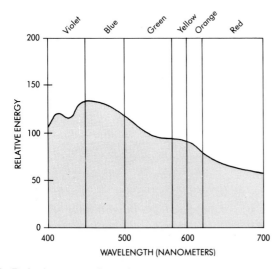

▲ **7.3 Relative energies of wavelengths in natural daylight**

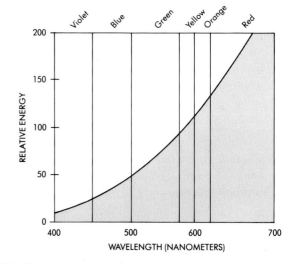

▲ **7.4 Relative energies of wavelengths in incandescent light**

▲ **7.5 Relative energies of wavelengths in ordinary fluorescent light**

after first examining attempts to standardize ways of examining colors and specifying desired pigmentation.

Lighting

In addition to the sources of coloring material, the apparent color of a reflective surface will also depend upon the light falling on that surface. For **critical color matching**—the technical term for mixing colors to match a given sample—

natural daylight from the north (in the northern hemisphere) is used as a standard. As shown in Figure **7.3**, north sky daylight at 7400 Kelvin (a measure of the color temperature of the light source) contains a balanced combination of all visible wavelengths, with a tendency toward the blue end of the spectrum. By contrast, incandescent lighting is high in red and yellow wavelengths, with relatively little energy from the greens, blues, and violets (**7.4**). As indicated in Figure **7.5**, ordinary fluorescent lights have sharp peaks in certain areas of the visible spectrum. These color distortions in incandescent and fluorescent lights will obviously affect the colors seen.

Because optimal north sky daylight is not reliably available, critical color matching must be done under special lights. Some fluorescent lights attempt to provide a fuller spectrum of wavelengths; filtered tungsten lamps and quartz halogen lights are said to approximate north sky daylight more closely. However, because many colors will actually be viewed under regular fluorescent or incandescent light, colors are often compared under equivalent lighting conditions.

The Munsell Notation System

The most widely adopted way of communicating about colors is the system developed by Albert Munsell and subsequently refined and recognized by the National Bureau

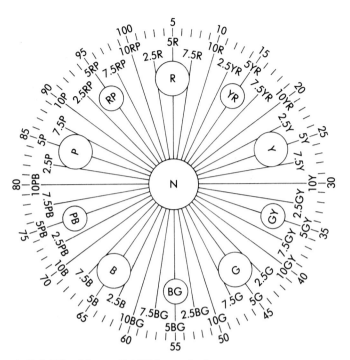

▲ 7.6 The Munsell 100-hue circle
Two ways of specifying hues are provided—the numbers from 1 to 100 around the circumference, and the letter and numbering system in the inner circles.

of Standards, the Munsell Laboratory, and the Optical Society of America. It is the basis for standards used in the United States by various official color councils, by the Japanese Industrial Standard for Color, the British Standards Institution, and the German Standard Color System.

As we saw in Chapter 2, Munsell graded colors in equal visual steps along three variables: hue, value, and chroma (saturation). Hues are divided into 100 equal steps and displayed around a circle (**7.6**) based on ten major hues: red, yellow-red, yellow, green-yellow, green, blue-green, blue, purple-blue, purple, and red-purple. Each is designated by its beginning initials in the inner circle and in some Munsell notations. Between each of these major hues are many intermediate hues, indicated by an infinitely expandable decimal system. As shown here, these can be expressed as points from 1 to 100, as on the outer circle. Alternatively, they can be labeled according to hue families, as in the intermediate circles, with the hue initials included in the designation. The number 5 indicates the midpoint in each hue family. The central N represents neutral gray.

In the Munsell system, values are expressed numerically as steps from absolute black (0/) to absolute white (10/), with the symbol 5/ used to indicate middle gray and its value equivalent in all the chromatic hues. In reality, absolute white and absolute black are never seen in material form.

The third designation in the Munsell color notation is chroma, conceived as equal steps from neutral gray to the greatest saturation seen in each hue at that level of value. The complete notation combines all three variables as hue/value/chroma. A brilliant vermilion red might be designated as 5R 5/14, whereas a less saturated "rose" red of equal value might be 5R 5/4. Finer distinctions in each variable can be indicated by decimal division (that is, 4.5R 4.3/11.8).

The C.I.E. System

To standardize color notations further, the 1931 International Commission on Illumination (*Commission Internationale de l'Eclairage*, or C.I.E.) developed a visual means for precise color matching that relied on mechanics rather than subjectivity. This system is based on lights and is therefore only indirectly applicable to pigments.

A computerized **spectrophotometer**, which measures the light energy given off by a reflective sample or light source, is used to measure three variables. One is **luminance**, the intensity of the light given off. We will look at this variable in Chapter 8. The other two, of relevance to subtractive mixtures, are hue and saturation. Together their values determine what is called the **chromaticity** of the color. In the horseshoe-shaped **Chromaticity Diagram** developed by the C.I.E. (**7.7**), pure spectral hues are placed by wavelength around the perimeter, with non-spectral purples represented by a straight line across the bottom. The center is the neutral sum of all hues. This point is white in light mixtures; in pigment mixtures, adding hues to each other "subtracts" light, creating a darker mixture that reflects less light.

Note that the areas covered by certain wavelengths in the C.I.E. diagram—particularly the blues and greens—are far larger than the yellow, orange, and red segments. This is so because the shape of the diagram is based on the color visibility or **Spectral Sensitivity Curve** shown in Figure **7.8**. According to scientific research, a person with normal vision looking at colored lights of equal energies under good illumination will perceive the yellow-green part of

▲ 7.7 The C.I.E. chromaticity diagram
The purest spectral colors are located on the outside of the flat-iron shape, with non-spectral purple across the bottom and the neutral sum of all hues (E = equal energy) in the center.

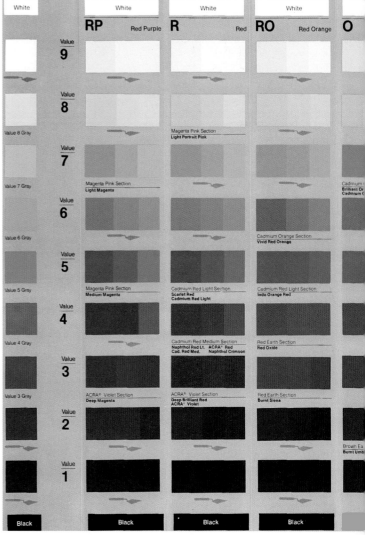

▲ 7.9 The Liquitex® acrylic color map
Hues are represented horizontally and values vertically, with two steps of decreasing saturation given on each paint chip. The Liquitex® oil color map is almost identical to this one.

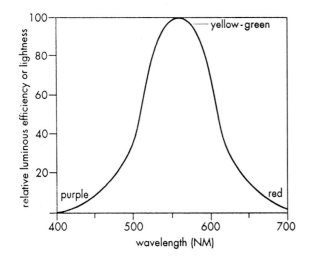

◄ 7.8 Spectral sensitivity of the normal eye
Cone vision is used to assess the relative brightness of colored lights of equal energies but varying wavelengths. Yellow-green is perceived as the brightest color.

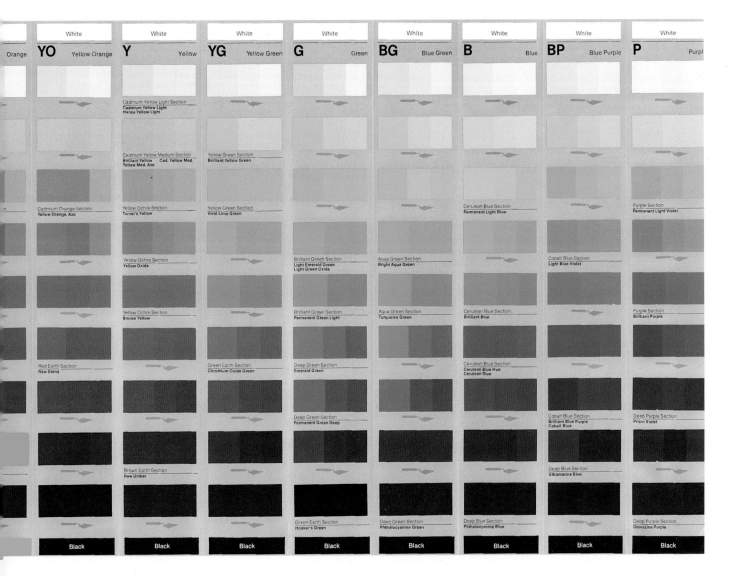

the spectrum (peaking at 555 nanometers) as brighter than all other parts. The visibility of lights drops off sharply toward each end of the spectrum. However, as we have seen, human visual perception is also capable of distinguishing very keenly between different colors, so this spectral sensitivity curve is an exaggeration of visual truth. The concept of *just-noticeable difference* is important in some color-matching situations; one may have to know how many steps of just-noticeable difference are allowable in approximating the color of a given sample.

Despite its limitations in representing the degree of noticeable difference between colors, the C.I.E. system offers a standard which is objective and does not depend on the permanence of pigmented swatches used as a control. The sample-based Munsell and Ostwald systems have now been improved by the establishment of C.I.E. values for the standard swatches; if these fade, new ones can be prepared.

Interestingly, the fact that C.I.E. measurements are based on wavelengths rather than actual color composition means that the same color can be created from many different mixtures. If a paint company wants to make sure that a new batch of a certain red-purple matches its previous batches, it can analyze the new batch with a spectrophotometer. If

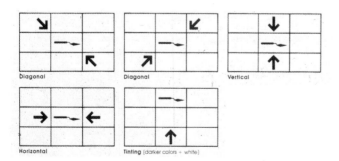

▲ **7.10** If its true complementary is added to a hue, they will lower each other's saturation until a neutral gray of lower value is formed. Another method of lowering saturation is to add a neutral gray.

▲ **7.12** Tube colors vary when used as glazes or tints. Each is shown in its original form in the central swatch, with its appearance when used as a glaze indicated on the left and as a tint on the right.

the new batch deviates numerically from the standard values of luminance, hue, and saturation for that red-purple, quantities of pigment can be added until the new batch is the numerical equivalent of older ones—even though its actual pigment composition may be different!

Mixing Oils and Acrylics

As an artist, you can apply this same scientific principle of considering many possibilities for mixing a desired color in subtractive work. But you cannot mix colors using traditional two-dimensional color circles (2.6) for reference because they typically show all hues at maximum saturation —and therefore different steps of value.

As a tool to guide paint mixing, Binney and Smith, suppliers of Liquitex® oils and acrylics, have prepared color maps that display hue, value, and saturation relationships two-dimensionally (**7.9**). To offer a broader mixing palette than that based on the ten-hue Munsell system, the Liquitex® color map adds yellow-orange and yellow-green, for a total of 12 basic hues, arranged horizontally. Vertically they are

▲ **7.11** To mix hues with reference to the Liquitex® color map, the best results are usually achieved by mixing colors nearest to the desired mixed color, diagonally, vertically, or horizontally.

graded by value. Changes in saturation are represented within each color chip. Each starts on the left with the most saturated form available at that level of value (many of which are available premixed as tube colors—those that must be mixed by the artist have a palette knife symbol below). The effects of mixing increasing amounts of a neutral gray of the same value, thus lowering the saturation of the color, are then shown in two steps. Less saturated versions of a hue can also be mixed by adding amounts of its complementary; doing so tends to "muddy" the mixture, as shown in Figure **7.10**. Some colors opposite each other on various color wheels may not be exact complementaries, and thus do not produce a neutral gray when mixed. However, an imprecise, softened, or muddy mixture may be what is desired.

To mix hues not immediately available in premixed tubes, there are at least three possibilities, as indicated in Figure **7.11**: adjacent diagonals, a horizontal mixture, or a vertical mixture. To mix a yellow 5 (light brown), for example, one could mix yellow-green 6 and yellow-orange 4, or yellow-orange 6 and yellow-green 4, or yellow-orange 5 and yellow-green 5, or yellow 6 and yellow 4.

The color map can be bent into a cylinder, just as Newton bent the straight spectrum into a circle, thus juxtaposing the red-purple end and the purple end for mixing purposes. Any of the adjacent combinations will yield an approximation of the desired color in the middle, depending on the exact amount and characteristics of the mixing colors used.

Tube colors vary in permanency, clarity, intensity, and tinting strength. The natural form of chrome yellow, for example, turns green or even greenish black over a long period of time; natural cadmium yellow is far more permanent but harder to use since it quickly dulls when mixed. Tube colors also vary in cost and toxicity, factors one may need to consider before purchasing a basic palette. However, many costly and/or toxic natural pigments have been replaced by synthetic ones.

Although many color theories posit that all colors can be mixed from three primaries, in practice this cannot be done with paint pigments. Yellow is a particular problem, for a high-value maximum saturation yellow cannot be created by adding white to a value 5 yellow, since this will decrease its saturation while lightening its value. Furthermore, if black is added to a high-value yellow to lower its value and saturation, the result is greenish, no matter what brand of paints is being used. Contrary to the idea that yellow is a primary color that cannot be mixed, we find that it can be mixed from the hues around it on the color map, as indicated above. To mix all the colors in the color map, we therefore recommend that students start with a basic set of 12 tubes of oils or acrylics: value 5 of red-purple, red, yellow, green, blue, and purple; value 8 yellow; value 3 red; base value blue-green; base value 75 blue-purple, Titanium White,

and Mars Black. Higher values can be created by mixing in some white; darker values can be mixed by adding black or the appropriate base value—a very dark step in the hue. These measures will tend to lower the saturation of the brilliant tube colors. Saturation can also be lowered by mixing complementaries or adding neutral gray. To lower saturation without lowering value, some white may be added to the mixture.

Additional hues can be mixed from adjacent colors in any of the four possible directions mentioned above. However, if the mixed pigments are of equal value, they will produce a result of lower value, for pigment mixing is a subtractive process. It may be necessary to compensate by starting slightly higher in value in one or both hues.

Various tube colors respond differently when thinned to transparency with a medium, forming a **glaze**, or when mixed with white to form a **tint** (**7.12**). The differences between some tube colors are then more apparent than when they are shown at full strength. The colors labeled by Liquitex® as "Deep Brilliant Red" and "Cadmium Red Deep," for instance, look almost identical in the tube form, shown in the central patches. But note how different they become as glazes or tints.

When mixing paints, the **Weber-Fechner Law** must be applied if colors visually equal in value are to be mixed. If we add equal parts of white or black repeatedly to raise or lower value, the rate of optical change will decrease. To create an optically equal series of differences, geometrically increasing parts of black or white must be added. The Weber-Fechner Law, formulated by Weber and Fechner in the nineteenth century, is stated thus: "The visual perception of an arithmetical progression depends upon a physical geometric progression." The difference between adding arithmetically increasing parts (1 + 2 + 3 + 4, etc.) and adding geometrically increasing parts (1 + 2 + 4 + 8, etc.) is shown graphically in Figure **7.13**, and in value steps in Figure 6.10.

All the above comments on paint mixing can be applied to both oils and acrylics. The pigments used today in both forms are the same; only the media are different. This is not to say that the two have the same visual effect. Oil is typically more glossy; acrylic tends to have a more matte finish, unless a lot of the medium is used. Oils can be blended wet-to-wet since they dry slowly; acrylics dry quickly. Over a long period of time, a quality acrylic paint should retain

This Physical Fact reduces to this Psychological Effect

This Physical Fact produces this Psychological Effect

▲ **7.13 The Weber-Fechner Law**

the original color of its pigment, for the medium dries as clear as glass, albeit somewhat darker than the wet tube paint. Oil paint tends to darken somewhat as it dries, and yellow as it ages.

Another problem can sometimes be seen in old oil paintings. The upper layers which were once opaque may

become rather transparent, revealing the underpainting, an effect so well known that it has a name: *pentimento*. Recognizing that the ground and underpainting may sooner or later be seen in the painting, artists have therefore learned to keep the ground and underpainting of oil paintings as light as possible, and build up colors with the addition of dark colors over light ones.

Ceramic Glazes

Ceramics employ clays which naturally vary in color, from reds, browns, and grays to the white-firing clays used for the finest porcelain. In addition, ceramic objects are often given one or more coatings of glaze, which is brushed, dipped, poured, or sprayed onto the piece and then fired to waterproof, often glossy, hardness. Glazes are made of chemical combinations known as silicates. Their fired color may not be apparent until after firing, so potters typically make or consult glaze samples for color references. If a transparent glaze is used, the color of the clay itself will show through. A matte glaze has a dull, non-reflective, opaque surface when fired. Fritted glazes have shattered bits of water-soluble, molten chemicals added, increasing their color clarity. Methods of firing will also affect ceramic colors. Old traditions are being revived by contemporary ceramic artists for their special effects. Heidi van Veen-Kiehne used the sixteenth-century Japanese technique of raku firing—brief placement in a hot kiln and then smoking in a bed of natural organic matter—and also threw soda into the kiln during the firing to create the serendipitous color effects shown in Figure **7.14**.

Students new to ceramics may work with commercially prepared glazes to lessen the uncertainties and chemical hazards of the process. Glazes must be matched with the clay body used, considering both the temperature at which they mature when fired and the degree of shrinkage during cooling. Lead is a common ingredient in glazes; without it, glazes are harder to brush, flowing less readily and drying more quickly. Lead, however, like some other glaze ingredients, is toxic and must be handled only with great care.

Many experienced potters prefer to compound their own glazes from a variety of chemicals. Recipes for those that work well are prized and saved, with samples. The recipes include three basic chemical ingredients: silica,

▲ **7.14 Heidi van Veen-Kiehne, Teapot**
Copper handle, 7 × 11 ins (17.8 × 27.9 cm).
Soda-raku fired, grass reduction.

which forms the glassy surface and is provided both by the clay (kaolin) and feldspars (potash, sodium, calcium, alumina, and silica); flux, to help the glaze and clay body fuse; and alumina, which makes the glaze more viscous and hardens it. There will also be pigments in glazes used for coloring, such as manganese dioxide, chromium, copper sulfate, cadmium, potash feldspar, barium carbonate, zinc oxide, or copper carbonate. Such ingredients are mixed by "recipes" specifying their percentages. Chemists also prepare test chips to study the effects of differences in firing temperature, length of firing time, and clay body used. Figure **7.15**, for instance, is part of a series of tests by potter Susan Peterson to study the color effects of firing the same opaque glaze formulation at three representative kiln temperatures: low (cone 4), medium (cone 5), and high (cone 10). The results show that hues are most saturated at low firing temperatures.

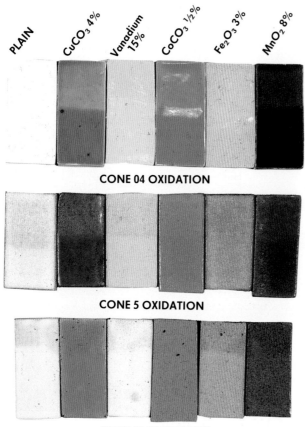

▲ **7.15** Susan Peterson's glaze tests demonstrate the effects of different firing temperatures on glaze colors.

Colored Glass

From the third millennium B.C., the people of Mesopotamia knew how to create objects of colored glass. When soda, silica, and lime were heated together, the glass was usually of blue-green hue because of the iron impurities in sand, which took the form of silica in the formula. The Romans learned to neutralize such impurities by adding manganese or antimony to produce a colorless clear glass. Brilliant hues could be produced by adding metallic oxides, with the results affected by the temperature of the firing. Copper was used at different temperatures to produce turquoise, dark green, or deep reds.

Very small portions of metal oxides produce highly saturated hues in glass. An intense blue results from adding only one part of cobalt oxide to 10,000 parts of the base glass. These jewel-like colors are made even more brilliant by the light that passes through transparent or translucent glass. Glass artists are also able to juxtapose hues of varying colors by techniques which allow the fusing of bits of differently colored glass to the main form. Threads of contrasting colored glass may be trailed over the piece, or bits of colored glass may be picked up as the piece is being formed, thus incorporating them into the surface. After the base and colorants are fused, the additions may be left to stand in low relief or flattened for a smooth surface. Dale Chihuly's *Venetians* series (**7.16**) is an exuberant exploration of such juxtapositions of color and elaborations of form. Chihuly often tells his assistants to "punch up the color," and says of the resulting works, "People seem to like them."[1]

Color Printing

Inks, like dyes, are colorants dissolved in a medium. In graphic design, they are generally used for mass reproduction of artworks originally created in some other medium. There are two ways of doing this: four-color process and flat (or match) color.

In **four-color process**, it is possible to mix most colors from three primaries plus black and the white of the paper (if it is white) by printing the same surface four times in the process, or primary, ink colors. These ink primaries are cyan, magenta, and yellow. In four-color process printing, tiny dots of these hues are juxtaposed so that they will be mixed visually by the viewer's eye. Black dots are added to deepen the dark areas and increase contrast. This system is therefore often referred to as **CMYK**, for cyan, magenta, yellow, and black (or "key").

Four-color process is typically used for the reproduction of **continuous tone** artworks (in which there are unbroken shifts in value, as opposed to shifts in value reproduced by dots), such as paintings and watercolors or, preferably, photographed transparencies of such reflective art. The process begins with photographic or electronic **color separation** of the original continuous tone work. That is, the work is photographed or scanned through filters in the additive primaries—red, green, and blue. The red filter allows only blue and green to pass through, creat-

▲ **7.16 Dale Chihuly, *Evelyn Room with Stems and Venetians*, 1991**
In transparent glass works, colors can be juxtaposed three-dimensionally.

ing cyan. The green one allows only red and blue, creating magenta. And the blue filter allows only red and green light to pass through, creating yellow. The positives printed from these filters are also **screened**, turning values into varying densities of tiny dots. They are then printed one color at a time, starting with yellow, building up to a print that closely resembles the colors of the original even though, when seen under magnification, it is quite different (**7.17**, **7.19**). The screens for each color are set at varying angles to each other, rather than being directly printed one atop the other or set at regular angles that would cause undesired geometric moiré (wavy) patterns. When printed, the tiny juxtaposed dots give the illusion—if not the reality—of smooth transitions in values and hues.

It is difficult to match colors precisely with four-color process. For one thing, printing inks are not yet totally pure, so each of the primaries absorbs some of the light it is supposed to reflect. Various means of correcting color imbalances caused by this imperfection are therefore used by printers when high-quality reproduction is desired. Another problem is the impossibility of using the four colors to reproduce certain colors accurately—such as turquoise (which is warmer than cyan), orange-reds, lemon yellow, and fluorescent colors. An expensive option, when high-quality reproduction is needed, is to add one or two more process colors, such as lemon yellow, to increase the range of possibilities. Some specialized printers therefore have six- and even eight-color presses for fine-art work.

A typically less expensive way of introducing broad areas of color into a printed piece—such as a poster or advertisement (as in Figure 9.10)—is the **flat color** method. Here the designer may prepare transparent overlays indicating areas to be printed in one to four colors, or may simply mark regions of a single original for the printer

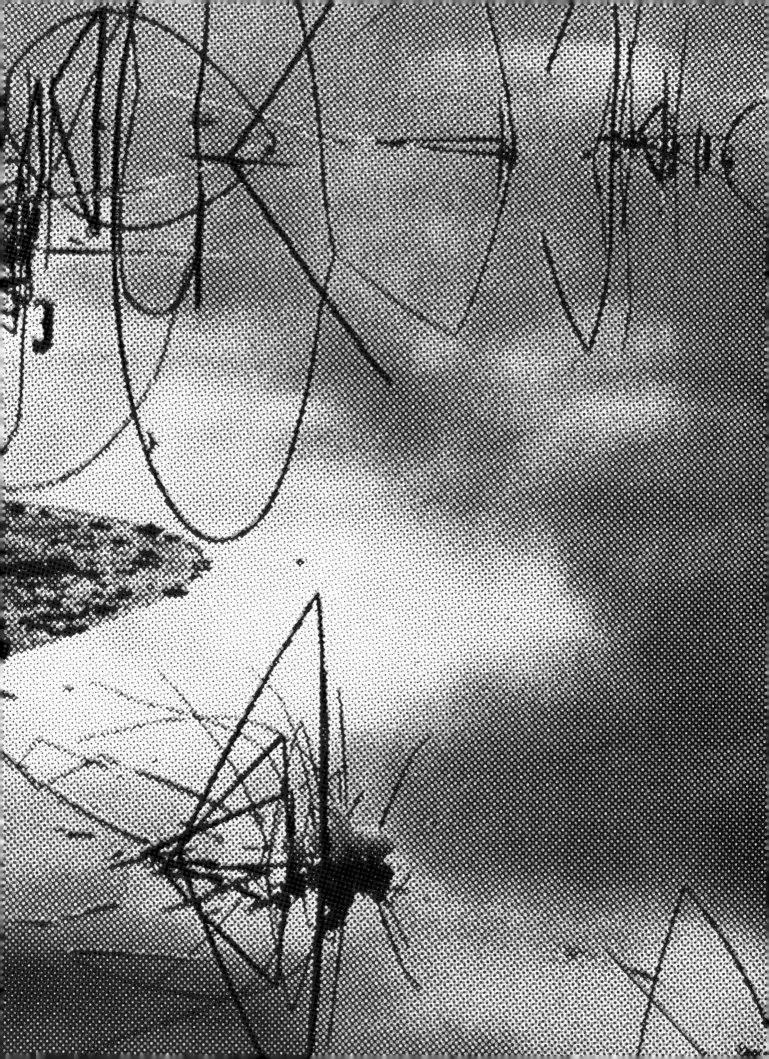

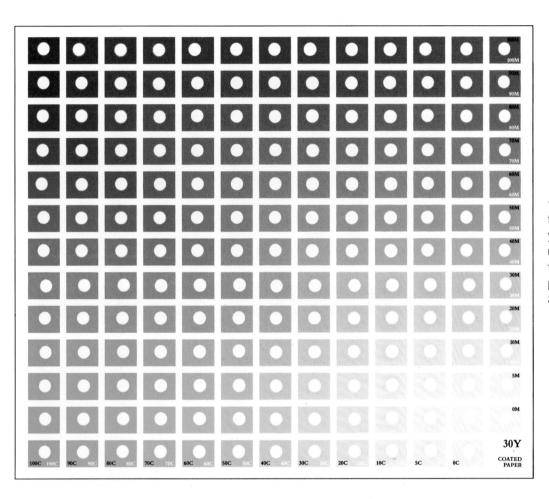

◀ **7.18** A page of color finder tints, in which the yellow part of the mixture is 30 percent throughout, with percentages of magenta and cyan varying.

to print in different colors. There are two ways of choosing and communicating these flat ink colors to the printer. One is based on the process colors. Tint charts (a sample page of one is reproduced in Figure **7.18**) have been developed with varying percentages of yellow, magenta, and cyan. Usually these charts hold magenta and cyan percentages constant and vary the amount of yellow from 0 to 100 percent through a series of charts. The one shown here mixes a 30 percent screen of yellow with all possible mixtures of cyan and magenta. As the dots get close together, resulting in a higher percentage of color in the mixtures, the value becomes darker. To gauge the effect of adding

black as an extra color, the printing company that prepared this chart also offered a transparent acetate overlay with percentages of black. Colors are then matched with samples and specified in percentage terms. For example, one of the subtle, unnameable colors on this chart would be called 30%Y, 10%C, 60%M.

A second, commonly used method for color matching and specification is the Pantone Matching System (PMS). It is now based on nine "basic colors" carried by printers (**7.20**) plus black and transparent white, which are mixed according to PMS formulas to form a total of one thousand colors. To choose colors and communicate them to the printer, a graphic designer can use any of a number of tools displaying the PMS colors. Figure **7.21**, for example, shows the Pantone Color Guide in the form of a fan. Each page of the fan displays seven similar colors that vary slightly in formula for comparative purposes. Pages from different

◀ **7.17** An enlargement of an area of Peter Good's poster (7.19), revealing the underlying dot structure of the screens.

parts of the fan can also be compared side by side. To increase the number of colors available, the designer can specify slight alterations in the formulas. The C or U following the Pantone numbers indicate "coated" or "uncoated" paper. All colors are shown on both coated and uncoated stock, for they are considerably more brilliant on the former, which has been sealed with a clay covering so that inks will sit on the surface rather than be absorbed.

The uncertainties of color specification are now minimized in a newer technology for color reproduction: **giclée (Iris) printing**. This is a computerized process. It begins with scanning of original art into a computer or initial creation of art on a computer (see Chapter 8). The art is stored in the computer's memory with reference to the additive red–green–blue (**RGB**) lights of a computer monitor, but it can also be previewed in approximate form on the com-

◀ 7.19 The color separation process
Color separations from a 1970 poster by graphic designer Peter Good, employing a photograph by Bill Ratcliffe. The image has been separated by the printer—The Hennegan Company—into 200-line yellow, cyan, magenta, and black screens. They are overprinted in that order—as shown in the bottom line—to reproduce the final image.

small as a red blood cell. One company using this expensive technology to create limited edition art prints, Cone Editions Press, claims that its modifications of the process have extended the color range possible in printing, to include deep, rich colors and good blacks. Nevertheless, there are concerns that the inks usually used in giclée printing will fade rather quickly under normal lighting conditions. Experiments are under way to lengthen their lifespan.

Janet Cummings Good points out that even if such a print should fade, the image remains as brilliant as ever on its computer file. Of the processes behind the creation of her Iris giclée prints such as *Gold icon, heart leaf* (**7.22**) she says:

> The computer has fed and fuelled my obsession with color since I got my hands on my first color monitor and printer in 1995. The analytical side of my mind loves the limitless possibilities for fine-tuning hue, value and saturation with the click of a mouse, the choice of a number, the sliding of a bar, the reshaping of a curve.
>
> Of course, the analytical is always at the mercy of the intuitive, which needs to ponder, contemplate, and react for no reason other than to come to a sense of personal sureness. Both approaches are facilitated by seeing the richness and subtlety of color that is produced by the miraculous little ink jet printer simply spraying pigment on paper.
>
> Any completed print is always preceded by a myriad of trials. And when the "final" print is established, I can choose to create one-of-a-kind or a series. The true "electronic original" is then archived away, remaining available to me as raw material to rethink, reform, reconfigure, and recolor. The wonder of the electronic file is that it stays fresh and pure, retaining forever its potential for being printed or recreated.[2]

puter as a subtractive CMYK separation to see in advance the effect of overlaying one color by another. Many layers can be built up and adjusted as the artist desires, often with the assistance of computer specialists. The colors are then applied to paper by ink nozzles that spray one million tiny droplets of ink per second in a way that creates the effect of a near-continuous-tone image. The droplets in this Iris giclée ("squirt") technology vary in size, but may be as

Despite efforts to calculate color effects in advance, there are still imperfections and surprises in color printing technologies. Even in the high-end giclée system, there is the complication of the difference between RGB additive mixtures and CMYK subtractive mixtures. Whereas cyan is one of the basic subtractive printing colors, cyan cannot be precisely displayed by a computer monitor. Furthermore, CMYK systems are all limited in their ability to print certain colors such as ultramarine blue and cadmium orange, the latter of which is too highly saturated to be mixed subtractively from yellow and magenta.

◀ **7.20 PMS basic colors**

PANTONE® Basic Colors 1 XR

PANTONE Yellow C

PANTONE Warm Red C

PANTONE Rubine Red C

PANTONE Rhodamine Red C

PANTONE Purple C

PANTONE Violet C

PANTONE Reflex Blue C

PANTONE Process Blue C

PANTONE Green C

C = Coated Paper

© Pantone, Inc. 1963, 1987

There are also other variables which are likely to affect the outcome of any color printing process. The paper's grain and absorbency will make a difference in the visual effect of inks applied to it, and of course its own color becomes one of the factors in the color mixture. The appearance of the inks themselves is affected by variables such as the sequence in which the colors are printed, the opacity or transparency of the ink formulation, the amount of water in the ink, the surrounding temperature, the size of pigment particles, the dryer used in the ink, its viscosity and tackiness, and the amount of ink used in the job. As the paper is passed through the press, the printing speed, humidity in the area, and drying time are among the many factors that can alter the final results and must be carefully controlled.

Color Photography

Black-and-white photography records differences in value, but color photography must also record differences in hue and saturation. The procedures and chemistry used to do so are complex and involve both additive and subtractive color mixing systems.

For both color prints and transparencies, the recording of colored images on film typically begins with an **integral tripack**: film with three

▶ **7.21 The PMS fan**
With ink formulas for each of 1,000 colors, it is printed on both coated and uncoated paper.

thin layers of gelatin with sensitizing dyes. These dyes are now so sensitive that they can register light beyond the limits of the visible spectrum, from about 200 nanometers at the ultraviolet end to more than 1,300 nanometers at the infrared end. When the tripack is exposed to an image, it registers the image in the light primaries—blue, green, and red—by separating metallic silver grains from the silver halides. The result is invisible, however, until it is developed.

In the **color positive** or **reversal process**, used largely for transparencies such as slides, each layer is developed with chemical couplers that cause dyes to be released in unexposed areas in the subtractive primaries yellow, magenta, and cyan. When all three are superimposed, the area will appear black, the result of subtractive mixing. Areas of yellow and magenta will appear orange; yellow and cyan will make green; and magenta and cyan create blue.

In a **color negative process**, typically used for making color prints, dye-forming couplers are in the tripack itself. The first developer brings out the complementary colors in the exposed areas as a color negative. This color negative may then be printed onto special paper containing more dye-forming couplers in color-sensitized layers. The couplers in the paper will turn cyan, magenta, and yellow into their additive complements: red, green, and blue.

Many elaborate chemical adjustments and refinements are made to enable color reproduction by these methods to be as accurate as possible, without bias toward any particular area of the spectrum. This accuracy is often aesthetically desirable, for many photographers seek out interesting or beautiful color effects in

▲ **7.22 Janet Cummings Good,** *Gold icon, heart leaf*
Iris print, image 3¼ × 3¼ ins (8.25 × 8.25 cm), paper 8 × 8 ins
(20.3 × 20.3 cm). Edition of five.

▲ **7.23 Diane Althoff,** *Untitled,* **2000**
Chromogenic print mounted on aluminium, 144 × 30 ins
(366 × 76 cm).

▶ **7.24 Eliot Porter,** *Pool in Brook, Pond Brook, New*
Hampshire, **1953**
Dye-transfer print, 10¹¹/₁₆ × 8⁵/₁₆ ins (27.1 × 21.1 cm).
© 1990, Amon Carter Museum, Fort Worth, Texas,
Bequest of Eliot Porter (P1989.19.23).

the world around them and then attempt to record them on
film, as in Eliot Porter's capturing of a fleeting moment of
the vivid effects of sunlight on water (**7.24**).

However, sometimes the artist's purposes are better
served by distortion of the colors of the original image.
Photographed objects may become vehicles for color
experimentation that has nothing to do with their original
coloring. In her untitled chromogenic print (Figure **7.23**),
Diane Althoff has used the camera to record something
whose identity is lost as she enlarges the image to a twelve-
foot height. It becomes a surreal exploration of color and
nebulous forms in space.

As a photograph is taken, manipulation of exposure
time and choice of film will affect value and contrast but hue
will remain largely unchanged. Colored filters placed over
the lens will bias the results toward a certain color; diffrac-
tion filters will bend light into prismatic effects. Dramatic
alterations in color may also be made in the darkroom,
using techniques such as chemical toning, **solarization**

(whereby the development process is briefly interrupted by exposure to low-intensity colored light, reversing the colors especially in high-value areas), and **posterization** (whereby continuous tone images are converted into distinct flat tones, in any color).

Colors can also be manipulated without limit in images scanned into computers before printing. In **7.25**, Frank Noelker has used the capabilities of the computer to re-adjust the colors in his photograph. Noelker finds that the computer allows him to make changes which are nearly

◀ **7.25 Frank Noelker,** *Untitled*
Iris print (detail), courtesy of the artist. Frank Noelker travels around the world to photograph animals in zoo settings and then uses his computer to alter the colors, creating imagery that is at once convincingly natural and yet surreal.

▼ **7.26 Solvent dyes from** *The Color Index*

45370 **C.I. Acid Orange 11** (*Reddish orange*)
45370:1 (**C.I. Solvent Red 72**) is the free acid
45370:2 (**C.I. Pigment Orange 39**) is the aluminium salt

Dibrominate **Fluorescein** in aqueous sodium hydroxide and isolate as the sodium salt

Discoverer — Badische Co.
BIOS 959, 6, 26
FIAT 764 — Eosin H 8G
Am. J. Pharm. (Sept. 1942), 342 (see also *Coal-tar Color Regulations,* U.S. Food and Drug Administration. Sept. 1940, 13)

Slightly soluble in water (orange with faint yellow fluorescence)
Soluble in ethanol (orange with a greenish yellow fluorescence)
Soluble in acetone (pink with a yellow fluorescence)
Very soluble in furfuryl and tetrahydrofurfuryl alcohol
H_2SO_4 conc. — red yellow; on dilution — yellow brown with orange ppt.
Aqueous solution + NaOH — eosine red
Glycerol and liquid paraffin — good dispersion

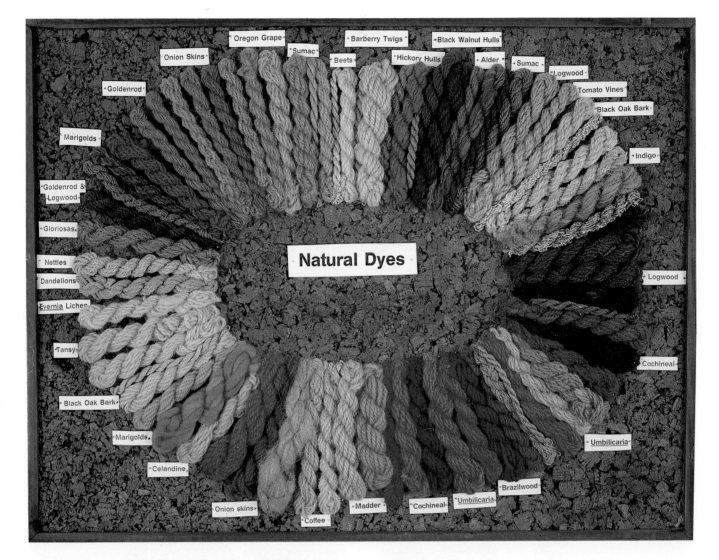

▲ 7.27 Pat McMullan, Sampler of natural plant dyes
Most natural dyes are typically subtle, of low saturation, with exceptions such as cochineal, logwood, and *umbilicaria* (a lichen).

impossible in traditional darkroom manipulation of photographs. He says:

I choose the digital process to print my documentary photographs because it gives me the greatest amount of control. Traditional color film cannot reproduce the color green in either hue or saturation with enough accuracy to suit my needs. I am able, through the computer, to reproduce all of the colors in the spectrum true to my original subject. I also love the different surfaces that I'm able to print onto in the digital process. I choose to print on rich watercolor papers instead of the plastic coated papers that traditional photography is limited to using.[3]

Fiber Dyes

The expanding world of fiber arts includes yarns, fabrics, basketry, and anything else created from linear materials woven together. Pre-dyed fibers can be interwoven to form patterns, or sheets of fabric can be dyed after they are

◀ **7.28** Swatches of color samples for rug hookers reveal a range of color choices.

woven. With modern chemistry, the range of colors possible is so vast that *The Color Index* (**7.26**), a professional color specification list, includes over 8,000 dyes classified by chemical structure, properties, and applications (not all of which fall into the visual arts).

Traditional hand-dyeing of fibers—an art still carried on by many handweavers—begins with gathering of the dyestuffs. Practically any plant material can provide some colorant, but certain leaves, stems, berries, seeds, barks, and roots are known to work especially well as sources. The most common natural dyes are in the yellow and earthy brown range.

Natural dyes from plants are often quite different from their own color. Beets and strawberries, for example, yield only beige, and purple pansy blossoms give an intense blue-green dye. Moreover, colors will vary from dyebath to dyebath. Nevertheless, natural dyes are appreciated for the very features that make them unacceptable to commercial dye houses: Their subtle colors may or may not be replicated, depending on seasonal variations in the dye plant itself. A sampler of natural dyes with their sources, as prepared by handweaver Pat McMullan, is shown in Figure **7.27**.

Natural dyes will only adhere to natural fibers, such as wool, cotton, jute, linen, and silk. These materials' own natural color will, of course, affect the outcome. Before dyeing, the fibers are wound into hanks and scoured to remove foreign matter that would interfere with the dyeing. Often the fiber is then simmered in a **mordant** to help set the dye and perhaps affect the color. The mordant is a chemical, such as alum, iron, tannic acid, tin, or copper. The dyestuff itself is boiled in water to release its dye and the mordanted material is then simmered for a time in the dye-pot. Longer dyeing typically deepens the value and may increase the intensity of the dye absorbed.

Dyestuffs are not usually mixed with each other directly, for the result tends to be a drab olive. If one therefore wanted to dye fibers green using goldenrod and logwood, one would first dye them with the goldenrod to be sure of getting a good yellow and then overdye some areas with the logwood, which by itself yields a purple or gray. Kitchen

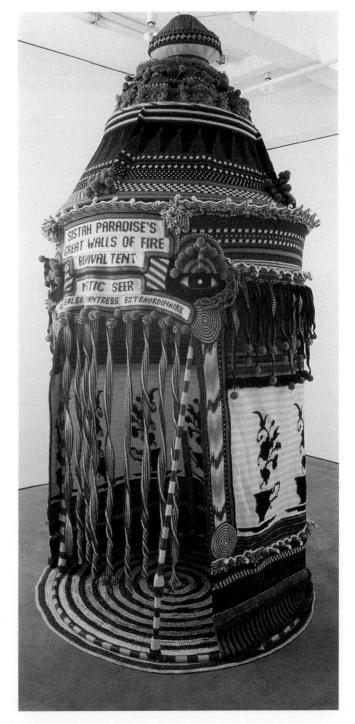

▲ **7.29 Xenobia Bailey, *Sistah Paradise Great Wall of Fire Revival Tent*, 1999**
Hand crochet, cotton and acrylic yarns, height 10 feet (3.04 m). Stefan Stux Gallery, New York.

ingredients—ammonia, baking soda, vinegar, or cream of tartar—may be added to the dyebath to alter the color. Adding vinegar to a purple grape juice dye, for instance, will turn it green!

This hand-dyeing procedure is a form of **direct dyeing**. Many artificial fibers, such as nylon and polypropylene, must be dyed by other means, since direct water-soluble dyes do not stick to them. **Dispersed dyes**, such as acetate dyes, are not soluble in water, but nonetheless disperse through the fiber when applied in a soap solution. **Reactive dyes**, such as henna for hair coloring and procions for dyeing cellulose fibers, bond chemically with the fiber. **Vat dyes** respond within the fiber after it has been subjected to a certain treatment, such as being exposed to air and sunlight or an acid solution. Indigo is a vat dye, turning fibers blue as it is exposed to the air. Successive dipping and exposure will gradually deepen the color.

Such methods allow manufacturers of yarns to offer palettes of color, in both natural and synthetic fibers, that range from the subtle, unsaturated colors prized by many craftspeople to very bright, pure hues that are hard to obtain with most natural dyes. Figure **7.28** shows a great variety of contemporary commercial dye colors for mixing and use by fiber artists.

Xenobia Bailey has used a full palette of fiber colors in her *Sistah Paradise Great Wall of Fire Revival Tent* (**7.29**), a cross between a Southern Baptist Revival Tent and an African full-body mask with eyes. In her "aesthetic of funk," its rings of color are described as a "Mandala cosmic tapestry of energy flow."

Brilliant synthetic dyes for clothing have changed the human landscape. In India, peasant women have adopted saris of synthetic materials in highly saturated, almost fluorescent hues that add a rich and happy note in the midst of a life in the mud and dust. Such colors retain their visual impact even under bright sunlight, and unlike the short-lived dyes in natural cotton saris, they retain their brilliant colors without fading from washing and use. On the other hand, the toxicity of some petrochemical dyes—such as procions—may present serious environmental hazards and health risks to workers in dye plants.

Fading of Subtractive Colors

Fading from exposure to light is a problem with many dyes, inks, and pigments, both natural and synthetic. Sunlight and bright indoor lighting can be extremely harmful to colors. Museums therefore display works under subdued lighting conditions. At one time, collectors used to keep their watercolors and prints in drawers instead of displaying them, for the colors would break down. Even with today's art technologies, it is unwise to hang either oil or acrylic paintings in direct sunlight, which would affect their colors. The fading of colors happens gradually over some time and may not even be noticed unless there is contrast with an area that was always in the shade. Color photographs may last only 12 to 15 years without discernible fading, in contrast to the much greater longevity of black-and-white photographs. Early Iris giclée prints from computers lasted only two-and-a-half years before they began fading. Intensive efforts with papers, inks, and sealant coatings make it possible to prolong the life of an Iris print to approximately the same as a color photograph: 12 to 15 years.

When individual collectors or museums have paid high sums for art, they are concerned that it should last long into the future. In Chapter 10, we will examine attempts to restore the original colors of aging masterworks.

8
Light Mixtures

People were being quite emotionally overcome [by her virtual reality installation] but I don't really have anybody's response because none of them could talk.

CHAR DAVIES

We rarely pay attention to the primeval source of color on our planet: the light of our sun. But to celebrate the millennium in Rome, Peter Erskine placed laser-cut, heliostat-oriented prisms among the ancient Roman ruins to follow the sun's beams as they played across the surfaces, refracting them into ever-changing patterns of brilliant colors (**8.1**).

Even artificially-created lights have in the past not been widely used as art media, though they have been extensively studied by scientists. Now, however, technology is turning the world of light into a luminous palette for artists. Potential areas in which light can be manipulated include video, computer graphics, lasers, and holograms.

Video

The term **video** is used both for electronic light signals broadcast to television sets and for images displayed on television monitors directly from videotapes. These dynamic visual images are usually recorded electronically by video cameras, which scan a scene to analyze and communicate its light patterns. The light received in the camera

▶ **8.1 Peter Erskine, *New Light on Rome* 2000**
Laser-cut prism installation in the cryptoporticus of the Domus Transitoria of Nero. The cryptoporticus was a cool underground walkway, lit by natural light through slots which Peter Erskine strategically appropriated for prismatic displays of spectral colors.

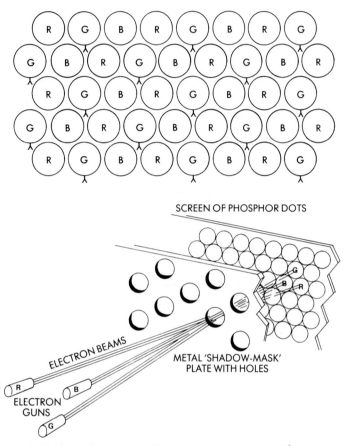

SCREEN OF PHOSPHOR DOTS

ELECTRON BEAMS

METAL 'SHADOW-MASK'
PLATE WITH HOLES

ELECTRON
GUNS

▲ **8.2 Phosphors and electron beams in a color television tube**
The upper picture is a considerably enlarged diagram of the mosaic of red, green, and blue phosphors on the screen of a television set built on the shadow-mask system. Below is an enlarged diagram of the shadow mask, showing its use to focus the electron beams on one triad of phosphors at a time during the scanning process.

is divided by a system of mirrors into the three light primaries—red, blue, and green. For transmission, these are then converted into two signals indicating **chrominance** or **chromaticity** (a combination of **dominant wavelength**, or hue, and **purity**, or saturation) and **luminance** (the light-mixture equivalent of value in pigments).

This information is broadcast through the air or fed electronically to a receiving monitor, which decodes the video signals corresponding to the light primaries. These are sent

through electron guns, usually one for each primary. Each sends beams to the screen of the picture tube, the inside of which is coated with hundreds of thousands of tiny dots of red, green, and blue fluorescing powders, called phosphors. When hit by electron beams, they give off a certain amount of light, depending on the luminance signal. In many television sets, a **shadow mask**—a metal plate with thousands of small holes—is used to keep the electron beams focused only on one triad of phosphors at a time, preventing them from spilling over into other areas (**8.2**). The electron guns rapidly scan all the phosphors, traveling along horizontal lines, and thus rebuild the image on the entire screen just as it was when originally scanned by the video camera. This process occurs 30 times a second in a standard screen in the United States, which is composed of 525 scanning lines. The European system uses 625 lines, scanned 25 times a second. The persistence of our vision keeps the image from appearing to flicker.

Red, blue, and green are used as primaries in video transmission because they can produce the widest range of mixtures. It comes as a great surprise to many people that there is no yellow in a television tube. The yellow that we "see" on a television screen is actually an optical mixture of tiny dots of green and red. Green and blue juxtaposed in space or flashed quickly one after the other will produce a cyan sensation; red and blue juxtaposed in time or space will appear magenta. Black areas have no light coming through; white areas are a mixture of all three primaries. Luminance (value) differences are controlled by the amount of light released.

The saturation and balance of colors between the three primaries can be controlled to the viewer's taste by adjusting controls on the monitor. In early television transmission, colors were exaggerated to demonstrate the flashiness of the medium, but nowadays somewhat more subdued, natural colors are preferred.

Computer Graphics

Computer graphics use monitors that are essentially the same as television screens. They use the same red, blue, green primary system of phosphor activation, though they are capable of slightly higher saturation. Video and computer graphics have within their range a greater degree of

saturation in colors than is possible with any subtractive medium, for they are based on the purity of colored lights. However, phosphors are not as pure as they theoretically might be, and the trichromatic mixing system means certain mixtures are not possible.

Figure **8.3** uses the C.I.E. chromaticity chart (see p. 73 and 7.7) to illustrate the parameters of modern computer graphics color capabilities. Chromaticity coordinates for the red, blue, and green primaries in a standard computer monitor form a triangle that is much smaller than the flat-iron shape formed by the whole range of spectral colors. The purest spectral colors fall along the outer edge of this shape, with saturation decreasing gradually into the central point of equal energy (E), where x and $y = 0.333$. This point represents neutral colors, from black to white, with their value depending upon the degree of luminance, which is not shown in this two-dimensional diagram.

The primaries do not reach the corners of the flat iron because the phosphors are not as pure as spectral hues. Moreover, nothing outside the triangle can be mixed using the three primaries. Along each edge, hues are pure mixtures of the two connected primaries; within the triangle, all three primaries are involved to some extent in the mixture, until finally they all mix to a neutral in the center. The only way to mix a color outside the triangle is to have negative hues available as mixers—such as a minus blue which would subtract enough blue from the green and red to produce a pure yellow. Mixing a high yellow is the biggest problem with the RGB monitor; highly saturated cyan and magenta are also impossible.

These limitations are actually not apparent to the average eye, which finds the outer limits of computer graphics colors brighter and more saturated than any pigment colors, as indeed they are. Furthermore, computer graphics programs for color mixing are becoming increasingly sophisticated and are now able to create very fine gradations of hue, value, and saturation. There are a number of ways of setting these up.

Choosing Colors

Popular desktop graphics systems offer two simple ways of creating over 16 million colors, far more than the eye can actually distinguish. Firstly, the user can hold a "dialogue" with a color map, such as a wheel divided into hues with

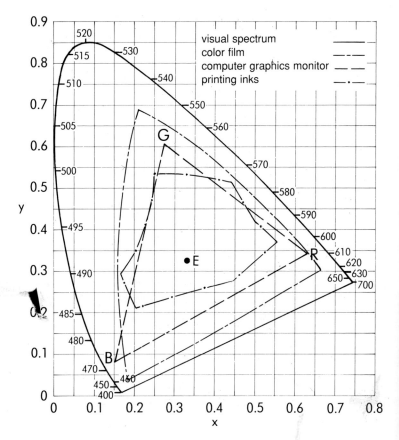

8.3 Chromaticity coordinates of the red, blue, and green primaries on the standard computer graphics monitor
Printing inks can reproduce only a comparatively small portion of the visual spectrum. Color film can reproduce a larger range than a television or computer monitor.

concentric circles showing gradations in saturation. Using a "mouse" to position a pointer on the screen, the computer artist can point to a place on the wheel and it will be displayed in a box. Placing the pointer close to yellow in the red area, for example, will bring up an orange. Slight movement of the pointer will make the color chosen more red or more yellow. The brightness (value) of the whole wheel can be changed by another maneuver.

The second way of choosing a color is numerical, by specifying saturation and brightness on a scale of 0 to 65,535 for each of the primary hues. The box showing the first color chosen may have a split screen; to change it

◄ **8.4** The Photoshop program offers several different ways of selecting and changing colors in an image on the computer monitor.

slightly, one could choose a slightly different number to see the result, whose color is displayed next to the first color on the split screen. The ease of color mixing with such a system makes color relationships fascinating and fun to manipulate.

Adobe Photoshop, a popular graphics program, presents a display on the monitor with a variety of ways of selecting a specific color. As shown in Figure **8.4**, the computer artist can move a small circle through a field of variations on a hue to select the one desired, or move arrows along a linear display, or type in the subtractive CMYK or additive RGB or **HSB** (hue, saturation, brightness) numeric values of the color. Once the hue is chosen, the numeric CMYK notation calculated by the computer can be used in specifying printing inks.

In addition to using on-screen color-choosing devices, those with engineering training can program color mixtures numerically. Colorist Nathaniel Jacobson and computer specialist Walter Bender of the MIT Media Lab have collaborated to try to create computer color maps based on the Munsell system of color classification. The colors shown in this custom computer palette (**8.5**) are deliberately muted to approximate the softness of pigments rather than the glare of phosphors; none are shown at the maximum saturation possible for the monitor. In addition,

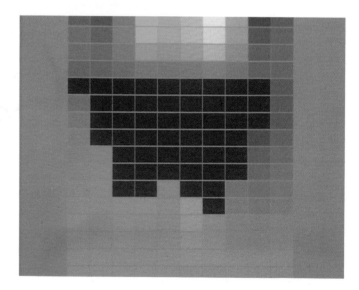

▲ **8.5 Nathaniel Jacobson and Walter Bender, MIT Media Lab computer graphics color map**

they are programmed to vary in visually equal steps, as in the Munsell system. One might think this would be easy on the computer, but it is, in fact, quite difficult, for mathematically equal amounts of light energy do not create visually equal steps in value. They must be measured by the most sophisticated of visual instruments: the human eye.

▲ **8.6 Ed Manning, Watson and Manning, Inc., *The Mona Lisa Blocpix Image***
Spatially quantized transformation.
The last frame is the painting itself—not a computer image.

Colors can be added to computer drawings by using an electronic drawing pad, a light pen to touch areas on the screen, or a pointing device such as a mouse to "click" the colors into place. They can also be programmed to develop along with computer-generated imagery such as the fractal image displayed in Figure 2.8.

Another approach to color in computer graphics is to digitize or quantize an existing image. This basically means electronically scanning and converting it into numbers that correspond to points on the x and y axes of the monitor screen as graphed in Figure 8.3. Computers with graphic capabilities have screens divided into **pixels**, which are individual picture elements, like mosaic tiles. The more pixels, the finer is the possible resolution in the image. Figure **8.6** demonstrates the visual results of digitizing the *Mona Lisa* with increasing numbers of pixels. The color variations—averaged for each pixel—become finer and

▲ **8.7A** Douglas Kirkland's original photograph of Audrey Hepburn.

8.7B (above right) A version of the same photograph, digitally manipulated to appear as a high-contrast image of bright, flat colors.

finer mosaics of colored blocks. It is possible to render an image with what appear to be continuous gradations in tone if the computer has a substantial memory. The larger the computer's memory, the more pixels it can support.

Once the image is scanned into the computer's memory, it can be manipulated endlessly. Colors can be added and changed in hue, saturation, and brightness at will; shadows, highlights, and midtones can be added wherever the artist wants them. Figure **8.7A** shows the original photograph of Audrey Hepburn which Douglas Kirkland used as the starting point in a manipulation process that resulted in the final piece shown in Figure **8.7B**. Among other changes, Kirkland converted the image to high contrast, burned in certain low-value details from the original that would have been lost in high contrast, and then used a limited palette of six colors to replace those in the original. Kirkland observes that, in using powerful computer programs:

> You have to know when to blow the whistle on yourself. We have this incredible wide-open possibility, but we have to learn when to say no and when to say yes. It's like having a wonderful musical instrument that can make any sound in the world—but you have to put those sounds together to make a beautiful song.[1]

In Adobe Photoshop, a user-selected range of color choices in the image are displayed side by side to help in making aesthetic choices. The "current pick" is juxtaposed with other possible choices as one works with alterations in hue, value, or brightness in the shadows, midtones, or highlights. The entire original may be shown in reduced size in many variations side by side on the monitor, or the image may be "cut" into "test strips," as in Figure **8.8**. This allows the computer artist to apply separate color treatments to each section and view the result before printing, like a traditional photographer making test strips with different color filters.

▲ **8.8 Test strip sample**

To avoid obvious jumps between different hues and values used in representing gradations across a three-dimensional form, the PostScript program offers up to 256 gradations between two colors, for the equivalent of an airbrushed effect. This number of choices is not necessary in a small area, but if a program had only 50 choices and if they were stretched across ten inches, there would be only five bands of color per inch. In such a case, the bands themselves would be noticeable as hard-edged shapes, an effect that an artist might not desire.

A person with normal color vision can distinguish approximately 150 different hues in the visible spectrum. Scientists calculate that when differences in value and saturation are factored in, our eyes can probably distinguish about seven million different colors. But high-end computer workstations can generate a palette of 16.7 million colors on the screen—almost ten million more than we can actually see. Is this pointless extravagance? Perhaps not, for this tremendous ability allows for very gradual gradations between colors. We can visually detect very small differences between certain hues, but not between others, so such abundance of differences is necessary to ensure that nowhere in the even subdivisions of color choices can we detect unwanted jumps.

Computer Color Printers

"Hard copy" output from what is created on the computer screen may take the form of high-resolution film negatives, slides, or paper prints. Usually some kind of color printer is used initially by computer artists to check the results before the disk is sent to more expensive output devices. As prices of computer-driven printers fall and their quality improves, many graphic artists are also producing usable final results with their own desktop computer systems, for short-run applications such as signs and displays.

Both the cheapest and the most expensive of color printers are based on **inkjet** technology. In these, colored ink is sent through nozzles onto the paper by heat or hydraulic pressure. Low-end color inkjet printers are quite inexpensive, but they cannot provide brilliant, accurate color, as can be seen in comparing Figure 8.9A with other options. Most graphic artists thus use desktop inkjet printers only for rough comps or simple transparencies and presentations. At the other end, very expensive giclée printers are also based on inkjet technology. Here, tiny dots of varied sizes are squirted from CMYK nozzles onto paper or other material, on a drum rotating 100 to 150 inches per second in the case of the Iris 3047 printer. It may take up to an hour-and-a-half to fully build up the image, which nearly approximates continuous tone. The more expensive inkjet printers use six or eight colors of ink, rather than four. Figures **8.9A**, **B** and **C** show the different results obtained from three types of printer.

Another technology supports **color laser** printers. A laser beam is used to charge the drum in an area to be printed. This charge attracts toner particles, which are thus drawn to the page and thence fused to the paper by heat. Figure **8.10** illustrates the basic mechanism used. There are four separate toners and developers for the CMYK colors. These toners are not so bright as thermal wax, but the images are clearer than those from low-end inkjet printers.

Although the sophistication of the printer will influence the quality of the reproduction, no process using printing inks can equal the brilliance of the hues created on the screen with pure lights. Better reproductions are possible with special cameras that photograph the screen, or even better, make a slide from the electronics. Some of these can create a very dense image by averaging the color between the pixels. Such equipment, however, is still very expensive.

▲ **8.9A** An inkjet reproduction of an image, with 500 percent enlargement to show how the color is laid down in dot patterns.

Color Management

Graphic designers are now frequently called on to provide precise color-matching with computer technology. **Color management** in computer graphics means the use of computer software to consistently produce the very same

▲ **8.9B** Laser reproduction of the same image, with 500 percent enlargement showing dithering of the dot patterns.

▲ **8.9C** Iris (giclée) reproduction of the same image (with 500 percent enlargement), approaching continuous tone printing.

colors from one device to another, such as from computer screen to print, or original to print, or one screen to another, or print proof to final proof. This is not an easy matter. The additive colors seen on the screen in phosphors of red, blue, and green are quite different from subtractive prints created from cyan, magenta, yellow, and black (**8.11**). Whereas the computer monitor can display over 16 million colors, no printing system can reproduce them all. There are only one thousand Pantone spot colors; the best CMYK printers can only reproduce about 5,000 colors. Even a color transparency can reproduce "only" 15,000 colors. Color management thus inevitably involves limiting

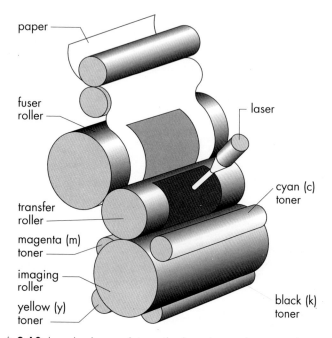

paper

fuser
roller

laser

transfer
roller

cyan (c)
toner

magenta (m)
toner

imaging
roller

yellow (y)
toner

black (k)
toner

▲ **8.10** In color laser printers, the laser beam charges a drum, attracting toner particles. They are then fused to the paper by heat.

the computer's output, as well as attempts to ensure that the color seen on the monitor or in chosen color swatches matches what is printed.

Precise calibration of all devices—scanner, monitor, proof printer, and final printer—also becomes necessary. Computer software providers have adopted a uniform C.I.E. method of calibrating scanners by using them to read a standard "scanner target" of color patches. However, there is no uniform way of calibrating color printers, and the colors seen on different computer monitors may differ considerably in contrast, color balance, hue, and saturation. As the potential for accurate color reproduction has developed in computer graphics, graphic artists' work has become more complicated as they strive to coordinate all systems for precise color matching. It is likely that these complications will be considerably ironed out in the future by new software, but the basic gap between additive colors and subtractive colors will nonetheless remain.

Dynamic Imagery and Virtual Reality

Computer graphics enable artists to create computer animation using color change through time as well as space. Internet websites now often employ animated graphics in color to catch attention. The technology can also be used for fine arts applications, such as video art. Herbert Franke's *Metamorphoses* (**8.12**) tells a color story with a surprise ending as the background shifts from a subdued red-purple to a strong red. When this sequence was created in 1984, number-crunching was required to program the computer to display such changes. At that time, this highly technical process was intimidating to many visual artists. Herbert Franke suggests that the same thing happened when photography was first introduced:

> An experience made at the beginning of the photographic work repeated itself at this point: we thought at first that it would be painters who made use of the new medium, leading it into branches of art; in reality, such people showed a lack of interest and a new branch of the arts came into existence. Computer graphics have also been largely ignored by exponents of the visual arts. The people who are today concerned with computer animation come only to a small extent from the ranks of the visual arts. A much larger proportion of them rely on training as photographer or cameraman, mathematician or programmer. It is obvious that artistic possibilities opened up by computer graphic systems are leading to the formation of a new profession, standing somewhere between art and technology.[2]

By now, computer skills have become common among artists, and more user-friendly software makes it far easier to develop dynamic as well as static computer graphics. And no longer does computer-generated imagery seem to sit on a flat screen—now **virtual reality** works give the impression of surrounding the viewer in a participatory experience in which the environment is composed entirely of light. In Char Davies' *Ephemere* (**8.13**), participants don a stereoscopic headset and a chest-mounted device that translates their body movements and breathing into a virtual journey through virtual landscapes. These consist only of computer-generated lights creating the impression of a surreal three-dimensional world. Since the subject of this virtual reality "immersion" is the fleeting nature of time, everything encountered is in constant flux. Seeds explode

▲ **8.11 Website of University of Connecticut Department of Art and Art History**
To reproduce the same colors precisely in subtractive and additive technologies—such as this computer rendering of subtractive art—requires complex color management.

▶ **8.12 Herbert W. Franke, Stills from computer film *Metamorphoses,* 1984**
DIBIAS picture processing system. Computer graphics can be used to develop color stories varying through time.

into light, night turns into day, rocks pulsate. The objects in these ephemeral landscapes are, moreover, transparent and permeable rather than solidly opaque. With her background as a painter, Davies says she

> worked with transparency and textured shadow-casting to create spatial ambiguity, merging objects and space, figure and ground. … Just as the invention of film—through the technology and craft of photography—extended the stillness of painting into

the flow of time, the technology associated with immersive virtual reality extends beyond the two-dimensionality of painting and film, into enveloping "circumferal" space. … In works such as these, perceptual boundaries between inside and out may be experienced as permeable as the virtual and immaterial are confused with the bodily-felt, experienced as strangely real.

The visuals in these works are soft, luminous, and translucent, consisting of semi-transparent textured three-dimensional forms and flowing particles: the three-dimensional forms have

▼ **8.13 Char Davies, still from *Ephemere*. Virtual reality installation**
Char Davies' painterly approach makes virtual reality a truly immersive experience in semi-abstract landscapes of shifting colors and forms.

been designed to be neither wholly representational (i.e. recognizable) nor wholly abstract, but to hover in between, creating perceptual ambiguity. By animating these forms, and by enabling the participant not only to see them but to float through them as well, it is possible—because of their varying degrees of transparency—to create spatially ambiguous figure/ground relationships. ... In my work, ambiguity is the key to softening, lessening the distinctions between things.[3]

Laser Art, Holography, and Multi-Media

The merger of art and technology has also carried light mixtures into brilliances equal to that of the sun, in the form of lasers. Originally developed for scientific purposes, laser lights are also used to create kinetic art shows.

Prior to the invention of lasers in the 1960s and 1970s, it was impossible to work with **coherent light**—light in which waves are all of the same length, in unchanging relationship. Laser light approaches this ideal. It is generated by an oscillator, which creates pulses in a thin tube filled with some electrically excitable medium, such as helium and neon. Light projected into this cavity is reflected many times from one end of the tube to the other by a system of mirrors, creating standing waves of energy. The medium used determines the spectrally pure color that results from this process. A helium and neon mixture gives a coherent red light of 633 nanometers.

Laser sculptures can be created by setting up reflecting materials in the path of the thin laser beams or by projecting the beams through a smoky atmosphere so that they can be seen. For laser light shows, the beams may be moved so quickly that persistence of vision causes viewers to perceive lines of colored lights on a screen rather than moving dots of light. Their movements may be coordinated with music, either manually or electronically. Video/Laser III, constructed by music professor Lowell Cross and physics professor Carson Jeffries, has been used to create the symphony of light envisioned by Scriabin for performances of his *Prometheus* (**8.14**).

Advances in laser technology have also made **holograms** possible. These are two-dimensional images formed by wave fronts of light (or sounds or electrons) that reconstruct the visual impression of a three-dimensional object. To create this effect, a laser beam is split. Part of it—the object beam—is reflected onto an object from an angle; the other part—the reference beam—is projected onto photographic film. The light waves bouncing off the object from the object beam intersect this non-reflected light on the film, creating an optically three-dimensional interference pattern. When the resulting hologram is viewed from different directions, the part of the image seen changes, just as it would if one were moving around a three-dimensional object.

Although this technology is being employed in many nonaesthetic ways—such as difficult-to-forge images on credit cards—some artists have adopted the hologram as a

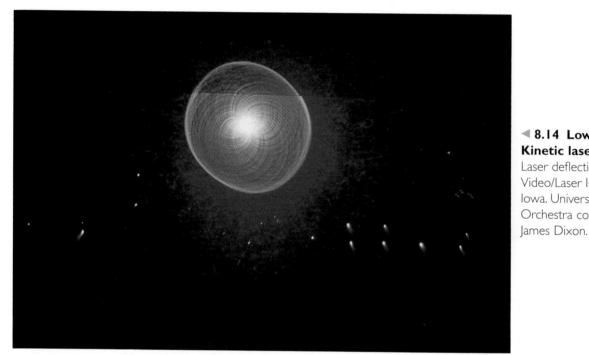

means of creating imagery with the glowing purity of pure spectral lights. Some would maintain that lasers and holograms reveal the essence of color: having no substance, they are an optical phenomenon resulting from the eye's response to the reflection and refraction of clear light.

Contemporary electronic possibilities have led to entirely new kinds of aesthetic experiences—multi-media installations in which computer-controlled sounds, laser light displays, holograms, video art, and virtual reality setups surround and perhaps interact with the viewer. These possibilities are requiring revamping of museum and gallery spaces so that participants can explore ephemeral worlds of pure light.

Video artist Nam June Paik took over the entire Guggenheim Museum in New York for a multi-media show (**8.15**) including a "waterfall" of zigzagging laser beams, a circle of video monitors on the ground floor beaming video clips upward, and flat screens around the spiralling ramps displaying rapidly-changing video montages. Spectators became part of the spectacle, as projected colors played across their own bodies, movements of which also interrupted and distorted the projected light patterns. Art critic David Joselit observed:

The excess Paik produces in his art, both its carnivalesque euphoria and its melancholic distraction, engages a bigger problem than does much recent media art: the problem of television and its role in our world. Paik pummels the television set, extracts its guts and spills them on the floor. But at the same time, he teases out of the monitor a hybrid video stream composed of diverse elements, synthesized and reordered. In other words, Paik sees television as both a set of institutions and a language that is probably the most widely "spoken" in the world.[4]

► **8.15 Nam June Paik, *Modulation in Sync: Jacob's Ladder*, 2000**
Laser light, waterfall, mirrors, steel armature. Bohen Foundation Collection, promised gift to the Solomon R. Guggenheim Museum, New York. Nam June Paik employed an array of light technologies to create this installation as part of a retrospective of his work that occupied the entire Guggenheim Museum.

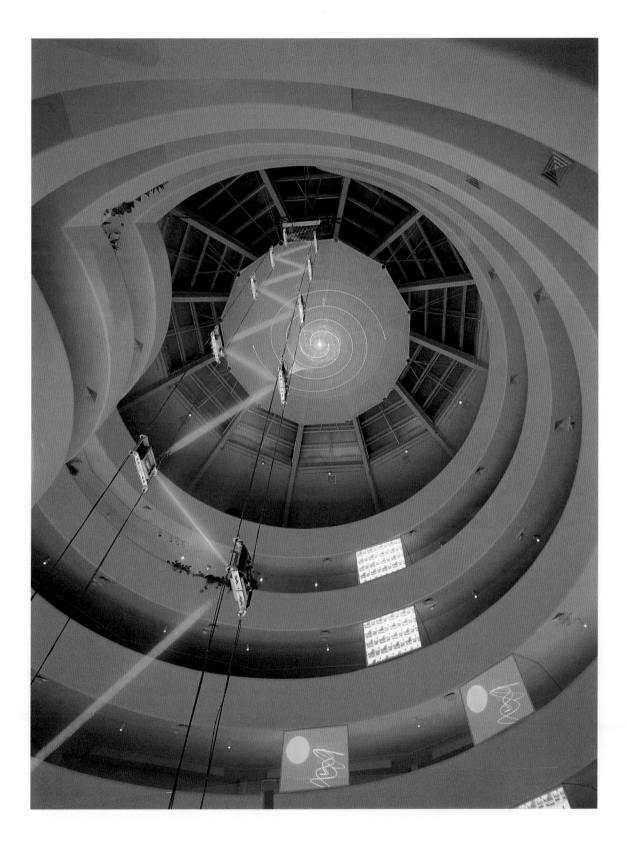

9
Color Combinations and Interactions

*Give me mud and I will make the skin of Venus out
of it, if you will allow me to surround it as I please.*

EUGÈNE DELACROIX

Thus far we have dealt with colors largely in isolation from each other. But in reality, we rarely see colors singly. Colors are surrounded by other colors, and they all interact in our perception. There are two ways of looking at this basic fact: We can seek pleasing or exciting combinations of color, if that is our aim, or we can study and exploit the ways that juxtapositions of specific colors affect our perception.

Color Schemes

The art of combining colors to create pleasing harmonies was approached as a science of sorts by many color theorists in the past. Certain color groupings were thought to be far more aesthetically appropriate than others, and attempts were made to list and prescribe the kinds of relationships that seemed to work best. Today, this approach is more typical of applied designers than fine artists; interior decorators are more likely to think in terms of color schemes than are painters. And in all the visual arts, effective color combining is more a matter of adding a pinch of this and a bit of that, to taste, than of following precise recipes. The underlying structures have been studied and understood, then used in intuitive and original ways.

The simplest color scheme is **monochromatic**. A single hue is used, often with variations in value and saturation to avoid monotony. Deborah Muirhead's *Nebula* (**9.1**) is painted almost entirely in varying values of bluish grays at

low saturation, with just subtle hints of grayed yellow-green. With all the colors available to the contemporary painter, why has she so limited her palette? Muirhead explains:

> My work is about my continued interest in the ideas of elegy, memory, and mystery. In my paintings I try to evoke these sensations by creating an atmosphere of light with color. The reductiveness of my palette is not a limitation. In fact, it requires the viewer to participate longer with the painting in order to have color revealed and shrouded images emerge. The neutral grays of various tonalities of repressed hues are built up with thin glazes of paint in an attempt to suggest this ephemeral presence.[1]

Whereas the flow of Muirhead's monochromatic color shifts occurs subtly, mysteriously, with no hard edges, sharp edges may often be distinguished between areas of very similar hues, as in Ad Reinhardt's monochromatic *Abstract Painting, Blue* (**9.2**). Although he has used only blues of low to medium value, the hue mixtures—a bit more green, black, or purple in the different blues—prevent the colors from flowing into each other visually. Each defines a distinct, hard-edged shape if viewed under proper lighting. Some of the shapes seem to come forward, as if they were

▶ **9.1 Deborah Muirhead,** *Nebula*, 1991
Oil on canvas, 6 × 5 ft (1.83 × 1.52 m). Private collection. Despite the abundance of colors available in the modern palette, monochromatic variations on a single hue can be very effective.

sitting or floating on top of the surrounding color. Here the intentionally limited monochromatic color scheme allows us to give our full attention to these spatial effects and to the relationships of shape across the picture plane.

Variations on a single monochromatic theme obviously do not have to be boring. Often designers break up the inherent unity of a monochromatic scheme by using neutral colors —white, black, grays, and browns—as well as variations on the chromatic hue.

The next closest harmony is an **analogous** color scheme, which uses several hues lying next to each other on a color wheel. This is an imprecise concept, for color wheels can have as few as six colors or as many as hundreds or thousands of variations, depending on the size of the steps between hues. On a six-hue wheel of pigment primaries and secondaries, blue and green lie next to each other. Based on such a wheel, the azure-painted gravel paths and green gardens of Daan van Golden's *Aqua Azul* (**9.3**) would be said to constitute an analogous color scheme. However, in this context they appear to be highly contrasting. The harmony would be closer if there were more intermediate hues, such as a range of blue-greens of varied values and saturations (as indicated on the 12-hue color circle in Figure **9.4** and expanded in the color map in Figure **9.5**). The colors would also seem more closely related if there were less value contrast between the high-value blue (a blue 7 on the color map) and the dark green borders (value 4 green), and if the sole blue of the gravel paths were not so highly saturated. It is clearly apparent that the artist was not intent solely on creating a quiet, calming color combination, although the color choice is

◀ **9.2 Ad Reinhardt, *Abstract Painting, Blue*, 1952**
Oil and acrylic on canvas, 75 × 28 ins (190.5 × 71.1 cm).
Carnegie Museum of Art, Pittsburgh, Pennsylvania.
Even in a monochromatic work, slight variations in hue and value allow the viewer to see differences and therefore edges between colored areas.

▶ **9.3 Daan van Golden, *Aqua Azul*, 1987**
Painted gravel on the paths of the Botanical Gardens, Amsterdam.
Blue and green, an analogous color combination often used today, was deplored by earlier color theorists as offensive and vulgar.

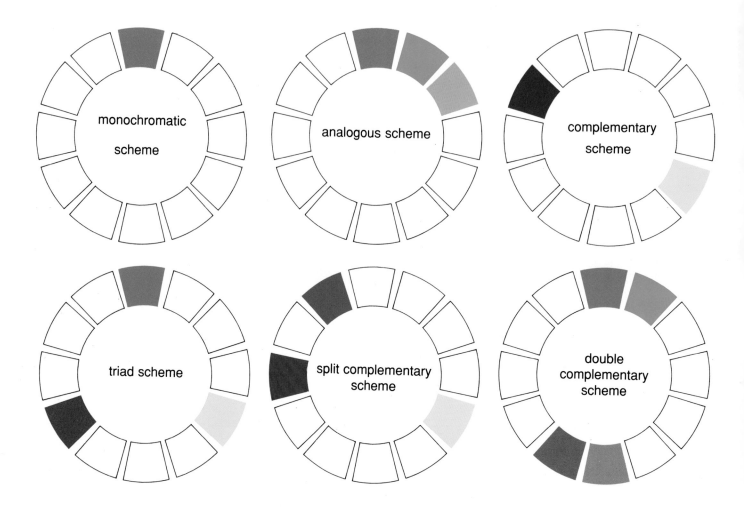

monochromatic scheme

analogous scheme

complementary scheme

triad scheme

split complementary scheme

double complementary scheme

▲ **9.4 Standard color schemes**

▶ **9.5** Broad use of analogous colors might encompass three or four adjacent hues with many variants in value.

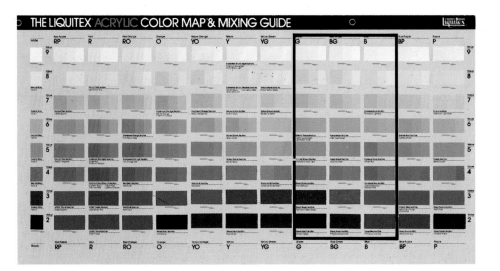

▲ **9.6 Vincent van Gogh, *Peach Blossom in the Crau*, 1889**
Oil on canvas, 25 ³/₄ × 32 ins (65.5 × 81.5 cm).
Courtauld Gallery, London (Courtauld gift 1932).

actually a traditional one. In the seventeenth century, the paths of this garden were, in fact, laid in blue tiles.

A high degree of contrast is expected in the third kind of color scheme: **complementary**, in which the two principal colors lie opposite each other on a color wheel. In a sense, complementary hues are related like the two ends of a balancing device—they hold each other in equilibrium. If we think in terms of warm and cool colors, a complementary color scheme may provide a psychologically satisfying balance between these two extremes. Goethe even felt that the eye hungers to see the complement. He wrote of "the demand for completeness, which is inherent in the organ,"[2] supplying after-images of the complement if it is not actually present. While providing psychological completeness, complementary colors used together also intensify each other's appearance, so the result tends to be stimulating, as in Van Gogh's *Peach Blossom in the Crau* (**9.6**),

in which highly saturated purple and yellow are repeatedly juxtaposed.

Toning down the saturation of complementary hues—and raising or lowering their value beyond the level of maximum saturation—lessens the visual contrast between

▼ 9.7 Charles Emile Heil, *Lotus,* c. 1912
Watercolor on paper, 16 × 22 ins (40.6 × 55.8 cm).
Museum of Fine Arts, Boston.
An almost-black green provides a complementary foil to the high red of the lotus blossom, with toned-down complementary contrasts echoed throughout the painting.

them. Nevertheless, even at reduced contrast, complementaries may still subtly intensify each other's liveliness. Charles Emile Heil's *Lotus* (**9.7**) relies primarily on the contrast between green and red, both of which are painted at high value or relatively low saturation. This color scheme has been further balanced and varied by a secondary interplay of two other hues that are complementary to each other: yellow and blue-purple.

When two hues adjacent to each other on a color wheel are used with their respective complements, such as blue-green and blue with red-orange and orange, the scheme is called **double complementary**. Another scheme derived from the complementary pattern is **split complementary**,

in which the hues to either side of the complements are employed, thus softening the contrast slightly. As used by Rufino Tamayo in his home outside Mexico City (**9.8**), a split complementary scheme offers a surprising juxtaposition of yellow, red-violets, and blue-violets. Tamayo enjoys the unexpected and had the ceilings of his home painted in chromatic hues—blue, mauve, yellow—while keeping the walls white. As he notes with amusement: "Usually it's the other way around." Although Tamayo strives to touch the universal in the human spirit, he does so by way of ancient pre-Hispanic and popular Mexican aesthetic themes, reflected in his color choices:

> I've used the colors of both my palettes here: those the village people use in their daily lives because they're cheap, like the blues and whites and ochers, and those bright colors they buy especially for fiestas.[3]

A broader range of contrasts is seen in the **triadic color scheme**, which draws on three colors equidistant from each other on a color wheel. In his *Builders* (**9.9**), Jacob Lawrence has used the triad of pigment primaries—red, blue, and yellow—interwoven with brown, black, and grays. These "neutral" colors are visually interlocked with the chromatic hues, like flat shapes in a jigsaw puzzle, so that they are not mere background foils for the other colors. If anything, it is the black head of the hammer that most immediately draws our attention in this busy scene. Although the colors have been painted evenly, rather than with the value gradations associated with three-dimensional form, careful use of lines of one color extending into another— such as the blues enhancing the outline of the foremost worker's bent leg and the contours of his head—help us to recognize a slight volume in these figures. The interplay of dark blue against light blue, dark red against light red, and dark yellow against light yellow resembles the complex point and counterpoint rhythm of a vigorous jazz composition, used here to commemorate the workers whose various manual tasks combine to construct the buildings in which we live and work.

Another approach to harmonizing colors is to use colors together that vary in hue independently of any of the above schemes but that are nonetheless similar in value. Bruno Paul's poster (**9.10**) juxtaposes a low saturation blue-green, red, and yellow of nearly the same value—approximately value 6 on the Munsell system—making them appear to

▲ **9.8 Rufino Tamayo, Part of living room with pre-Columbian pieces, near Mexico City**
Split complementary color schemes may offer unexpected color partnerships.

belong together. To bring striking contrast into this muted scheme he adds a slightly darker brown (a yellow 5) and fully dark black accents on the storks and the typography. For variations on this basic equal-value theme, one could include colors of slightly higher or lower value. Rigid symmetry would require balancing additions of higher value with some of lower value, but few works of art are so rigidly patterned.

Rather than using hues that balance each other at intervals around a color wheel, or values that line up horizontally across a color map such as the one in Figure 9.5, artists may choose to balance lights against darks. J.M.W. Turner (1775–1851) was an artist who worked primarily in this way, analyzing color combinations in terms of the harmony of value contrasts or, as he put it, "the compelling power of colors used as shade to light, that wrought the whole to harmony."[4] A useful guideline for artists is that it is impossible to get a good light unless it is offset against a dark, and

◀ 9.9 Jacob Lawrence, *Builders*, 1980
Gouache on paper, 34 1/4 × 25 3/8 ins (86.9 × 64.5 cm).
SAFECO Insurance Company, Seattle.
Here values of red, yellow, and blue are used as a triad; any other colors equidistant from each other on a color wheel form a triad, but its character will differ depending on the hues chosen.

▲ 9.10 Bruno Paul, *Exhibition in the Old National Museum, Munich: Arts and Crafts*, 1901
Poster. State Museum, Munich.
Colors of equal value may seem to belong together; variations in value within the same composition avoid monotony.

vice versa. If the artist were working so formally as to strive for absolute balance of values, there would still be no need for equal amounts of darks and lights, for lights expand and appear to take up more room than darks. In Turner's *Light and Colour* (**9.11**), wherever the artist wants a light to appear more dramatically luminous, he juxtaposes it to a dark area. The whole painting is like a swirling tunnel, with light appearing through the darkness, an abstract representation of the welcome appearance of light as a storm clears.

Another means of creating harmony among colors was suggested by Chevreul. He described it as:

> the harmony of a dominant coloured light, produced by the simultaneous view of various colours assorted according to the law of contrast, but one of them pre-dominating, as would result from the view of these colours through a slightly-coloured glass.[5]

In accordance with this, Mauro & Mauro's promotional piece for Champion International (**9.12**) uses varied hues of very low saturation and high value, all blended by having a single dominant color in common. The die-cut papers all appear to be seen through a film of the same cream color that surrounds them.

Theorist Rudolf Arnheim looked for dynamic relationships among pigment hues: "similarities and differences, mutual completion, concord and discord." From his efforts, he came to the following conclusions: 1) The three primaries—red, blue, and yellow—are pure hues and therefore not related to each other except that they add up to a complementary triad. 2) The three secondaries—purple, orange, and green—each consist of equal parts of two of the primaries and therefore act as a "bridge" between them. 3) The six tertiaries contain unequal parts of two primaries (such as a red-purple, which has more red than blue in it—as can easily be seen in the color wheel in Figure 2.9). "Being thus unbalanced," he stated, "the tertiaries are highly dynamic, prone to interact with other colors and, for this reason, particularly inviting for pictorial composition."[6] However, artists work with an enormous palette of potential colors rather than the twelve spectral hues of the color wheel, and can push them this way and that depending on how they choose to use them.

Black and white are typically considered "neutral" and therefore are not often mentioned in theories of harmonious color relationships. However, some artists use them

◀ **9.12 Mauro & Mauro, Design for Champion International, Stamford, Connecticut**
Promotional piece with layered die-cutting. One of many possible color harmonies suggested by Chevreul was the impression of a "dominant coloured light" influencing all hues in a work.

as prominent hues in their own right. Daniel Buren used black and white as strong contrasting colors in his installation *Topical Arguments* (**9.13**) in an old warehouse that has been turned into a museum for contemporary art. He multiplied the effects of the relationships of the black and white stripes to the yellow-lit walls, and the shapes of arches within arches, by reflecting them from an enormous slanting mirror, some 14,000 square feet in extent.

Naive, folk, or "outsider" artists often use color intuitively without reference to any established system of color harmony. Bessie Harvey's *Tribal Spirits* (**9.14**) employs extremely raw colors, in no seeming order, but juxtaposes

hues and combines them with black in such a way that they have a more spiritual quality than we would usually associate with bright reds, blues, golds, and yellows. The spirits she experiences in the wood come to life with a glowing energy from the way she uses the paint, as if dynamic light patterns were emanating from their hair. The spots of white draw everything together and further add to the sensation of pulsating light. She is using color choices very confidently in her own personal way.

Color Interactions

Whether or not colors are combined according to established color schemes, one should always be aware of the optical effects that adjacent colors have on each other. Particularly in two-dimensional work, every color used will be affected by what is next to it. Colors are never seen in isolation.

Consider the perceptive observations of Henri Matisse, who often juxtaposed areas of flat-painted colors, as in *Red Interior, Still-life on a Blue Table* (**9.15**):

◀ **9.11 J. M. W. Turner, *Light and Colour (Goethe's Theory: The Morning After the Deluge, Moses Writing the Book of Genesis)*, exhibited 1843**
Oil on canvas, octagonal, 30½ ins (77.4 cm).
Tate Gallery, London.
Turner was fascinated by the juxtaposition of light and shade, the principle upon which many of his compositions are based.

◄ 9.13 Daniel Buren,
Topical Arguments
(Arguments Topiques),
May 1991
Installation, black and
white stripes 3 ½ ins
(9 cm) wide, mirror
14,000 square feet
(1300 sq. m).
Contemporary Art
Museum (CPAC),
Bordeaux, France.
Whereas white and black
are often given a
supporting or background
role in artworks, here they
are treated as significant
colors in themselves.

If upon a white canvas I jot down some sensations of blue, of green, of red—every new brush stroke diminishes the importance of the preceding ones. Suppose I set out to paint an interior: I have before me a cupboard; it gives me a sensation of bright red—and I put down a red which satisfies me; immediately a relation is established between this red and the white of the canvas. If I put a green near the red, if I paint in a yellow floor, there must still be between this green, this yellow, and the white of the canvas a relation that will be satisfactory to me. But these tones mutually weaken one another. It is necessary, therefore, that the various elements that I use be so balanced that they do not destroy one another. … My choice of colors does not rest on any scientific theory; it is based on observation, on feeling, on the very nature of each experience.[7]

Beyond this world of perceptible color interactions lie mysterious optical color phenomena that transcend the physi-

cal properties of a work of art. Optical color interactions are most apparent to those who know to look for them. Other people may not "see" them because there is no model of reality confirming their existence; they allow their brains to override their visual receptors. Some interactions happen very quickly; others take some time to develop.

One of the optical phenomena noticed by Goethe and Chevreul is what Chevreul called **successive contrast**. That is, as we noted in Chapter 3, if one stares at a color for some time and then looks away, one "sees" its complement as a colored glow. Back in Figure 3.4, after looking at the red turtle, you probably saw a green turtle when you shifted your gaze to the white space next to it. Goethe explained this phenomenon as an innate striving for completeness:

When the eye sees a colour it is immediately excited, and it is its nature, spontaneously and of necessity, at once to produce

▲ **9.14 Bessie Harvey, *Tribal Spirits*, 1988**
Mixed media, 45 × 26 × 20 ins (114.3 × 66 × 50.8 cm).
Dallas Museum of Art, Texas.
Spots of white give a unifying framework to this seemingly
uninhibited use of color.

▲ **9.15 Henri Matisse, *Red Interior, Still-life on a Blue Table*, 1947**
Oil on canvas, 45¼ × 35 ins (115 × 89 cm).
Kunstsammlung Nordrhein-Westfalen, Düsseldorf, Germany.
To prevent adjacent colors from diminishing each other's
perceived brilliance, Matisse has in places separated them by
borders of black, white, or gold.

another, which with the original colour comprehends the
whole chromatic scale. A single colour excites, by a specific
sensation, the tendency to universality.

To experience this completeness, to satisfy itself, the eye
seeks for a colourless space next to every hue in order to
produce the complemental hue upon it.[8]

If, however, there is no white space next to an intense color
sensation, the color we perceive when we shift our gaze is
a combination of the complement of the original and the
color of the space itself. Jasper Johns worked intentionally
with this principle to create *Flags* (**9.16**). If you stare at the
dot in the middle of the upper flag for 60 seconds and then
shift your gaze to the dot in the center of the rectangle

below, you may perceive the red and white stripes and
white stars on blue background of the United States flag.
This is a complex optical mixture and takes a while to
develop.

Johns' *Flags* series is one of the few artistic efforts that
purposefully use the phenomenon of successive contrast.
However, the effect does occur when we look for a long
time at any color. When working with a large area of red,

◀ **9.16 Jasper Johns, *Flags*, 1965**
Oil on canvas, 6 × 4 ft (1.82 × 1.22 m). Collection of the artist. Stare at the dot in the upper flag for perhaps a minute and then quickly transfer your gaze to the dot below to see the effect of successive contrast.

▲ **9.17** Look at the border between red and blue for a while and note the optical effects. Compare them with those occurring when the two hues are separated by broadening bands of white and black.

for example, it may appear to shift toward green or gray; if one does not rest one's eyes by glancing away, one will lose the ability to see the red as another person just looking at it would. Visual fatigue can change our perception of any color.

A phenomenon that is used consciously in some art-works is what Chevreul called **simultaneous contrast**. In this case, complementary colors—or any strongly contrasting colors—that are adjacent will intensify each other along the edge where they meet. If you stare at the center of Figure **9.17** for some time, you will begin to see a brighter glow of each color just inside the edge where they meet. Compare this effect with the interactions of these colors when separated by widening bands of black (to the left) and white (to the right). Do the colors intensify each other as much when separated by white as by black? How does widening the intermediate line alter the effect? At what point?

Simultaneous contrast, first commented upon by Leonardo (see Chapter 6), has often been used by painters and graphic designers. Just as to get a good light, you need to place it next to a dark, it is a similar rule of thumb that to get an intense hue, it helps to place it next to its complementary. In her *Ikon* (**9.18**) Mary Franks has surrounded Mary's traditional blue robe with a red-orange field, bringing out by simultaneous contrast a glowing quality in the yellow area next to the robe. It is not just the depiction of a halo; it actually has a luminous appearance. Josef Albers observed that strongly contrasting hues of high saturation and equal value—even if not precisely complementary—will vibrate optically along the edge where they meet, creating a sensation of transparent, glowing light that enforces the boundary line and the shapes it divides.

Albers also systematically studied the possibilities of making one color look like two different colors, pushing it in opposite directions according to the background color it is seen against. This is an optical illusion of particular

▲ **9.18 Mary Franks, *Ikon*. Etching**
At the edges where two lines meet, what happens? Do all the edges of the central figure work in the same way?

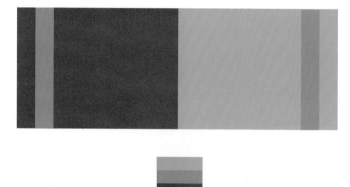

▲ **9.19** A middle mixture will look like two different colors when presented against its parent colors.

▲ **9.20** Two physically different colors can be made to appear nearly identical by careful choice of colored grounds.

usefulness in applications such as graphic designs with limited palettes. In Figure **9.19**, the same blue-green has been placed on green and blue. But because the eye automatically compares these strips with what surrounds them, it sees the strip on the right as bluish in comparison with the green and on the left, greenish in comparison with the blue. In a sense, each ground subtracts its own energy from what lies upon it. This effect is most readily created with a third color that is a **middle mixture** between the other two; the three bars below demonstrate that the color used

as the strip is actually a blue-green, a mixture of blue and green. Proportions and distances are also critical; if the two strips were very close, they could more readily be compared with each other than with the grounds and one would see that they were the same.

Less useful but equally fascinating is the ability to deceive the eye into thinking it is seeing fewer colors than have actually been applied. Using the same principle that a ground will subtract its hue from anything applied to it, a blue-purple has been placed on a blue and a red-purple on a red in Figure **9.20**, creating the illusion that the small squares are nearly identical. When compared with each other below, removed from the grounds, they are readily seen as two different hues.

Notice something else in Figure 9.20: The small square almost seems to merge with its ground on the right, whereas it pops out boldly on the left. The greater the difference between colors—in hue, saturation, and/or value—the greater the apparent spatial distance between them, especially if the edges between them are hard rather than soft. An optical glow caused by the eye's reaction to the contrast in hues begins to surround the small square on the left, further lifting it away from the red ground.

Albers devised a single framework for working with these interactions: a square within a square within a square, set off-center so that the relative proportions of the colored areas are varying rather than uniform. This great *Homage to the Square* series opened up so many possibilities that experimenting with the effects of precise color combinations occupied Albers for almost 30 years. Albers stated:

> In my work
> I am content to compete
> with myself
> and to search with simple palette
> and with simple color
> for manifold instrumentation
> So I dare further variants.[9]

Albers found that in the case of a true middle mixture in hue and value, such as the rust color between the red and the olive in *Equivocal* (**9.21**), the parent colors would seem to leap across to reappear along the far edges of the middle color. Next to the red on the right-hand side, there is an olive-green glow, created by the subtraction of red from the rust. Part-way across the rust band the effect begins to

reverse, creating a red glow along the edge that abuts the rust, which is darkest where it can be compared with the white ground. These optical variations create a fluted effect, as though the bands were rounded in or out in space.

Another type of interactive use of color is found in **transparency effects**, in which one color appears like a film lying over another. To make this appear visually sound, one must mix pigments that convincingly give the appearance of visual mixtures of the colors in question. Moreover, the one that is to appear on top must dominate the blend; otherwise it will not make spatial sense. Dorazio's *Construction Eurasia* (**9.22**) presents a complex series of transparencies with, in many places, up to three ribbons overlapping each other on top of a white ground. If the colors are modified accurately, each ribbon's spatial relationship to the others should be discernible.

Often artists play with the suggestion of transparency effects without making them fully logical. Michael James' quilt, *Rhythm/Color* (**9.23**), provokes us to try to follow the

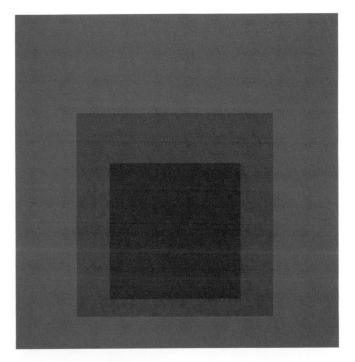

▲ 9.21 Josef Albers, *Equivocal*
From *Homage to the Square: Ten works by Josef Albers.* Silkscreened print, 11 × 11 ins (27.9 × 27.9 cm). Collection of Arthur Hoener.

◄ 9.22 Dorazio, *Construction Eurasia,* 1964
Oil on canvas, 5 ft 6 ins × 8 ft (1.7 × 2.4 m). Private collection.
Follow the illusionary overlappings of any of these ribbons to discern the nuances of multiple transparency effects.

▲ **9.23 Michael James, *Rhythm/Color: Morris Men*, 1986**
Machine-pieced cotton and silk, machine quilted, 8 ft 4 ins × 8 ft 4 ins (2.54 × 2.54 m).
Within a general framework of transparency effects, Michael James contradicts the effects of see-through mixtures in many of the color "intersections" in this quilt.

◀ **9.24 The Bezold Effect**
Changing a single color in this composition brings out certain shapes and hides other ones. The artist has also rotated the second version 180 degrees, further disguising the underlying similarity between the two.

▲ **9.25 Edouard Vuillard, *Breakfast*, 1892**
Oil on canvas, 12 × 10½ ins (30.4 × 26.6 cm).
Paul Rosenberg and Co., New York.
Colors of equal value tend to merge with each other optically along their edges, so that the boundary between them vanishes.

effects of overlaid colors, which in this case are not at all transparent in actuality. Rather, they are pieces of opaque fabric pieced together side by side. James has created the fascinating impression of striped bands crossing each other, causing transparent color mixtures in some areas and overlapping non-mixtures in others, with surprises at every turn.

Wilhelm von Bezold, a nineteenth-century rug designer, discovered another optical interaction, which now carries his name: the **Bezold Effect**. He found that he could change the entire appearance of his rugs by changing or adding only one color. Usually this is done by substituting a different color for the one that occupies the most area. In Figure **9.24** the change in the dominant hue from red to

blue dramatically alters the whole. Not only do the colors change; different shapes are also brought out in one version and hidden in the other. It is also possible in some cases to alter the whole by changing a color that does not occupy the largest area, especially if it is used in a striking way.

If colors of equal value or very similar hue are juxtaposed, the boundaries between them will vanish. It will be difficult to determine where one stops and the other begins. The effect of **vanishing boundaries** is fairly easy to produce with colors of either very low or very high value. In painting the woman's blouse in *Breakfast* (**9.25**), Edouard Vuillard has juxtaposed reds and blues of such high value that one merges quietly into the other, even though at medium value and high saturation these are highly contrasting hues. Elsewhere, such as the black projection across the woman's lap, the rungs of her chair, and the area of the floor beneath, colors of similar hue but slightly differing value also tend to merge where they are juxtaposed. With highly saturated middle values, colors must be really close in hue to lose the edge between them.

The color theorist Ogden Rood devoted a whole chapter of his *Modern Chromatics* to the subject of "The Small Interval and Gradation," stressing the importance of vanishing boundaries in our perceptions of the world around us:

> One of the most important characteristics of color in nature is the endless, almost infinite gradations which always accompany it. It is impossible to escape from the delicate changes which the color of all natural objects undergoes, owing to the way the light strikes them.... Even if the surface employed be white and flat, still some portions of it are sure to be more highly illuminated than others, and hence to appear a little more yellowish or grayish; and, besides this source of change, it is receiving colored light from all colored objects near it, and reflecting it variously from its different portions. If a painter represents a sheet of paper in a picture by a uniform white or gray patch, it will seem quite wrong, and cannot be made to look right till it is covered by delicate gradations of light and shade and color.[10]

The last three kinds of optical color interactions concern what happens in the spaces between colors. One of these is the phenomenon of **phantom colors**. In some cases, colors spread beyond their physical boundaries to tint

◄ **9.26** Phantom colors are those that tint surrounding neutral colors with their own hue. This effect is most obvious in the "yellow band" of this computer drawing, but it also occurs to a certain extent in the other bands.

larger neutral areas in their own hue. In Figure **9.26**, the ground is a uniform white, but the thin yellow lines alongside the green- and red-dotted lines in the center spread to cast their influence over the white in the central panel. Where red and green lines cross the verticals in the next panel to the left, the effect changes to ephemeral red and green flashes of color on the white, or an overall brown sensation. And to the far left, the white may have a blue cast. These phantom colors appear most readily when the lines have a slightly jagged edge, rather than a perfectly straight one, perhaps setting up an excited pattern in the eye. What do you see on the white to the far right, where only blue lines have been applied?

As we have discussed, the persistence of our vision allows us to perceive mosaics of tiny dots in a few primaries on a television screen, or in four-color process printing, as areas of optically mixed colors. The nineteenth-century experimentation with application of colors, which can be seen in the work of Delacroix (10.13) and later evolved into Impressionism and Postimpressionism, had as one of its

objectives the intensification of painted colors. The Postimpressionists Paul Signac and Georges Seurat tried to achieve this goal by using a palette of pure spectral colors (Seurat used 11 hues spread evenly around the color wheel, plus white for tinting) and applying them in small unblended bits, in the attempt to coax the eye to blend them optically. A detail of the technique is shown in Figure **9.27B**. In theory, it would avoid the darkening of physical subtractive mixing and approach the additive effect of light mixing, with optical mixtures of high saturation. This technique was known as **Divisionism**, or, when the white ground was allowed to show through and assist the blending, **Pointillism**. Signac claimed these results:

> By the elimination of all muddy mixtures, by the exclusive use of the optical mixture of pure colors, by a methodical divisionism and a strict observation of the scientific theory of colors, the neoimpressionist insures a maximum of luminosity, of color intensity, and of harmony—a result that has never yet been obtained.[11]

▶ **9.27A Georges Seurat,**
Les Poseuses, 1888
Oil on canvas, 6 ft 7 ins ×
8 ft ¾ in (2 × 2.45 m).
Private collection, Switzerland.
In some areas, Seurat
juxtaposed dots of pure hues,
mixing them optically rather
than blending them on the
palette.

▼ **9.27B** In this detail of
9.27A, Les Poseuses, do the
dots create optical mixtures
or has Seurat mixed the
perceived colors on his
palette?

Divisionist painters actually attempted two different kinds of effects. By juxtaposing dots of analogous colors, they hoped to create luminous admixtures in spectral hues; by juxtaposing complementaries, they sought luminous gray mixtures. In Seurat's *Les Poseuses* (**9.27A**), red and blue dots across the women's contours generate grayish shadows, while in the grass of Seurat's famous painting reproduced on the left of the painting—*A Sunday Afternoon on the Island of La Grande Jatte*—blues, greens, and yellows are used together to stimulate the eye to mix bright greens. In fact, these experiments were not entirely successful. Chevreul had warned that interweaving of the fine threads of complementary colors would create dull optical mixtures, unlike the brilliant additive effect of mixing colored lights.

Such efforts continue into the present. John Roy was fascinated by the potential interface between science and art. He used a computer to convert photographs into triangular grids of dots, which he then enlarged to one-quarter-inch diameter, and colored in the red, blue, and green phos-

◀ **9.28 John Roy, *Untitled*, 1999**
Computer-plotted pointillist painting.
Using a triangular grid filled with ¼-inch (6 mm) red, green, and blue dots, John Roy created what he called "purely perceptual colors." He explains, "In this kind of painting, illusionary colors [are] produced by a kind of color mixture that occurs across larger regions of the painting space, which is perceptually disengaged from the physicality of the pigments used to produce them."[12]

phors of additive light mixers, such as in computer monitors. These dots are so large that they are clearly visible in the original. But once viewers back away far enough—or the image is sufficiently reduced in size—they are able to perceive the image in an approximation of its original colors, mixed optically by the eye from the additive primaries. The yellow you "see" in Roy's autumn landscape shown in Figure **9.28**, for instance, does not actually exist in the painting—it is mixed in your brain as a purely perceptual color.

Extraordinarily successful optical mixtures were created by a twentieth-century artist, Arthur Hoener. Distressed that physicists could perform magic with color, which he felt was really the province of the artist, Hoener experimented with precise colors and proportions until he was able to create convincing optical mixtures, such as the reds, blue, and yellow we see in his *Synergistic Color Painting* (**9.29**). Figure **9.30** reveals his technique at close-hand, showing the mixing hues he was using, all of them high value and none of them a traditional pigment primary. Hoener called his approach **synergistic color mixing** because each color seen is the result of the cooperative effect of two colors. He explained:

> The thing that is important in order to get the synergistic color to work is to understand the relationship of color to its ground color. A dark color on a white ground will look almost black; it's hard to see the color quality of it. With a medium-value color on a white background you can see the hue of that color and you might even get a simultaneous contrast effect, which would be the opposite of that color developing in between the lines. As the color becomes lighter, the eye does not overreact to what it's looking at and allows you to see the energy of the color.

When physicists talk about color, they always talk about it in terms of energy. Most of the time when artists work with color, they deal with the overreaction of the eye to the color: an after-image, vibrating colors, contrasting colors, enhancement of green by putting a red next to it, and so forth. Synergistic color is really taking advantage of the fact that the energy of the color is available to be mixed with other colors. Using that principle of how color relates to its background, it is possible to mix almost any color. The color sensation is then highly satisfying, because you, the viewer, are supplying it. But for the artist to create this effect, both the precise hues and the proportions in relationship to the ground are very, very touchy.[13]

Hoener said he had to number the jars of paint he used because once he began laying them down together, there was no way he could recognize them. In fact, the mixtures work so well that he intentionally threw them off just slightly so that viewers can see the lines of the mixing hues themselves. Otherwise people simply think they are seeing yellow, failing to recognize that the yellow is a magic combination of thalo green and orange-pink, for instance. Like all color interaction effects, this optical mixing works best if we relax the defensive grid that makes us label things rigidly

▶ **9.29 Arthur Hoener, *Synergistic Color Painting*, 1978**
Acrylic on canvas, 32 × 32 ins (81 × 81 cm).
Estate of the artist.
In Hoener's synergistic color mixtures, a white, gray, or other pale ground is the stage for optical mixtures which become additively lighter than the colors used to mix them.

▲ **9.30 Arthur Hoener, Color diagram of synergistic color mixing**

according to what we "know" we are seeing, and prevents us from recognizing the extraordinarily varied realities of color.

When this defensive grid is truly relaxed, it is even possible to see chromatic hues in a black-and-white work. Bridget Riley coaxes the eye to see vivid hues by using linear motion, precise spacing, and the contrast between black and white in her *Crest* (10.23). Arthur Hoener achieves a subtler red sensation in the thin lines of *Duo* (**9.31**). Let your eyes unfocus while looking at it from different distances. Goethe observed long ago that looking at the edge between a light and a dark area with a magnifying glass, thus pulling it out of focus, will cause one to see a spectrum of hues. The lens of the glass is curved just like the human eye. It may be that when the eye is thrown slightly out of focus—in *Duo* by being unable to focus on the thin lines while the fatter black dots are demanding attention, in *Crest* by being cast off by the repeated wavy lines—this same spectral effect occurs. Since we will perceive more of the world around us if we are carefully attentive, appreciating optical colors requires that we first abandon our attempts to control what we see and then carefully observe the optical realities of our perceptions.

▶ **9.31 Arthur Hoener, *Duo*, 1980**
Ink on paper, 30 × 40 ins (76.2 × 101.6 cm).
What hue do you perceive in the thin lines? Do you see any other chromatic colors?

10

Color in Fine Art

*We treated color like sticks of dynamite, exploding
them to produce light.*

MAURICE VLAMINCK *Fauvist painter*

Over time and across cultures there have been
many different ways of using color in the fine
arts. To a certain extent, these have been gov-
erned by technology. The earliest peoples had a palette
limited to the pigments that were common in local earth,
chiefly the red and yellow ochers of iron and the black of
manganese. The most primitive of cave paintings are mono-
chromatic drawings, but some—such as those in the caves
at Lascaux, France, dated around 15,000 to 10,000 B.C.—
incorporated washes to suggest three-dimensional form
within the drawn outlines (7.1). These were polychromatic,
involving more than one color for subtle shading.

Non-Western Traditions

Surviving small-scale, technologically simple societies tend
to use natural dyes, paints, and found objects for color in
the ritual pieces we now regard as works of art. Within the
limitations of what is at hand, they use color with great
sophistication. Using only green, red, white, and black pig-
ments set against the natural colors of wood, the Northwest
American Coast headdress maker has created a bright,
lively composition through complementary contrast (**10.1**).

As synthetic, chemically-based colors become available
to developing cultures, they readily adopt them for their
brilliance. The introduction of glass beads to the Plains
Indians of the United States supplanted earlier work in dyed
porcupine quills with such masterpieces as Mrs. Minnie Sky

Arrow's seven-pound fully beaded buckskin piano recital
dress (**10.2**). In rural India, some women now use brilliantly
pigmented manufactured powders for their *rangoli*—
designs painted on the earth or floor to welcome guests.
The difference in saturation is evident in the *rangoli* pattern
being created in Figure **10.3**. Some areas of the designs are

▲ **10.1 Raven and ermine headdress from the
Oowekeeno at River Inlet**
Cedar wood and bark, eagle feather, wool, steel, and iron,
length 32¼ ins (82 cm). Courtesy of the U'mista Cultural
Society, Alert Bay, British Columbia, Canada.
Complementary colors add to the fresh appeal of this
traditional mask.

◀ **10.2 Mrs. Minnie Sky Arrow, Recital gown, 1890**
Beaded buckskin dress. Smithsonian Institution, Washington, D.C.
Among the traditional Plains Indians, the introduction of glass beads allowed intense color harmonies, worked out in precise geometric designs.

◀ **10.3 *Rangoli*, India**
The few areas of traditional natural pigments in this auspicious design are of lower saturation than its areas of brilliant industrially manufactured pigment powders.

created with powder made by rubbing *geru*, a soft stone that yields a red-brown dust, whereas the rest of the pattern is created with bright modern manufactured pigmented powders. Yellow was traditionally created with turmeric powder, which like the *geru* is considerably less saturated than the synthetic powders of the same hues. Saturated or not, the hues celebrate auspicious aspects of life, such as white for purity, red for fertility, yellow for good fortune, and green for the abundance of plant life.

Being limited to what they could find or trade for in colored materials has not restricted color awareness in non-industrial societies. The vocabulary of the Maoris in New Zealand, for example, includes 40 color words used to distinguish between different kinds of clouds and over a hundred words for what Westerners call "red." In the evolution of languages, the first color terms seem to have referred to a distinction between light and dark; names of hues came later. In some languages, when talking about the surface appearance of an object, people use words that include references to texture and value; hue does not belong to a separate category of observations.

Often color use in works of art is determined by philosophical principles. Colors often carry symbolic meanings, as we have seen. Moreover, many peoples have strong ideas about which colors "should" be used. Chan (Zen) Buddhist and Daoist influences in China led some painters to shun bright colors in favor of the subtle inks used in calligraphy, considered the highest of the arts. Li Cheng's *A Solitary Temple Amid Clearing Peaks* (**10.4**), where washes of very unsaturated color are used to create forms, reveals a highly restrained interpolation of local colors.

The principles of classical Japanese painting place restrictions on adjacent colors. Using a color wheel of five primaries (yellow, blue, black, white, and red), the masters of this tradition say that no color should be juxtaposed with either of its parents, for to do so would detract from both colors. This observation is in alignment with principles of color interaction discussed in Chapter 9. The Persian miniature tradition in painting depicts an idealized world without shadows. This tradition was carried to India and adapted to devotional painting of beloved Hindu deities, as beautifully

◀ **10.4 Li Cheng, *A Solitary Temple Amid Clearing Peaks*, Northern Song dynasty (c. A.D. 950)**
Ink and slight color on silk hanging scroll, 44 × 22 ins (11.8 × 55.9 cm). The Nelson-Atkins Museum of Art, Kansas City, Missouri. Purchase: Nelson Trust. 47–71. An austere aesthetic led Chinese landscape painters to avoid bright hues, even though they were available.

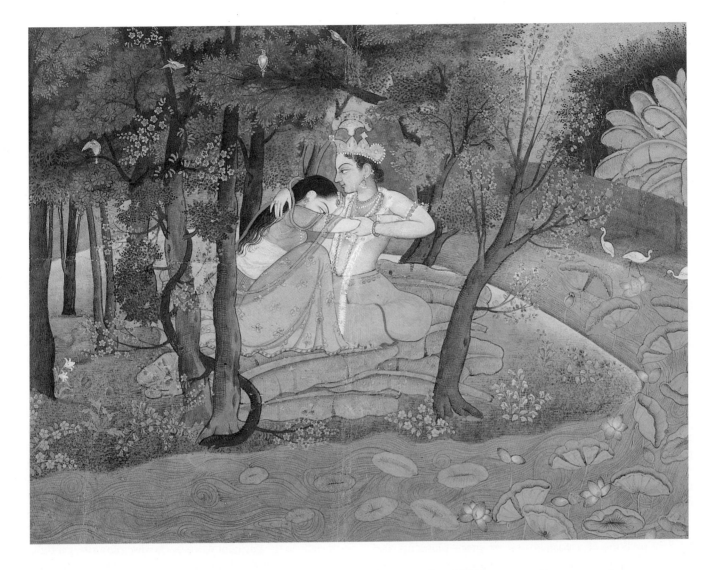

▲ 10.5 *Hindu Deities Krishna and Radha in a Grove,*
c. 1780
Gouache on paper; 4⅞ × 6¾ ins (12.3 × 17.2 cm).
Courtesy of the Trustees of the Victoria and Albert Museum,
London. Crown copyright.

illustrated by the gouache of Lord Krishna and his consort
Radha (**10.5**). In the tiny idealized space, colors serve a
spiritual purpose, with bright yellow emphasizing the pure
light emanating from the figures, and paradisal jewel-like
hues surrounding them. This is a world of pure beauty,
seen through the eyes of love.

Historical Western Approaches

The expansion of the limited prehistoric palette within
Western art has been plotted on the C.I.E. diagram (see
Figure 7.7) by Stephen Rees Jones (**10.6**). He has taken
four representative periods in the history of Western art to
show the gradual outward expansion of hues available:
prehistory, Egyptian antiquity, Early Renaissance (1500
C.E.), and the nineteenth century. From the diagram you
can see that up to 1900, artists were not able to capture a
full range of spectral hues with existing dyes and pigments.
Today the frontiers of color have been pushed outward by
petrochemical dyes and computer graphics, and there are

▲ **10.6 After Rees Jones, The history of the artist's palette in terms of chromaticity**
The newest colors available to artists have extended the range of saturation possible, though the purity of the spectral hues, shown around the outside of the C.I.E. diagram, still eludes us.

literally millions of colors in use. As more pigments and improved media have become available, ways of using color have changed as well. In the following sections, we explore some distinctively different approaches to color in the evolution of Western art.

The Western tradition in painting is thought to have begun with the ancient Egyptians. Archaeologists have found their paint-boxes of stone or marble, up to 3,500 years old, with eight to fourteen wells for different colors. These apparently included terracotta red, light and medium yellow ochers, turquoise-blue, green, black, and white, all used to fill in flat drawn shapes. In the fifth century B.C., certain Greek wall painters who applied tempera to wood, stone, plaster, and terracotta began to use a little shading to suggest three-dimensional form in space. Remarks by ancient

historians—particularly Pliny—have led us to believe that these painters limited themselves to a bold four-color palette: red, yellow, white, and black. However, recent research reveals that blue was also used, often for shadow effects rather than for dominant colors of objects.

Until the thirteenth century, tempera was often applied to dry walls of plaster, with a brilliant white gesso ground added to hold the paint and give it a luminous quality. The **fresco** technique, developed to a high art during the Renaissance, involved applying water-mixed pigments directly to wet plaster. Only those pigments that were water-soluble and resistant to the lime of the plaster could be used in this way—chiefly the subtle earth colors of ochers, umbers, chalk, charcoal, and pink and green clays. More brilliant mineral pigments, such as those used for blues, had to be added in tempera (which included a binder such as egg or glue) *a secco*, that is, after the plaster was dry. Those painted *al buon fresco* (true fresco) were more durable but tended to have a pale transparent quality, as in Giotto's *Lamentation* (**10.7**). Giotto (*c.* 1267–1337) was notable for his emphasis on modeling of figures by use of highlights and shading, creating the illusion of three-dimensional form on a two-dimensional surface by mimicking the way light acts in the natural world. Because colors could not be blended on the fresco but instead had to be applied stroke by stroke, gradations in tone were built up in side-by-side value sequences and then blended by hatching with a brush. Note that Giotto uses not only shades and tints of the same hue for highlights and shadows in most of his figures, but also shadows of complementary colors, especially in the garment worn by the disciple to the far right.

Several centuries later, Michelangelo (1475–1564) was commissioned to fresco the, ceiling of the Sistine Chapel in the Vatican. Controversy rages among art historians about the colors he actually used, for the work has been restored from very subtle, dark hues (**10.8**) to colors of great freshness and brilliance (**10.9**). Those in favor of the restoration point out that the somber colors long associated with Michelangelo were actually the result of dust accumulation, smoke from lighting and heating devices, and dark overpaintings and darkened glue added by previous restorers. Removing this accumulation with special chemicals reveals very vivid colors. However, some critics prefer the frescoes in their darker, less saturated state, perhaps following nineteenth-century preferences for the unifying dark,

▲ **10.7 Giotto, *Lamentation*, c. 1304–13**
Fresco, 91 × 67½ ins (230 × 202 cm). Scrovegni Chapel,
Padua, Italy.
Giotto's shading technique involved use of darker and lighter
values of the same hues or, in some areas, shadows of
complementary hues.

golden glow associated with Venetian oil paintings (for a
while, even museums treated paintings with dark varnish
that grew darker over time).

A new surface brilliance in hues appeared with the intro-
duction of oil as a medium for pigments. Initially difficult to

work with because of its slow drying time, oil was adopted
by painters in the Netherlands once drying catalysts had
been invented in the late fourteenth century. The first great
master of the medium was Jan van Eyck (c. 1390–1441),
who fully exploited the greater saturation, transparency,
and opacity possible when oil rather than tempera was
used to carry the pigments. The many layers he used
included a white ground which glowed through the upper
layers of oils, an underdrawing, and then layers of paint
from light to opaque darker values or more saturated colors
and transparent glazes. The optical effects of this layering
created variations and vividness in hues that far tran-

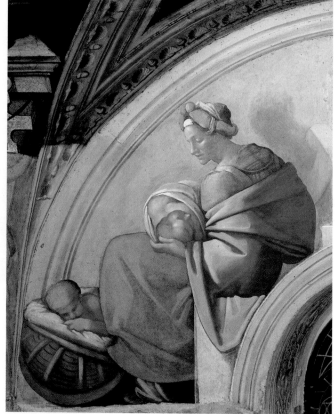

▲ 10.8 and 10.9 Michelangelo, Details from the Sistine Chapel ceiling frescoes, Vatican, Rome, 1508–12, (left) before and (right) after restoration
We cannot be absolutely certain what colors the Old Masters used, but those who restored the Sistine Chapel ceiling were convinced that Michelangelo worked with bright hues, obscured until 1989 by dark accumulations of varnish and soot.

scended the limited palette of the time. One of Van Eyck's early fifteenth-century palettes consisted simply of brown verdaccio (a dull pigment used for shading), red madder (a bright hue from the root of the madder plant), ultramarine (genuine lapis lazuli), yellow ocher, terre-verte (green earth), orpiment (yellow), sinopia (iron oxide red), and peach black. Van Eyck's great *Arnolfini Marriage*, or *Giovanni Arnolfini and His Bride* (**10.10**), illustrates that skillful use of these pigments in oils allowed very subtle and continual gradations of tone. But Van Eyck still maintained the old tradition of precise color boundaries between figures, based on the original drawing, no matter how distant they were.

Color began to break loose from the rigid outlines of drawing in the sixteenth-century work of the Venetian artist Titian (*c.* 1490–1576), who is considered one of the greatest colorists of all times. Cleaning of some of his works reveals that they were originally far brighter in hue than the golden glow they have acquired through aging of the oil and accu-

▶ 10.10 Jan van Eyck, *The Arnolfini Marriage (Giovanni Arnolfini and His Bride)*, 1434
Oil on panel, 33 × 22 ¹/₂ ins (84 × 57 cm).
National Gallery, London.
Van Eyck was a great master of using glazes to increase the brightness of hues in the limited palette of early oil paints.

mulations of varnish. Venice was a major port and Titian had access to rare and expensive imported pigments. Even more significant is his direct use of paint as a drawing medium. Rather than beginning with an underdrawing and then filling it in, according to sixteenth-century art historian Giorgio Vasari, Titian painted "broadly with tints crude or soft as the life demanded, without doing any drawing, holding it as certain that to paint with colors only, without

▼ **10.11 Titian, *Venus and the Lutenist*, early 1560s**
Oil, 5 ft 5 ins × 6 ft 10½ ins (1.65 × 2.1 m).
Metropolitan Museum of Art, New York.
Titian was famous in his time as a great colorist who painted directly with colors rather than filling in drawings.

▶ **10.12 Jan Vermeer, *The Lacemaker, c.* 1669–70**
Oil on canvas on wood, 9¾ × 8¼ ins (25 × 21 cm).
Musée du Louvre, Paris.

the study of drawing on paper, was the true and best method of working, and the true design."[1] X-ray analysis suggests that Titian reworked many sections, composing with areas of contrasting colors as he went along. If the dancing figures in the distance in Titian's *Venus and the Lutenist* (**10.11**) are compared with the brilliantly realized miniatures in the mirror of *The Arnolfini Marriage*, the difference in use of colors becomes obvious. Titian suggested form with dynamic slashes of color, though he worked in a far more controlled way to create the luminous, softly modeled nude Venus. He maintained the time-consuming practice of glazing for these transparent effects and spoke of using up to 30 or 40 glazes.

In the seventeenth century, Jan Vermeer painted a small corpus of exquisite works in which subjects are informally posed, but depicted with very careful compositional use of color. In Vermeer's *The Lacemaker* (**10.12**), a single splash of brilliant red yarn spills over from its confines as a bold counterpoint to the high yellow and the subtleties of the rest of the composition. Note that Vermeer also works very carefully with complementary hue changes for shadows and adds pearl-like flecks of high value to give a precious excitement to the image. There seem to be two light sources—one from the rear, casting a purple shadow on the wall beyond the woman, and one from the front right, throwing a strong light onto the left side of her face and gown. However, the effects of the lighting are subtly manipulated to balance one color against another in the composition, rather than to portray precise visual realism.

By the nineteenth century, color had become one of the major focuses of certain artists. One was Eugène Delacroix (1798–1863), who observed color effects in nature very carefully and sought to recreate natural lighting by a sort of additive optical mixing on the canvas. He juxtaposed unmixed bright pigments, often in complementary colors, coaxing the eye to mix them when the work is seen from a distance. This **broken color**, such as the many interwoven hues in the garments of the horsemen in *The Combat of the Giaour and Hassan* (**10.13**), is quite different from earlier works, where, for example, a red form would be painted entirely in shades and tints of red. Like his contemporary Goethe, Delacroix observed complex optical phenomena such as color shadows. From a seacoast studio he saw:

the shadows of people passing in the sun on the sands of the port: the sand here is violet in reality, but it is gilded by the sun: the shadows of these persons are so violet that the ground about them becomes yellow.

And on a person reclining in the sun against a fountain, he saw:

dull orange in the carnations, the strongest violets for the cast shadows, and golden reflections in the shadows which were relieved against the ground. The orange and violet tints dominated alternately, or mingled. The golden tone had green in it. Flesh only shows its true color in the open air, and above all in the sun.[2]

With Claude Monet and his fellow French Impressionists, attempts to capture the color effects of light took precedence over depiction of forms. Monet's pioneering effort in this direction, *Impression—Sunrise* (**10.14**), is a patchwork of colors arrayed as if they were just striking the eye, without being interpreted as forms by the brain. Monet counseled a young artist:

When you go out to paint, try to forget what object you have before you—a tree, a house, a field, or whatever. Merely think, here is a little square of blue, here an oblong of pink, here a streak of yellow, and paint it just as it looks to you, the exact color and shape, until it gives you your own naive impression of the scene before you.[3]

The nineteenth-century development of portable tubes for premixed permanent pigments in all hues had made it feasible for artists to paint outside, directly from nature, as opposed to tediously grinding and mixing each color in the studio and trying to use layers and juxtapositions to create brilliant hues that were not available in earth pigments. Monet mixed these tube colors with lead white to give them a pastel light-struck quality and then positioned them unblended on the canvas. As we saw in Chapter 3, Monet did not paint in local colors—the hues stereotypically associated with objects as seen under average lighting from close by, such as green for tree leaves. Instead, he attempted to record the evanescent realities of light as its vibrations were reflected off the material world.

Of the Postimpressionists, Seurat continued the experimentation with optical mixing of unblended dabs of color (9.27), though with a far more controlled technique than

▶ **10.13 Eugène Delacroix, *The Combat of the Giaour and Hassan*, 1826; detail below**
Oil on canvas, 23½ × 28⅞ ins (59.6 × 73.4 cm).
Photograph
© 1998 The Art Institute of Chicago, All Rights Reserved. Gift of Mrs. Bertha Palmer Thorne, Mrs. Rose Movius Palmer, and Mr. and Mrs. Arthur M. Wood, 1962.966.
Broken color was apparent in the evolving work of Delacroix, amongst others.

Monet, for whom speed was of vital importance in capturing a fleeting impression. Paul Gauguin (1848–1903) took color in another direction, juxtaposing broad masses of contrasting colors which intensify each other, as in *The Day of the God* (**10.15**), rather than breaking local color into small pieces that blend optically to a gray. Gauguin said:

> A meter of green is greener than a centimeter if you wish to express greenness. … How does that tree look to you? Green? All right, then use green, the greenest on your palette. And that shadow, a little bluish? Don't be afraid. Paint it as blue as you can.[4]

Gauguin used colors not only to emphasize nature but also to reflect the mysteries of inner responses to life, "feeling expressed before thought."[5]

▲ **10.14 Claude Monet, *Impression—Sunrise*, 1872**
Oil on canvas, 19 ½ × 25 ½ ins (49.5 × 64.8 cm).
Musée Marmottan, Paris.
This is the painting from which the Impressionist movement
got its name. It is an attempt to capture ephemeral light
sensations rather than solidly defined forms.

Twentieth-Century Western Approaches

In the twentieth century, some artists have continued the
tradition of representing local colors in their works, while
others have carried the nonrepresentational color trend
to its extreme. A particular escape from the local color of
objects occurred with the Fauves ("wild beasts," as their
critics called them). Influenced by non-Western arts, they used
intense colors joyously in whatever way they chose rather
than trying to imitate nature. André Derain's *Turning Road,
l'Estaque* (**10.16**) plays lines and masses of highly saturated
color against each other. "The problem," he wrote of his
intentions for this painting, "is to group forms in light."[6]

In the works of Sonia and Robert Delaunay, color
became a playful design tool entirely divorced from form.
Through explorations in the crafts, Sonia Delaunay tran-
scended the traditional boundaries of painting and entered
a world of pure color. In her *Tango-Magic-City* (**10.17**),
nonfigurative color shapes seem to be in constant rhythmic
motion, with many things happening simultaneously, as
they do in life. They stem purely from the active imagina-
tion of the artist, the liberated child within.

▲ **10.15 Paul Gauguin, *The Day of the God
(Mahana No Atua)*, 1894**
Oil on canvas, 27³/₈ × 35³/₈ ins (69.5 × 90.4 cm).
Art Institute of Chicago.
Gauguin was one of the first Western artists to use colors
expressively, selectively intensifying certain color tones seen in
the outside world for the sake of design and expressiveness.

Another of the many new approaches to painting evolv-
ing early in the twentieth century was the **collage**. In these
relatively two-dimensional works, **found objects** are glued
to a flat surface in such a way that one looks from one to
the next to assess their interrelationship.

Artists working in collage or low-relief constructions
with found objects are forever on the lookout for interest-
ing and beautiful shapes and colors in objects around them.
Some become very appreciative of subtleties of color that
would be difficult to paint—the beauty of rust, for example,
the patina of long handling, or the faded hues of something
that has often been rained on. They collect discards that
have caught their eye—leaves, unusual stamps, bits of
printed matter—the innate beauty or interesting design of
which they can expose through placement and contrast.

Although modern art often tended toward non-figurative
work, representational art continued to evolve, and with it,
the usage of color. Many artists worked independently,

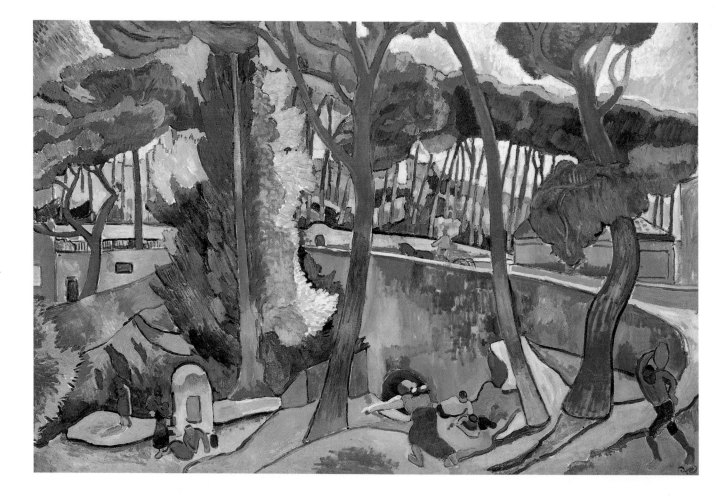

▲ **10.16 André Derain, *The Turning Road, l'Estaque*, 1906**

Oil on canvas, 4 ft 3 ins × 6 ft 4¾ ins (1.3 × 1.95 m).
The Museum of Fine Arts, Houston; The John A. and Audrey Jones Beck Collection.
The Fauves—"wild beasts"—moved even farther from local colors, substituting exuberant, highly saturated hues for the duller tones of real life.

with a great variety of idiosyncratic approaches. Pierre Bonnard attempted to paint the subtleties of light as it played across surfaces. He was one of a group of painters who called themselves "Nabis" ("prophets"), for they experimented with new ways of using color and composition in order to bring forth certain emotional responses as well as to explore visual patterns. In Bonnard's *Nude in a Bathtub* series (such as

Figure **10.18**), paint of various hues is dabbed on in such a way that the model's body is almost lost as a distinct form. Her skin becomes an evanescent, iridescent surface which merges with the water. Bonnard wrote:

> The object is not to paint life. The object is to make painting. The main subject is the surface, which has its color, its laws, over and above the objects.[7]

By mid-century, the so-called New York School had established two particular directions in use of color. One was Abstract Expressionism, exemplified here by Franz Kline's *Scudera* (**10.19**). The direct use of oils—and increasingly, acrylics—without underpainting or underdrawing had with this group become an end in itself. The free, expressive gesture of the artist, traced through the trail of color it left on the canvas, became the focal point of the painting. Some of these artists, including Kline, used white and black

as colors in themselves, of equal importance to the chromatic hues. In works such as *Scudera*, colors interlock on the same plane rather than existing in figure-to-ground relationships where one would appear to lie in front of the other in space.

Helen Frankenthaler even erased the spatial distinction between color and the canvas on which it sits by staining unprimed canvases with thinned acrylic paints. Acrylics—industrial pigments in synthetic resin—were becoming available in clear, highly saturated, sometimes even fluorescent or metallic hues that did not yellow with age as oils tend to do. Frankenthaler's *Nature Abhors a Vacuum* (**10.20**) revels in the interplay of these radiant hues floating in a boundless space, the whiteness of which accentuates their brilliance. Acrylics dry so quickly that they are difficult to blend; pouring or mopping these thinned paints onto the

◄ **10.17 Sonia Delaunay, *Tango-Magic-City*, 1913**
Oil on canvas, 21 ³/₄ × 18 ¹/₈ ins (55.4 × 46 cm).
Collection Kunsthalle, Bielefeld, Germany.
Delaunay's paintings reflect a total divorce of color from form, allowing it free play as a plastic element of design.

◄ **10.18 Pierre Bonnard, *Nude in a Bathtub*, 1937**
Oil on canvas, 48 × 59 ½ ins (122 × 151 cm).
Paris, Musée National d'Art Moderne.

◀ **10.19 Franz Kline, *Scudera*, 1961**
Oil on canvas, 9 ft × 6 ft 6 ins (2.7 × 1.9 m).
Courtesy of Philip Samuels Fine Art.
In the work of some Abstract Expressionists, black and white maintain their status as true colors.

▶ **10.20 Helen Frankenthaler, *Nature Abhors a Vacuum*, 1973**
Acrylic on canvas,
8 ft 7 1/2 ins × 9 ft 4 1/2 ins (2.63 × 2.86 m).
Private collection.
In Frankenthaler's radiant stained canvases, flowing colors and background merge in an endless space.

canvas one at a time produces transparent overlapping rather than blended color sensations. This is not to say, however, that Frankenthaler did not mix her colors. She experimented freely with mixtures, explaining:

> It occurred to me that something ugly or muddy could be a color as well as something clear and bright and a namable, beautiful known color. ... I will buy a quantity of paint but I hate it when it dries up and I haven't used it. If I have a pot of leftover green and a pot of leftover pink I will very often mix it just because I want to use it up. If it doesn't work—well, that's a loss.... For every [painting] that I show there are many, many in shreds in garbage cans.[8]

Frankenthaler's abstract organic color areas are somewhere between Abstract Expressionism and what is often called

Color-Field painting. This label is used for works which consist of large colored fields rather than the color trails of paint gestures. Mark Rothko's *Blue, Orange, Red* (**10.21**) almost hides the hand of the painter but it is not laid down in solid, uniform masses of color. Rather, it is built up of transparent layers of oils which give the impression of glowing light.

Compare the subtle variety in coloration of Rothko's painting with another development—the **Hard-Edged painting** typified here by the work of Ellsworth Kelly. His *Green, Blue, Red* (**10.22**) is exactly what it says it is. There is no attempt to develop subtleties of color or texture in the color field; each area is painted uniformly in unmodulated color, as if to industrial standards. One is confronted by the sheer facts of the three colors. This absolutely nonobjective

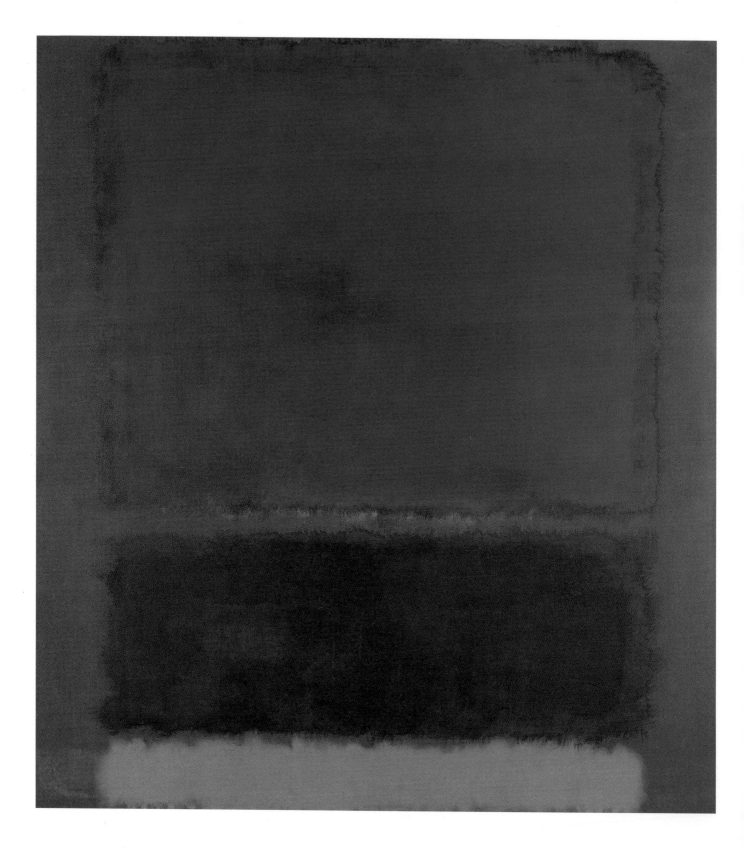

◀ **10.21 Mark Rothko, *Blue, Orange, Red*, 1961**
Oil on canvas, 7 ft 6¼ ins × 6 ft 9¼ ins (2.3 × 2.07 m).
Hirshhorn Museum and Sculpture Garden, Smithsonian
Institution, Washington, D.C. Gift of Joseph M. Hirshhorn
Foundation, 1966.

▲ **10.22 Ellsworth Kelly, *Green, Blue, Red*, 1964**
Oil on canvas, 6 ft 1 in × 8 ft 4 ins (1.8 × 2.5 m).
Whitney Museum of American Art, New York.

approach leaves the viewer to explore the only points of drama in the painting: the hard edges where the colors meet. If you stare at the edge shared by the red and green you may begin to see some simultaneous interaction effects. Just inside the green border a luminous glow of even more highly saturated green develops; the red on the other side of the boundary similarly becomes even redder, as each hue optically "subtracts" any trace of itself from the other. The same thing begins to happen along the edge shared by the blue and red if you stare at it long enough.

Taken to an extreme, this kind of optical interaction becomes Op Art. As we have seen, painters such as Josef Albers (9.21) and Richard Anuszkiewicz (3.11) give the viewer more color sensations than they have physically created. Their color combinations confuse our perceptual apparatus, and somewhere in the passage from eye to brain illusory colors begin to appear. Another figure in this movement—Bridget Riley—is highly successful at making us perceive chromatic colors where only black and white actually exist. The eye quickly tires of trying to maintain focus on the black and white lines of her *Crest* (**10.23**) and soon begins to see all sorts of phantom colors in the white areas. Even the black lines change to unexpected brilliant hues if you look at the work long enough, letting your eyes go out of focus. Just what colors you will perceive and how long it takes them to develop will depend upon your visual flexibility (how willing you are to allow what you see to change), the lighting, and how tired your eyes are.

A final major development in the use of color in the fine arts is the infusion of crafts approaches and techniques. Many artists trained in the crafts have crossed the old boundary into fine art, undermining the traditional distinction between the two. Artists from crafts disciplines often use natural materials, thus returning to unsaturated hues.

Today many of the approaches to color developed in the past are still in use, but new ones are also continually evolving. In computer graphics, a vast range of luminous colors, some of them never before available to artists, are now readily mixed and viewed on the screen.

With the potential for creating millions of colors—more colors than the eye can even distinguish—computer artists now have the opposite challenge of that faced by the earliest artists, who had to make the most of a limited palette of earth pigments. The challenge in computer art is to make effective color choices in the midst of so many possibilities. There is also the challenge of capturing the attention of contemporary viewers who spend many hours a day being visually assaulted by extremely rapid image changes on television and who have a world of color imagery competing for their attention on the Internet.

Amidst the visual noise of our times, a quiet or sober voice may draw attention by its very subtlety. After an initial period of gay abandon in choosing and juxtaposing highly saturated colors, many computer artists are now intentionally limiting or subduing their palettes to suit the "painterly" aesthetics of what many people would categorize as fine art, as in Figure **10.24**, which advertised the work of the Center for Creative Imaging in Maine.

Nevertheless, the luminous brilliance and variety in colors available to computer artists, especially to those using television screens or colored films rather than printing inks for their final production, has initiated a new aesthetic which will be judged by different standards of taste from those of the older media, such as oil and watercolor paintings.

▶ **10.23 Bridget Riley, *Crest*, 1968**
Emulsion on board, 5 ft 5½ ins × 5 ft 5½ ins
(1.66 × 1.66 m). Mayor Rowan Gallery, London.
Stare at this "black-and-white" work for a
while to see what illusory chromatic
hues begin to appear.

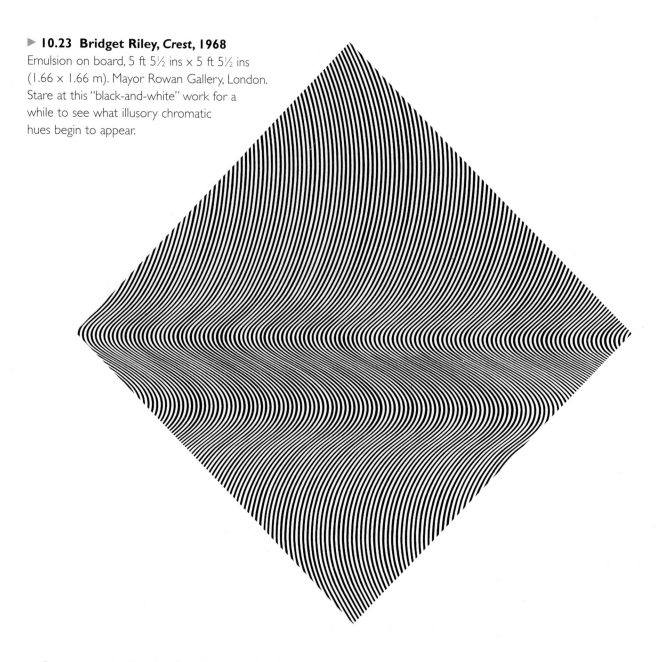

Computer artist Ron Lambert has even let the computer itself be the arbiter of taste, allowing it to make its own choices of colors. Lambert scanned a black-and-white image of his fingertips into his computer (**10.25**), and then, as he explains:

> zoomed in until all that can be seen are the color pixels. This removes the images from any context where they are recognizable as fingerprints. The viewer is meant to initially notice

▶ **10.24 Alan J. Kegler, *The Surveyors*, 1993**
Computer image.
Confronted with the availability of more color choices than the human eye can even distinguish, early computer artists often chose the brightest of colors. Mature use of the computer as an art medium now means that less saturated colors and an intentionally muted palette may instead be employed.

◀ **10.25 Ron Lambert, *Pixels from a Scan of my Fingertips #2*, 2000**
Inkjet print, 6 × 6 ins (15 × 15 cm).

▼ **10.26 Bill Viola, *Stations* (detail), 1994**
Video/sound installation with five granite slabs, five projections and five projection screens. The Museum of Modern Art, New York. Gift to the Bohen Foundation in honor of Richard F. Oldenburg.

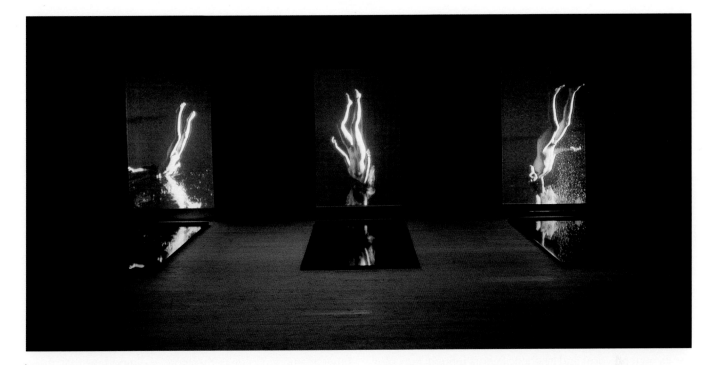

only the aesthetics of color, an aspect of the work that is a façade. Although the images are unique to my person, the visual clues, the colors, were determined by the computer, therefore having no basis in truth.[9]

The extent of the new possibilities has not yet been fully explored. As computer artist David Em says:

> How physically and spiritually removed sitting in front of a computer terminal is from the experience of a prehistoric cave painter making a red handprint on a cave wall. Perhaps, if the prehistoric painter were presented with Velázquez's paint box and brushes it would take him a little while to grasp what had been delivered into his hands. And perhaps it will take us a little while to appreciate that the computer, which has so suddenly appeared in our midst, is likewise a wonderful and mysterious gift.[10]

Modern technologies are also being brought into play to create installation pieces that surround the viewer with

unique color environments and even virtual realities. Bill Viola uses video projections and sound to immerse viewers in dynamic imagery that is manipulated to blur the boundary between real and unreal. His *Stations* (**10.26**), installed in the Museum of Modern Art in New York, does so with five granite slabs, video projections, and projection screens. This installation work itself refers to the "crisis of representation and identity" created by the new technologies.

At the other extreme from artwork that is based on modern technologies, there is growing critical appreciation of folk art, multicultural art, and outsider art. Serious attention is being paid to works created outside the mainstream of Western aesthetic tradition, and thus uninfluenced by academic ideas of appropriate color choices, as in Bessie Harvey's sculpture shown in Figure 9.14.

Each new development requires flexibility and imagination in our aesthetics if we are to explore fully its particular contribution to our work with colors.

11

Color in Applied Design

*The dynamic structure of color and light delights my eye,
disturbs my lazy thoughts, lends wings to the rhythm of
my heart and to the quick breath of my wishes.*

HEINZ MACK

In applied design, as in the fine arts, color use has broken away from its traditional restrictions. There are, however, certain commercial and practical limitations on color choices. Many applied design disciplines—from giftwrap to product design—are affected by shifting tastes in color. Psychological associations with certain colors may also play an important role. Colors have compositional and spatial effects, already examined in previous chapters, that influence their commercial use.

Beyond these general considerations, each discipline has its own practical and aesthetic factors influencing color use. For instance, the increasing use of Internet websites for conveying information and selling products has brought great creativity to the medium of computer graphics, featuring eye-catching color imagery animated through time.

Color Trends

In applied design fields, color choices are strongly influenced by the demands of the marketplace. To a certain extent, trends in public color preferences are manipulated by the commercial industries; change is orchestrated for the sake of increased sales. Trends in color palettes are usually led by the fashion industry, with home fashion colors often following sometime later. As Ed. [sic] Newman of the American Textile Manufacturers Institute puts it:

> The word "fashion" is synonymous with the word "change." Fashion begins with fabric. Fabrics begin with color. Each season, color must make a new statement for fashion to con-

tinue its natural evolution. Our eyes need refreshment. ... We may have disliked the way we looked in last season's clothes, but this season offers the opportunity to wear new colors, groom differently and appear as a new person. And if we are still unsatisfied, three months later there's a new season ...[1]

In buying ready-to-wear clothing, consumers seem to be initially drawn to the two inches of color they can see in a garment sandwiched amongst others on a rack. Only if they like the color will they take it off the rack and consider its other features. Color is therefore so important that most industrial countries have color councils who gather and feed information about changing consumer preferences to manufacturers. The International Color Marketing Group of the Color Association of the United States, for example, supplies its color forecasts to members in the textile, apparel, interior design, paint, building products, automobile, and communications industries two years ahead of each selling season. Each season's palette takes into account aesthetic judgments about suggested color combinations. It considers the practicalities of translating the predictions into technically feasible dyeing and printing processes. Fanciful names are given to these trendsetting colors, such as "Wallstreet Green," "Tahitian Sunset," "Mountain Mauve," and "Barbarossa Brown." To help communicate the precise meanings of these names, color swatches and a color matching service are provided. Nevertheless, designers in certain industries—such as office furniture—maintain that they avoid specifying these "custom" colors

because of color matching and production scheduling problems.

Although color trends quickly change, certain generalizations have been formulated about color preferences. They are thought to revolve around the state of the economy. During recessions, those who can afford them surround themselves with luxurious fabrics, such as velvets and chiffons in rich colors, as an uplifting antidote to the mood of the times. In times of abundance, the balance in industrial countries tends to shift toward "naive" fabrics and colors. During the affluent 1960s, for instance, the all-white look and faded denim prevailed.

Affluence inevitably brings tension, so for decades, there has been an overall preference for blue in industrial societies. Leatrice Eiseman of the Pantone Color Institute, speaking of the fact that blue leads in consumer preference tests in the United States, observed:

> It comes as no surprise that Americans overwhelmingly chose the color that best evokes a soothing, calming tranquillity in a frantically fast, often insecure world. It may seem a stretch to equate color and design directions with our state of mind and body, but these trends have always reflected society's concerns and interests, and surviving stress is a key issue in today's world.[2]

However, color preferences differ within different social groups within the same culture. Eiseman notes:

> A preference for red is directly linked to the most secure within a society, with the most economically stable segment, or achievers, such as high-powered active women who are unafraid to take risks.[3]

Another general observation is that for every action there will be a reaction. Brilliant colors that glorified the limits of modern dyeing technology peaked in the late 1970s, followed by a reactionary preference for more subdued tones and a certain discretion in color combinations. Then in the 1980s came the excitement of vibrant color choices in computer graphics, followed by more subtle aesthetics in some computer art but even wilder choices in other computer works.

Aside from these ups and downs in public preferences, it appears that the public has become accustomed to a high degree of color use in the designed environment. The days when cars came in only one color (black) and when a "color" telephone meant one in white or ivory are unlikely to return. Designer colors now run to salmon and lavender office chairs, pink portable radios, tables of brilliant primary colors, and airplanes painted orange. Consumers have long since become accustomed to color in their kitchens as well as their living rooms. Many magazines and newspapers use color extensively, old black-and-white movies are being tinted for modern audiences, wheelchairs are now offered in vivid colors (**11.1**), and even staid universities are advertising themselves through multicolored websites.

Color Psychology

In addition to color trends, designers must be aware of innate psychological reactions to colors. As we found in Chapter 4, it is difficult to generalize about the way that

▲ **11.1 Kazuo Kawasaki, *Wheelchair***
Lightweight titanium frame, aluminum honeycomb wheels. Courtesy eX-Design, Inc., Japan.

▲ **11.2 "Clearly Canadian" bottle**
Beverages with just a faint hint of color in the liquid or the bottle give the consumers the impression that what they are drinking is as natural as water, and even more refreshing.

colors affect us. But it is clear that warm colors tend to stimulate, whereas cool colors have a calming influence. Such information should be used thoughtfully. Research into the effect of colors in store interiors suggests that while red is alluringly striking and works well in drawing people into a good selling environment, warm colors, on the whole, may make people feel somewhat tense. Their effectiveness in promoting purchases inside stores could depend on whether the items are inexpensive, for quick impulse-buying, or whether they are costly purchases that require deliberation. If the latter, then cooler colors might encourage staying long enough to make a relaxed decision. The same principles are applied in restaurant interiors. Designer Kevin Grady explains, "Yellow [and] orange are intentionally used at fast food restaurants because they're seen both as hungry colors and jarring colors, so that you get people in, give them their food, and get them out."[4]

In packaging, the first goal is to catch the eye. Research indicates that consumers scan each package on a supermarket shelf for only 0.03 seconds. Thus the packaging must attract the customer to buy it, and the color should also help to convey an image of the contents. Considerable market research has been done about the effects of colors on buying habits, but most of it is closely guarded by the companies, who use it to get ahead of their competition. Yellow, orange, and red are often effectively used to stimulate and draw attention; purple is frequently associated with luxury products; blue suggests cleanliness, quietness,

or financial stability; green and brown evoke an impression of nature and are often used in packaging to suggest environmental "friendliness." Gold, silver, and black effectively promise sophistication and high-quality merchandise. Gray is favored for conservative audiences, promising practicality and soberness. White may be used to suggest purity. As Dr. Russell Ferstandig, a psychiatrist and marketing consultant, explains, "Color serves as a cue. It's a condensed message that has all sorts of meanings."[5]

In commercial use of color, there are conventions about which colors to avoid as well as which ones to use to create certain effects. Black is rarely used in food products, because in the West it is associated with death; on cigarette packaging, people could associate it with lung cancer. Red may remind people of debt. Pink is linked with femininity and is therefore avoided in "masculine" products, and also in products for contemporary businesswomen. Too much yellow is thought to be disturbing, and too much purple overwhelming.

Transparent, nearly clear colors in beverages convey to today's health-conscious affluent consumers the impression of drinking something as calorie-free and healthful as water. Sales are booming of bottled beverages stripped of color so that they have the appearance of lightly flavored water, perhaps with just a hint of hue in the packaging or liquid. In "Clearly Canadian" flavored water (**11.2**), with which this successful marketing trend began, the bottle was tinted pale blue to give the illusion of a natural spring, but the liquid was left clear as water, as shown in the glass alongside. "Clear says purity, and clear says refreshment," explains Jeffrey B. Hirsch, marketing consultant.[6]

Combinations of warm and cool hues can be used symbolically to convey mixed messages. A package of laundry detergent printed in blue and red suggests aggressive cleaning action. In television advertising, colors can be juxtaposed in time as well as space. In the prize-winning Levi's television commercial shown in Figure **11.3**, everything is tinted blue, with a bit of yellow. The blues set a hip tone,

▶ **11.3 Frames from a television commercial for Levi's jeans**
In this sequence of colors, the predominant blues create a sense of incompleteness, which is resolved by the red of the Levi's logo.

further emphasized by the guitar music the men are playing. But all this blue creates a psychological longing for something else—the balance of the spectrum—which is finally satisfied by the small red trademark patch. It becomes the object of one's stimulated desires. Similarly, in the midst of bright colors so often used to draw attention, a "30-second seduction" where all colors are grays until the orange of orange juice is shown is highly effective in arousing desire for that product.

Designers of logos attempt to use colors as well as line and shape to establish corporate identity. Reds—which seem to suggest a certain assertiveness and activity, as the red in the Levi's logo—are still the going favorites. However, new entries in this field include bright yellows, oranges, and purples. Banks, on the other hand, are said to prefer reds, blues, and violets. In all graphic arts, the designer's ideas are restricted by the client's requirements.

Graphic Design

Graphic designers are not as bound by color trends as fashion and interior designers. Their mandate is to evolve fresh ideas in exciting and stimulating designs continually, and this includes exploring the whole range of colors and combinations. Nevertheless, graphic design does have its own special considerations. Color may be used for specific practical purposes in business communications, and is thus expected to show practical results. It may be expected to call attention to important information, to help people locate information (as in signboards routing drivers through busy airports to specific terminals), to convey meanings nonverbally (such as "Go" or "Stop!"), to break down information into categories (as in the colored grounds and graphics that are used with increasing sophistication in Internet websites), and to make information more readable.

Another major consideration in graphic design is where and how a design will be printed or displayed. A logo, for example, must be reproduced on a variety of surfaces, including different kinds of papers and perhaps even fabrics, but the customer expects the logo color to remain exactly the same no matter where it is printed. This does not happen automatically; uniformity in color may require many adjustments by the designer. Furthermore, deep blues and greens and hot reds are often difficult to obtain

▲ **11.4 Milton Glaser, Novel cover**
Reverses—used for the white areas of this cover—are used to extend the possibilities when a graphic designer is limited to only a few ink colors.

because printing inks are transparent and must be applied in several layers to achieve these colors.

In computer graphics, by contrast, an enormous range of colors is theoretically at the artist's disposal; great discrimination is needed in making choices among them. Designers of Internet web pages have to work within one

severe constraint: Their graphics must download quickly, lest the viewer should become impatient and switch to another website. Quick downloading may necessitate a somewhat limited palette, or use of solid colors across broad areas instead of broken colors, or selective compressing of color data, placing speed ahead of picture quality.

For budgetary reasons, graphic designers in print media must often work with a limited palette—perhaps only one or two colors of flat-printed ink on a white or colored ground (if the latter, its hue will show through and alter the transparent inks). This limitation has led to great ingenuity to achieve the appearance of variety. Some common techniques are the use of percentage screens or half-tones for value gradations, overlapping color blends, and **reverses** (in which images or typography appear in the ground color, surrounded by ink, rather than the other way around). Milton Glaser's novel cover (**11.4**) uses black and green ink on white stock, with the green ground printed first, the black printed over it for the typography and the dark areas of the half-tone figure, and a reverse for the title and cook's head and hat. This use of colors accentuates the white, which is responsible for conveying the essentials of the message. For a reverse to be effective, the ink surrounding the ground must be dark enough for the ground color to show up well by contrast.

Single colors develop subtle tones when used in small amounts—such as areas of type—across a broader area. Black letters on a white ground tend to produce an overall gray effect that is best judged by squinting at the area to catch its tone rather than reading the words. You can perhaps see this tone by squinting at a page of this book, and then comparing it with the pages from other books or magazines. Typefaces with thicker lines produce different tones of gray from small, fine-lined print; large, bold headlines may retain a black and white contrast rather than being seen as a gray tone. Ink colors other than black will tone the paper in the same way. These tones should be examined and worked with thoughtfully as part of the composition.

In multicolored, two-dimensional graphic design, colors have strong effects on each other because they exist side by side on the same plane. Vigorous contrasts are optically interesting but may tire the eye; customers may prefer something that does not vibrate when they look at it. One way of capitalizing on the liveliness of hue contrast without

▲ **11.5 David Lance Goines, *Asilomar*, 1978**
Poster, 18 × 24 ins (45.7 × 60.9 cm).
A line of neutral brown, gray, black, or white is often used to soften the contrasts between adjacent color areas.

overstimulating the eye, as we saw in Chapter 9, is to separate color areas with a line of white, black, or some other neutral color. David Lance Goines has tied the shapes and colors of his *Asilomar* poster (**11.5**) together by wrapping a gold line around everything, but he has also added just enough of a black line beyond it to keep the gold from clashing with the other colors.

Graphic designers also work carefully with the traditional principles of design, such as repetition, variety, rhythm balance, compositional unity, emphasis, economy, and proportion. Color use is often a key feature of these factors. Consider the brilliant two-page advertisement in

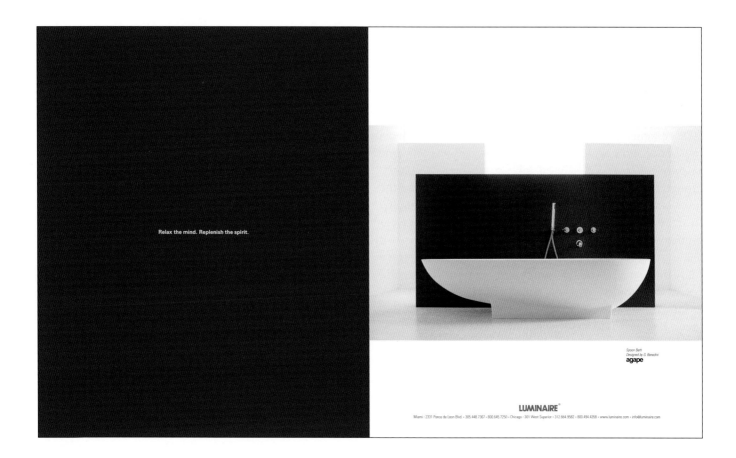

Relax the mind. Replenish the spirit.

Spoon Bath
Designed by G. Benedini
agape

LUMINAIRE
Miami · 2331 Ponce de Leon Blvd. · 305.448.7367 · 800.645.7250 · Chicago · 301 West Superior · 312.664.9582 · 800.494.4358 · www.luminaire.com · info@luminaire.com

▲ **11.6** Ad for Luminaire spoon bath designed by G. Benedini, *Dwell* magazine, August 2001, two-page spread inside front cover.

Figure **11.6**. One would have thought this a very difficult assignment. The product is white, and what is it? A bathtub. How can it be made to appear as something special and desirable? Firstly, the ad occupies the first two pages of *Dwell* magazine, inside the front cover. Then there is the choice of color: a solid, warm, uniquely indescribable red. The entire left page is a block of this unusual color, broken only by the white words written on it: "Relax the mind. Replenish the spirit." Then we look across to the right page and see a white shape against this same color, with the white already established in our mind and ready to be amplified. The use of light grays behind the red makes it stand out and even makes the red optically darker, helping to balance the two pages. The choice of the inside front

cover means that the left page is printed on heavy cover stock. When you turn the page and discover the ad, the weight you feel helps to make the red seem more stable, more solid. In every way, the designer has made the bathtub seem special by its surroundings.

Although the practical considerations of graphic design sometimes seem to place it in a different world from fine arts, many graphic designers nonetheless take clues from fine arts in the use of color. In the laptop computer advertisement shown in Figure **11.7**, the approach to lighting is borrowed from the Old Masters of painting. A strong light source creates dramatic contrasts between light and shadow falling across the forms and balances light and dark areas of the composition, rather as in Vermeer's *The Lacemaker* (10.12). The reference to tradition also serves a psychological purpose, suggesting that a woman does not have to sacrifice her traditional role in the home in order to carry on her career. The advertisement combines the old and the new: With miniaturized computer in her lap, a

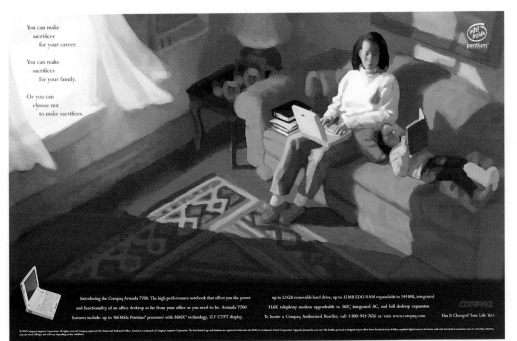

You can make
 sacrifices
 for your career.

You can make
 sacrifices
 for your family.

Or you can
 choose not
 to make sacrifices.

Introducing the Compaq Armada 7700. The high performance notebook that offers you the power and functionality of an office desktop as far from your office as you need to be. Armada 7700 features include: up to 166 MHz Pentium® processor with MMX™ technology, 12.1" CTFT display, up to 2.1 GB removable hard drive, up to 32 MB EDO RAM expandable to 144 MB, integrated 33.6K telephony modem upgradable to 56K; integrated AC, and full desktop expansion. To locate a Compaq Authorized Reseller, call 1-800-943-7656 or visit www.compaq.com.

COMPAQ

Has It Changed Your Life Yet?

11.7 Moments campaign, advertisement for Compaq Armada 7700 Computer from *Wired* magazine, October 1997
This modern advertisement borrows lighting techniques from the Old Masters of painting.

mother can work while staying home with her sick child, in a warm and cozy atmosphere bathed in sunlight and fresh air blowing in through the open window.

Interior Design

In interior design, in addition to the client's color preferences, suspected psychological effects of colors, color fashions, and aesthetic workability, there are also certain practical considerations for color choices in furnishings, flat surfaces, and lighting. Traditionally, interior designers were taught standard color harmonies (see Chapter 9) and cautioned that: 1) floors should be relatively low in value and saturation so they would hide soil and provide an optically firm base; 2) walls should be rather light and neutral in hue to provide a value gradation from floor to ceiling and to avoid clashes with the colors of paintings and furniture; 3) ceilings should be very light in value to give a sense of spaciousness and reflect lighting well.

These limitations have not inhibited the imagination of contemporary designers, however. They combine any colors they choose, so long as they can make them work. New

ease of upkeep in floor finishes has led to widespread use of light-colored flooring. At the same time, dark walls and ceilings are now often used to create a cozy atmosphere. As for acceptable harmonies, consider the striking combination of hot pink and yellow in the Emmanuel Chapel of Corpus Christi Cathedral (**11.8**). Like the gem-colored lights entering Gothic cathedrals through stained-glass windows, these high-keyed, high-value colors create an inspiring color environment. The hue and strength of the lighting is carefully coordinated to harmonize with the altarpiece, rug, wall and ceiling paint, and wooden furniture and framing.

Color choices for interiors should be made under the lighting in which the materials will be seen. Lighting is equally important in other arts, but only in interior designs is the type of lighting known in advance. A cool fluorescent light will emphasize blue-purple, blue, blue-green, and green but produce disastrous results in the warmer hues; warm fluorescent lights enhance the yellows, oranges, reds, and red-purples but do not show cool colors to best advantage. Incandescent light gives everything a somewhat reddish tint. Full-spectrum fluorescent lighting attempts to simulate sunlight. An alternative is to use both warm and cool fluorescent lights for color balance. In some cases, how-

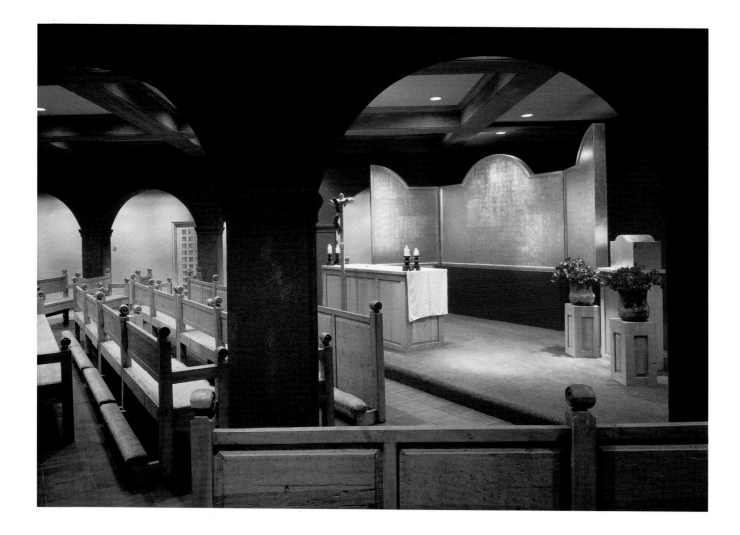

▲ **11.8 Emmanuel Chapel, Corpus Christi Cathedral, Corpus Christi, Texas**
Even church interiors may be the subject of contemporary color experimentation.

ever, balance is not desired. The General Electric Company suggests use of cool white fluorescent lights alone for banks, to create a sedate mood that implies stability of the institution, and warm fluorescents for displays of baked goods, upon which a bluish tint would be highly unappetizing.

Seen in large amounts, colors seem far more saturated than they do on small paint chips or fabric swatches. If one wants a quiet, subdued effect, it is often wise to choose colors from samples that are more toned down than the final result one envisions. The standard measurement tool for color selections and relationships in interior design is the Munsell Color Atlas. It consists of 1,500 detachable samples, in both glossy and matte finishes. Better still, large swatches of fabric or painted areas should be sampled in the area in question, with all colors to be used together present.

Early in the twentieth century, Western interior designers were told that bright colors should be reserved for small accents, with large areas reserved for subdued tones. In contrast to the earlier insistence on quiet color schemes for interiors, many contemporary designers are using large areas of bright colors for certain applications, as in Rufino Tamayo's living room (9.8) and the Emmanuel Chapel (11.8). Strong colors can be invigorating, and some human environments

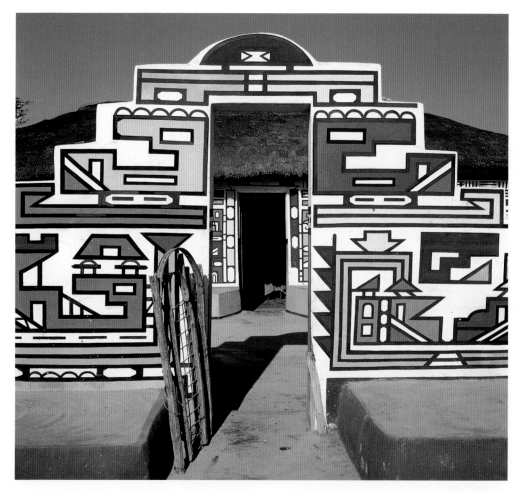

◄ 11.9 Ndebele house, South Africa
The strong sunlight of equatorial environments tends to wash out colors visually at midday, so brilliant colors that would seem garish in cloudier climates may be used in clothing and architecture.

are thought to benefit from their use. As we saw in Chapter 4, bright colors encourage activity and mental alertness, and are therefore increasingly used in interiors of schools and offices, as well as in fast-food places. Again, just as with quieter color harmonies, bright colors should be seen in samples large enough to judge the final effect, with particular attention to interactions between colors. Seen against backgrounds of a different hue from the white or gray ground of color samples, they may appear quite different. Often a range of potential colors is painted on a wall before final choices are made. Allowance should also be made for the fact that colors affect our sense of space. Highly saturated and warm colors make things look larger and closer; bright red walls or furniture would therefore have the overall effect of making a room itself appear smaller, for they would intrude optically into the space more than, say, pale blue walls or furniture.

Architecture

The lighting across the outsides of buildings changes continually. Exterior colors are therefore dynamic, and their appearance depends partly on the local climate and relationships to the sun. Under a bright tropical sun, bright colors tend to wash out visually, especially at midday, so very strong colors may be used without an overwhelming effect. The brilliantly contrasting synthetic pigments used by Ndebele women of South Africa to decorate architectural details, such as the house entrance in Figure **11.9**, are

◀ **11.10 The Masjid-i-Shah mosque at Isfah, Iran, Safavid period (1612)**
Cool colors are a welcome visual oasis in hot desert environments. Lustrous finishes on tiles gleam near-white when reflecting the brilliant sunlight.

powerful enough to retain their excitement even under the naturally brilliant lighting conditions.

In areas further from the equator with less direct, and also less frequent, sunlight—such as often overcast parts of Europe—colors appear more brilliant. Hues of walls and roofs will also affect absorption of solar energy. Hot climates often necessitate white walls and roofs to reflect heat away from the interior; darker walls and roofs will help warm a building in a cold climate. Even darker values may give a cooling visual impression if they are from the cooler range of hues, such as the blues used in the magnificent tilework of Muslim mosques. To the desert nomads living in a hot sand-colored environment, the cool blues and

greens were a refreshing foretaste of a heavenly paradise. Lustrous finishes were created by applying and firing metal oxides on the surface of initially glazed and fired tiles. This effect reflected highlights which visually raised the value of the hues to near-white (**11.10**).

In addition to the geographical and climatic considerations unique to architecture, aesthetic concerns also come into play. Throughout time and space, there have been two major directions in exteriors: use of the colors of nature or of the materials themselves, or use of applied colors. The latter has been common throughout history. The exteriors of great public buildings of ancient South and Central America, Greece, Egypt, the Middle East, and the Far East

were often richly colored with applied paints and tiles. The conservative, no-color approach to exteriors entered Western history with the Protestant Reformation, when ostentatiousness was declared vulgar and inappropriate for spirituality. This sparse aesthetic culminated in twentieth-century International Style architecture, which celebrates the integrity of unadorned modern building materials—raw concrete, glass, and steel.

Frank Lloyd Wright led the way to a different set of conventions in architecture. He denounced vivid chromatic hues as the province of "interior desecrators" and honored the earthy colors of nature, in an attempt to make buildings blend with the land. He worked with the warm colors of wood and local rock, and eschewed paint, using only a sand-finish coating or a terracotta red—the color of clay—when necessary. His famous Arizona home, Taliesin West (**11.11**), is a monument to his "Organic Architecture."

A very different reaction to the International Style is manifested in the eccentricities of what is called "Postmodern" architecture. No one style predominates, but versions range

▲ **11.11 Frank Lloyd Wright, Taliesin West, Arizona**
Wright, the apostle of "Organic Architecture," worked with the colors of the earth.

from the romantic to the playful, and often involve explorations back into the world of applied exterior color. The Pompidou Center for modern arts, designed by Renzo Piano and Richard Rogers (**11.12**), strikes a brilliant contrast to the sober hues of historic Paris, flaunting its exposed air-conditioning, electrical, water, and elevator equipment, color coded in blue, yellow, green, and red respectively. These colors, which mimic those used for industrial safety classifications, are intended to make the machinery of the building easily recognized and fun to see. Whereas ancient temples featured painted statues of the gods, in this building the gods of the machine age are given top billing.

In the currently popular "Deconstructionist" architecture of Frank Gehry, such as the Guggenheim Museum in

◀ **11.12 Renzo Piano and Richard Rogers, Pompidou Center, Paris (detail), 1971–8**
Industrial color-coding provides a brilliant exterior color scheme for the controversial—and highly popular—Pompidou Center.

◀ **11.13 Frank Gehry, Guggenheim Museum, Bilbao, Spain, 1997**
Guggenheim Foundation.

Bilbao (**11.13**), there is a return to unadorned industrial materials. But here the titanium cladding is treated very sensually, swathing dynamic curvaceous forms, so that it continually changes in color as we look across the sculptural surface. Before this famous museum was built, Bilbao was known primarily for its bad weather, but now even its cloudy climate has been turned into an asset, for in that dim light, the subtle nuances of color changes reflected across the silvery metal surfaces can be fully appreciated.

Landscape Design

In landscaping, designers work with all the colors of natural foliage: coppery reds, purple-greens, blue-greens, and yellow-greens, plus the blazing yellows, oranges, and reds of fall in some temperate areas. For the most part, greens predominate. To enliven the schemes produced by the hues of leaves, flowering plants and shrubs are often introduced. They yield displays that change with the seasons and whose shifting harmonies must be carefully anticipated. Springtime at Exbury Gardens in England (**11.14**) brings out the magnificent blossoms of over a million species of rhododendrons and azaleas. They were collected in the mountains of China and the Himalayas, where their colors cloaked the hillsides, and bred by Lionel de Rothschild, ever in search of pure and beautiful colors.

Landscape designers work with color on many planes, planning effects that change through time and space as one walks through the garden. Within a single impression, for example, there may be large areas of relatively low saturation, accented with brighter hues in smaller quantity. Some plantings, such as a field of heather, have a filmy color atmosphere, while others have the intensity of a few red tulips seen against duller greens. Jarring color contrasts may be broken up by intermediate plantings of white flowers or non-flowering foliage plants. Close color harmonies among flowers, such as the many reds in Exbury Gardens, or analogous purple and blue, are usually pleasing and are automatically varied by their juxtaposition to foliage hues. Gray-leafed foliage plants, such as artemisia, help to bring out the vitality in neighboring soft-colored flowers.

Foliage may also provide a compositional framework for the design. Leaf and trunk colors and textures suggest visual weights, with dark, massed colors appearing heavier,

▲ **11.14 Lionel de Rothschild, Exbury Gardens, Hampshire, England**
In this corner of the gardens, a monochromatic color scheme unites the varying reds of rhododendrons, but they are in complementary contrast to the many greens of the foliage.

and paler, more open areas appearing lighter. In a naturalistic planting such as Exbury Gardens, these weights may be distributed throughout, rather than arranged in rigid hierarchies; nevertheless, visually heavy weights at the base will give the whole scheme a sense of being firmly anchored.

Planting will also affect spatial illusions within a garden. Highly saturated and warm colors will seem close; cool, less saturated colors will seem further away. If bright colors

► **11.15 Philip Moulthrop, Wooden bowl**
Tulip poplar, 14 × 19 ins (35.5 × 48.2 cm).

▼ **11.16 Emile Gallé, *La Nature*, c. 1900**
Internally decorated glass bowl, height 5 ½ ins (14.5 cm).
Gallé developed a wide range of glass colors, many of them
unnameable, relatively unsaturated hues.

are placed in the foreground, with cool colors and less hue contrast in the distance, perspective will be stretched, increasing the apparent size of the area. A garden entirely in warm, bright colors will seem small.

Crafts

Natural materials, the media of the landscape designer, also form the basis for most crafts. In handmade functional items, today's aesthetic tends to honor the earthy, unsaturated hues of nature. Woods, for example, are often left unpainted to expose their natural beauty. Wood with rich or interesting coloration is prized for color effects such as those in Philip Moulthrop's bowl (**11.15**). Fine sanding and glossy finishes heighten the saturation of these natural colors.

Even when brighter colors could readily be used, as in Dale Chihuly's vividly colored glass works (see Figure 7.16), craftspeople may intentionally select a subdued palette. Although earlier artists had developed ways of staining glass in the brilliant, jewel-like hues seen in Gothic cathedral windows, for instance, the great nineteenth-century glassmaker Emile Gallé often used less saturated colors. Those in his *La Nature* (**11.16**) suggest a mystical communion with the elements, with colors softly suffused by the light shining through them.

Fiber arts often reveal a similar reverence for hues of low saturation in subtle harmonies. Even bright hues will tend to dull when used in thin, interwoven lines rather than larger shapes. However, modern dyeing techniques and fibers allow fiber artists to work with the whole range of colors. In fact, one of the artist's greatest difficulties is being selective when faced with a store full of beautiful colors.

Contemporary kimono artist Itchiku Kubota subtly incorporates a full spectrum of colors in his *Ohn (Mount Fuji)* kimono (**11.17**)—white in the pale blue sky, pinks and purples in the clouds and Mount Fuji, blues and greens below, and many colors of dark value in the foreground—but yet maintains a unified impression of cool hues. Thus his subtitle for this work: *Tender, Cool Dawn*. As in other crafts, fiber art also brings an interesting range of surface textures into the color effects. This piece stands as our final testimony to the excitement and limitless potential of color in the hands of the artist as a new millennium begins.

▲ **11.17 Itchiku Kubota, *Ohn (Mount Fuji): Tender, Cool Dawn***
Kimono from exhibition catalogue *Homage to Nature: Landscape Kimonos* by Itchiku Kubota.

COLOR PROBLEMS

These problems are based on the core course of Josef Albers, with many additions from the color courses taught by Paul Zelanski and John Fawcett at the University of Connecticut. The problems are abstract experiments with principles of color usage that can be applied to any media. We prefer to have students use silk-screened papers (including grays, which may have to be purchased separately) for their initial work with color. Cut papers are simple to manipulate and then affix with rubber cement, and they pique interest in colors that most beginning students would never mix with paints. Paint mixing problems are introduced later in the course, along with instruction in application of paints, modeling, blending, and use of a ruling pen. After some work with acrylic paints, problems can be solved either with paints or with papers—or with any other media, including fibers, photography, video, computer graphics, pastels, and collage with found materials. For an approach to the problems in the order they appear in the text, relevant chapter numbers are given in brackets.

1 **Ideal color** [2]: From the silk-screened papers, select a group of colors from the same family. From these, choose the one you think most representative of the hue, such as the reddest red. Present it within its family to express this idea visually.

2 **Make 3 colors look like 4** [2, 3, 9]: Select two different colors to be used as ground colors and place them side by side. Then choose a third color that will, when placed in small quantities upon each ground, look different in each instance, producing the effect of having 4 colors. A value change is relatively easy, especially if the third color is a middle mixture of the first two. If you can create a good value change, then try another one in which a hue change is created (as in Figure 9.19).

3 **Make 3 colors look like 2** [2, 3, 9]: Select two different colors to be used as ground colors and place them side by side. Then choose a third color that will, when placed in small quantities upon each of the ground colors, appear to be the same color as the ground opposite the one on which it is placed. This difficult effect is most easily created when working with very high or low values.

4 **Make 4 colors look like 3** [2, 3, 9]: Select papers in two different colors to be used as ground colors and place them side by side. Then select two other colors that, when placed in small quantities upon each of the ground colors, will appear to be the same color (as in Figure 9.20).

5 **Make one gray act as both black and white** [3]: Cut many different grays out of magazine pictures and paste them on a board so that they will evenly graduate from white at the top to black at the bottom. Then select a middle gray from the silk-screened paper and glue a thin strip of it over the graduated grays. The result will be that at the top the middle gray will appear black, whereas at the bottom it will appear as white (compare with Figure 3.10).

6 **Monochromatic free study** [2]: Do a free study with silk-screened or found papers using values and saturations of only one hue.

7 **Light and shadow** [2, 3]: Select four different colors of paper; then select a second set of four colors that relate to the first set in hue, but that are all equally darker or lighter. By placement of these colors, suggest that light is falling on one section, raising the value of all colors equally.

8 **A third vibrating color** [2, 3, 9]: Select 2 different colors that will vibrate when placed next to each other and that will produce a third color glow along the edge where they are joined.

9 **After-images** [3, 9]: Using rather saturated colors: (1) Use a large flat shape to create an after-image in its complementary (see Figure 3.3). (2) Use a series of smaller shapes (circles work well) to create a complementary glow at the edges of these shapes, with an after-image in the same color as the original (see Figure 3.4).

10 **Losing edges** [2, 5]: Select 2 colors that are close to each other in the Munsell Color Tree (Figure 2.15) so that when they are juxtaposed, the edge between them will tend to disappear. How far apart can they be in the color solid and still lose the edge?

11 **Spatial effects with values** [2, 5]: The stronger the value ˙contrast between adjoining edges, the greater the apparent spatial distance between. The closer they are in value, the closer they will appear spatially. Select a ground color and place upon it a series of colors that range in value contrast with this ground, from extreme to very slight. By ordering the series of colors, create a logical spatial regression.

12 **Spatial effects with hues** [2, 3, 5]: Repeat #11 but using hue rather than value contrasts, holding value constant.

13 **Free study in the plastic effects of color** [2, 3, 5]: Make a free study in colors using discoveries from problems 11 and 12.

14 **Psychological distances** [5]: Create 3 distinct illusions of distance by use of principles in #11 and #12: close view (using hard edges and strong contrast with the ground), middle distant view (soft colors and soft edges), and far view (edges being lost through lack of contrast with the ground). Use essentially the same design and palette and place all 3 on the same board.

15 Four seasons [4, 5]: Select 4 colors and by varying the amounts used of each, create 4 designs with distinctively different color "climates."

16 Color atmosphere free studies [4]: (1) Create a color atmosphere that will relate to an obvious sensory experience, such as cold, hot, wet, etc. (2) Do the same thing for a human emotion. See if the class recognizes it.

17 Relativity of hot and cold [4]: Select 2 colors that are of different "temperature," one hotter than the other. In approximately 5 equal steps, cool both hues until the originally hotter hue is demonstrably cooler than the original version of the cooler hue.

18 Free study [4]: Create a free study using papers you have so far avoided because you didn't like the colors. By manipulating color combinations and proportions, make the result aesthetically pleasing.

19 Vertical stripes [5]: Cut stripes of identical width and place them from top to bottom of a groundsheet in such a way that they develop different groups and spatial effects.

20 Paint mixing introduction [7]: Cover a small square—no more than 8 x 8 inches—with a series of similar shapes or similar strokes. Each should be a different color that you have mixed by blending tube colors.

21 Weber-Fechner Law [7]: Using layers of clear colored acetate or layers of glazes, create stair-steps or sequences of value steps in one hue that graphically demonstrate the difference between arithmetical progression in mixing (adding one unit each time) and geometric progression (1, 2, 4, 8, etc.), which produces optically equal steps in value.

22 Value scale [2, 7]: Use the Weber-Fechner principle and your eye to mix 10 equal steps from black to white.

23 Value chart [2, 6, 7]: Using the 12-hue Liquitex Color Map (Figure 7.9) or a 10-hue Munsell chart of value changes, mix and paint all hues in the full range of values, from 1 to 9. All rows should be painted horizontally. Rather than painting all values of a single hue at once, paint value 5 in all hues, then value 6, and so on.

24 Neutralizing complementaries [2, 6, 7]: Mix any 2 complementary hues as if moving in equal steps through the Munsell tree

from one side to the other, passing through neutral gray at the center. If steps are visually equal, there will be more of them for certain hues, such as red, than for their complement. A bit of white can be mixed in to keep the value from decreasing.

25 Magazine image I [7]: Select a black and white picture from a magazine and paint a section that is approximately 25% of the total area in local hues that so closely match the values of the original that the line between black and white and colored areas tends to disappear.

26 Magazine image II [7]: Do the reverse of #25, starting with a colored magazine image and painting at least 25% of it in gray values that match the values of the original.

27 Color story: Create a sequence of designs as a fold-out book on an accordion-pleated series of stiff papers. Colored papers or paints should be used non-objectively to tell a visual story with a beginning, middle, and end.

28 Optical mixtures [6, 9]: Select three different colors to be used as ground colors and place them side by side. Then select the color that, when placed as thin vertical stripes upon the ground colors, will act like three different colors and produce different optical mixtures on each. The colors can be displayed separately below.

29 Stationary optical mixture [9]: Using black and white in approximately equal amounts, create a design that evokes optical color illusions (see Figure 10.23).

30 Color schemes [9]: With the whole class using black and white xeroxes of a single painting (preferably one done in flat color areas), each student can be assigned a different kind of color scheme (monochromatic, analogous, etc.) in which to paint the work. Compare the effects.

31 Interpenetration of colors [9]: Select 2 colors and then a third that, when placed between the original 2, will transmit a color sensation of the opposite color upon the edges of the middle color, thus creating a rounded or modeled effect upon the central band of color (see Figure 9.21).

32 Optical transparencies I [7,9]: Select 2 opaque colors, plus a third that appears to be the result of one's being transparent and overlying the other. Place them in a simple design that convincingly demonstrates this transparency illusion.

33 Optical transparencies II [5, 7, 9]: First choose one colored paper to use as a shape and a second to be used as a groundsheet. Then create 3 designs starting from these colors and adding 3 additional colors that give the illusion that the shape is (a) a transparent material overlapping the ground sheet, (b) a color being overlapped by a transparent groundsheet, (c) a mixture so evenly divided between the color of the shape and that of the ground that its spatial position is totally ambiguous.

34 Painted transparencies [7, 9]: Using mixed colors, repeat #32 with paints.

35 Overlapping of light [8, 9]: Select colors that will produce the effect of a ribbon of light being overlapped by itself. When an overlap occurs, the color of that overlap will be lighter than the original single section of light. Build up these overlaps to the point where 5 overlaps will occur.

36 Overlapping of a transparent colored ribbon [9]: Same as #35, but in this subtractive case, overlaps will become darker (see Figure 9.22).

37 Bezold Effect [9]: Create 2 designs that are exactly the same except that one of the 5 colors used in the first is different in the second. By this change, make the second look entirely different from the first (see Figure 9.24).

Suggested Free Studies:

a Work with the subtleties of the outer limits of value, doing a study only in whites or near-blacks.

b Do a free study incorporating both papers or paints and pressed leaves or flowers. Use the found materials as areas of color; their original identity should not be obvious.

c Do a free study in variations on a single hue with one unexpected accent of another hue.

d Using any colors or style, do a self-portrait in cut or torn papers.

e Working from careful observation, do an image of a local landscape in cut or torn papers. This can be done in two different seasons for comparison of the changes.

f Use a Fauvist approach to color for the same landscape.

g Use 2 color media in the same image in such a way that they cooperate rather than fighting with each other.

GLOSSARY

Where a definition includes a term that is itself defined elsewhere in the Glossary, that word is printed in italics.

additive colors Colors made by lights which, when mixed, become lighter in *value*.

after-image The illusion of color and shape produced in the visual apparatus after staring at a strong color for some time. A positive after-image is the same color as the original; a negative after-image is its *complement*. See *successive contrast*.

analogous hues Those lying next to each other on a *color wheel*.

aniline dyes A family of colorants synthesized from coal-tar, including reds, black, greens, and blue-reds.

atmospheric perspective The tendency of forms seen at a great distance through a hazy atmosphere to blur toward uniformity in *hue* and *value*, with no sharp distinctions between colors or edges. In many atmospheres, everything will take on a blue cast.

azo dyes A large family of colorfast, highly saturated, synthetic colorants developed from petroleum.

Bezold Effect The possibility of changing a design considerably by simply changing one of its colors; discovered by rugmaker Wilhelm von Bezold in the nineteenth century.

broken color Layers of different colors applied to a painting so that they show through each other as opposed to being physically blended on the canvas or mixed on the palette.

chiaroscuro The use of light and shadow effects in a painting.

chromatic hue Any color other than black, grays, and white.

chromaticity In lights, a measure of the combination of *hue* and *saturation* in a color.

Chromaticity Diagram The plotting of *hue* and *saturation* coordinates on a two-dimensional grid.

chrominance In television, a signal indicating both *hue* and *saturation*.

chromotherapy The use of colored lights for healing purposes.

CMYK The four-color screen system (cyan, magenta, yellow, and black) commonly used in reproducing color photographs.

coherent light Theoretically, light in which the waves are all of the same length and in unchanging relationship to each other, as approximated by a laser beam.

collage A two-dimensional work of art in which *found objects* are glued to a flat surface.

color constancy The psychological tendency to see colors as we think they are rather than as we actually perceive them.

Color-Field painting A style originating from the mid-twentieth-century New York School featuring large, nonobjective areas of color.

colorimeter A computerized instrument that measures the amount of power in each *wavelength* in a light source. See *spectrophotometer*.

color management In computerized processes, attempting to hold colors the same no matter in what medium they are displayed or printed.

color negative process In color print photography, the activation of *dyes* in the film to release colors that are *complementary* to those in the original scene. A positive print in the original colors is then created from this negative.

color positive (reversal) process In the creation of color transparencies, a series of steps which culminates in the release of magenta, cyan, and yellow *dyes* in the film's three layers. These mix to form the colors of the original when the developed film is seen in the light.

color separation In printing, colored images are broken down into screens of certain *primaries* (in a *four-color process*, they are magenta, cyan, yellow, and black) which when superimposed and printed will yield an approximation of the original colors.

color wheel A circular, two-dimensional model showing color relationships, originating from Sir Isaac Newton's bending of the straight array of *spectral hues* into a circle.

complementary hues Colors that lie opposite each other on a *color wheel*. When placed side by side they will intensify each other visually; when mixed as *pigments* they will dull each other.

cones Special cells in the *retina* at the back of the eye which enable us to distinguish *hues* in daylight.

continuous tone In printing, referring to any image with a range of gradually changing *values*.

critical color matching The precise mixing of *pigments* or ink *dyes* to match a given sample.

direct dyeing Coloring of materials by immersion in water with water-soluble *dyes*.

dispersed dye A material colorant that is not water soluble but can be applied in a soap solution.

dithering Juxtaposition of dots of different colors in computer printing to produce optical color mixtures.

Divisionism The juxtaposition of tiny dots of unmixed paints, giving an overall effect of color when mixed optically by the viewer's eye from a distance, usually associated with the Postimpressionists. See *Pointillism.*

dominant wavelength In light mixtures, another term for *hue.*

double complementary A color combination in which *hues* adjacent to each other on the *color wheel* are used with their respective *complementaries.* See *split complementary.*

dye Coloring material dissolved in a liquid solvent.

dye sublimation Computer printing technology similar to *thermal wax transfer,* but with variations in the amount of heat applied to produce varying colors.

expressionistic color Colors chosen for their emotional impact rather than their fidelity to "standard" colors perceived in the external world.

flat (match) color In printing, the use of solid areas of unbroken color, often specified by a numerical system such as PMS (Pantone Matching System). See *four-color process.*

found object An object presented as a work of art or forming part of one, which was not initially intended for artistic purposes.

four-color process In printing, a technique for reproducing colored images by separating them into the *primaries* magenta, cyan, yellow, and black and printing each color from a separate plate. See *color separation.*

fresco A wall painting in which *pigments* are ground in water and stroked onto fresh plaster; when the plaster dries, the pigments form part of the surface itself.

giclée printing Computerized printing in which *CMYK* separations can be overlaid in advance to view the final effect, and in which colors are sprayed onto the paper as tiny drops of varying size for an effect approximating a *continuous tone* photograph.

glaze In oil painting, a transparent film of color painted over another layer of color. In ceramics, a glass-like coating of silicates that melts and fuses to the clay when it is fired.

Hard-Edged painting A painting with precise boundaries between nonobjective colored areas, characteristic of some mid-twentieth-century work.

hologram A two-dimensional image that appears three-dimensional, created from waves of light or other energy forms which develop interference patterns when deflected off a three-dimensional object.

HSB *Hue, saturation,* and brightness—the variables in color specified in television technologies.

hue The color quality identified by color names, such as "red" and "blue." This is determined by the color's *wavelength.*

inkjet printing Computer-based technology in which ink is sent through nozzles by heat or pressure.

integral tripack The common format for today's photographic film, in which three thin layers of gelatin containing chemicals that are sensitive to blue, green, or red lights are sandwiched together.

iodopsins Light-sensitive *pigments* in the *cones* of the eyes, thought to be somehow involved in our ability to distinguish *hues.*

lakes *Pigments* that are made from *dyes.*

limited palette The use of relatively few colors in a work of art.

local color The color sensation received from a nearby object under average lighting conditions.

luminance The degree of lightness or darkness in light mixtures, corresponding to *value* in *pigments.*

middle mixture In Josef Albers's color interaction experiments, a color that results from mixing equal parts of two other colors and is then shown between these two "parents."

monochromatic Referring to a color combination based on variations in *value* and *saturation* of a single *hue,* perhaps with the addition of some *neutral* colors.

mordant In fabric dyeing, a fixative.

nanometer One billionth of a meter, used in measuring *wavelengths* of light.

neutral A black, white, or gray—one of the nonchromatic *hues.*

open palette The use of a wide range of colors in a work of art.

Opponent Theory A model that accounts for color vision by means of hypothetical pairs of receptors responding to opposing colors; if they respond to one, its opposite is inhibited.

phantom colors Colors that spread beyond their physical boundaries causing illusory color sensations on adjacent *neutral* surfaces.

phase change/solid ink printing Computer-based technology in which colorants are solid wax, liquified only long enough for application to paper.

phosphors On the back of a television screen, tiny dots of blue, green, and red fluorescing powder, which radiate light when struck by an electron signal.

pigment Powdered coloring material used to give *hues* to paints and inks.

pixel In computer graphics, one of many tiny points on the computer screen determined by intersections of x and y axes.

Pointillism A technique in painting whereby dots of pure *hues* are placed close together on a white ground to coax the viewer's eye to mix them optically. (*Divisionism* is a similar technique, but without the white ground showing.)

polychromatic Multicolored.

posterization In photography, a developing process in which continuous tone images are converted into flat areas of any colors.

primary colors Those *hues* from which all others can theoretically be mixed; in *refracted colors,* red, green, and blue; in *reflected colors,* red, yellow, and blue.

principal hues Albert Munsell's term for the five *pigment primaries* used in his color model (green, blue, purple, red, and yellow).

purity In *video,* another word for *saturation.*

reactive dye A colorant that bonds chemically with the fiber.

reflected color Color seen when light is reflected from a *pigmented* surface.

refracted color Color resulting from passing light through a prism, breaking it down into its constituent *wavelengths*.

retina The inner surface of the back of the eye, where *rods* and *cones* respond to qualities of light.

reverse In graphic design, designation of shapes or letters that will not be printed with ink but remain the color of the paper, as a negative of the positive image provided.

RGB Red, green, and blue—the additive *primaries* used in color television.

rhodopsin Visual purple, a light-sensitive *pigment* in the *rods* of the retina.

rods Light-sensitive cells in the eye that operate in dim light to distinguish *values*.

saturation The relative purity of a color, also called intensity.

screen In printing, a dot pattern used to create the impression of a certain *value*.

secondary colors *Hues* made by mixing two *primary colors*.

sfumato Softly graded tones in an oil painting, giving a hazy atmospheric effect, highly developed in the work of Leonardo da Vinci.

shading In Ostwald's model, the color change that results when one adds black and decreases the percentage of the original *hue*.

shadow mask In common television sets, a metal grid with tiny holes lying opposite triads of *phosphors*, used to focus electron beams directly on the phosphors.

simultaneous contrast In general, the optical effect of adjacent colors on each other; more specifically, the tendency of *complementary* colors to intensify each other when placed side by side.

solarization A special photographic development effect in which development includes brief exposure to low-intensity colored lights, thus reversing colors.

spectral hues Those colors seen in a rainbow, or in the spectrum created when white light passes through a prism.

Spectral Sensitivity Curve A graphic representation of the degree of brightness perceived by the human eye in lights of different *wavelengths*.

spectrophotometer A machine used to measure properties of energy in each part of the spectrum in a sample of light or a *pigmented* surface. See *colorimeter*.

split complementary A color combination whereby a *hue* is used with the hues lying to either side of its direct *complementary*. See *double complementary*.

subtractive color mixing Combination of *pigments*, which results in darkened mixtures.

successive contrast The color phenomenon observed when differently colored areas are viewed one after another, as in looking at a white area after staring at a red one. If the initial image is highly saturated, its *complement* may seem to appear in the second area. See *after-image*.

synergistic color mixing Allowing the energies of certain *hues* to combine optically on a *neutral* ground color.

synesthesia The ability to gather sense perceptions from perceptual systems not usually associated with them, such as hearing colors.

tertiary colors The colors created by mixing a *primary* and an adjacent *secondary*.

thermal wax transfer A computer-based printing technology in which small dots of cyan, magenta, yellow, and black ink are fused by heat to paper.

tinting In Ostwald's model of color relationship, the effect of adding white and decreasing the percentage of the original *hue*.

toning In Ostwald's system, the effect of adding both black and white and decreasing the percentage of the original *hue*.

transparency effect A painted effect when one film of color is lying over another color.

triadic color scheme The use of three colors equally spaced from each other on a *color wheel*.

triadic color system An early-twentieth-century rule that there should be equal proportions of "sunlight" and "shadow" *hues* in a painting.

Trichromatic Theory The idea that there are basically three kinds of cones in the human eye: red-sensitive, green-sensitive, and blue-sensitive.

value The degree of lightness or darkness in a color.

vat dye A colorant that does not give the desired *hue* in a fiber until a second influence has been added, such as exposure to sunlight or an acid solution.

video Electronic light signals recorded from images and then displayed on a television monitor.

virtual reality Computer-generated illusionary experience of three-dimensional environments.

visible spectrum The range of *wavelengths* seen by the human eye.

wavelength The distance from crest to crest in a wave of energy.

Weber-Fechner Law The observation that to mix visually equal steps in *value*, one must mix geometrically increasing proportions of black or white.

NOTES

Chapter 3

1 Edwin H. Land, "The Retinex Theory of Color Vision," *Scientific American*, December 1977, p. 108

2 Claude Monet, conversation with W. G. C. Byvanck, quoted in Robert Gordon and Andrew Forge, *Monet*, New York: Harry N. Abrams, Inc., 1983, p. 163

3 Louis Kahn, quoted in John Lobell, *Between Silence and Light: Spirit in the Architecture of Louis I. Kahn*, Boston: Shambhala Publications, Inc., 1979, pp. 6, 22

4 Scriabin, quoted in Kenneth Peacock, "Synesthetic Perception: Alexander Scriabin's Color Hearing," *Music Perception*, Summer 1985 (vol. 2, no. 4), p. 483

5 Scriabin, quoted in Corrine Dunklee Heline, *Healing and Regeneration through Color*, Santa Barbara, California: J. F. Rowny Press, 1944, p. 21

6 Wassily Kandinsky, *Concerning the Spiritual in Art*, New York: Dover Publications, Inc., 1977; London: Constable & Co Ltd, 1977, p. 25 (originally published in 1914 as *The Art of Spiritual Harmony*)

7 Carol Steen in Susan Hornik, "For Some, Pain is Orange," *Smithsonian*, February 2001, p.50

Chapter 4

1 Chris, quoted in Harry Wohlfarth and Catharine Sam, "The Effects of Color Psychodynamic Environment Modification upon Psycho-physiological and Behavioral Reactions of Severely Handicapped Children," *International Journal of Biosocial Research*, 1982 (vol. 3, no. 1), p. 31

2 Adapted from Suzy Chiazzari, *The Complete Book of Color*, Shaftesbury, Dorset/Boston: Element Books, 1998, p. 21

3 Faber Birren, "Color as a Force," *Coronet*, January 1937, p. 192

4 George Chaplin, personal communication

Chapter 5

1 Paul Claudel, as quoted in Jean-Louis Ferrier, director, English translation by Walter D. Glanze and Lisa Davidson, *Art of the Twentieth Century*, Paris: Editions du Chêne/Hachette Livre

2 Gene Davis, interview with Walter Hopps, in *Gene Davis*, Donald Wall, ed., New York: Praeger Publishers, 1975, pp. 117–18

3 Leonardo da Vinci, *The Notebooks of Leonardo da Vinci*, Pamela Taylor, ed., New York: The New American Library, Inc., 1970; London: Cape Ltd, 1977, p. 36

4 Gene Davis, op. cit., pp. 119–20

Chapter 6

1 Aristotle, *De Coloribus*, quoted in Faber Birren, *History of Color in Painting*, New York; London: Van Nostrand Reinhold Company, Inc., 1965, p. 16

2 Leonardo da Vinci, op. cit., p. 38; and in Faber Birren, op. cit., p. 79

3 Ibid.

4 Sir Isaac Newton. *Opticks*, 4th edition. 1730. Reprinted by McGraw-Hill Book Co., New York, 1931, pp. 156–7

5 Johann Wolfgang von Goethe, *Theory of Colors*, trans. Charles Lock Eastlake, Cambridge, Mass.: The MIT Press, 1970, pp. 34–5

6 Johannes Itten, *The Elements of Color*. English ed., New York: Van Nostrand Reinhold Company, Inc., 1970, p. 66 (originally published in 1961 as *Kunst der Farbe*)

7 M. E. Chevreul, *The Principles of Harmony and Contrast of Colors*, 1839, quoted in Faber Birren, *Principles of Color*, New York; London: Van Nostrand Reinhold Company, Inc., 1973, p. 163

8 Ogden N. Rood, *Modern Chromatics*, 1879. Facsimile edition, New York: Van Nostrand Reinhold Company, Inc., 1973, p. 163

9 Ibid., p. 219

10 Roland Rood, *The Scrip*, April 1906, quoted in Rood, op. cit., p. 28

11 Faber Birren, *The World of Color*, 1939, 1948

12 Paul Klee, quoted in *Color*, London: Marshall Editions Ltd., 1980, p. 95

Chapter 7

1 Dale Chihuly, quoted in Margaret Moorman, "Venetians, Persians, and Niijima Floats," *ARTnews*, April 1993, pp. 11–12

2 Jan Good, personal communication, December 11, 2001

3 Frank Noelker, personal communication, May 24, 2001

Chapter 8

1 Douglas Kirkland, quoted in Lynda Weinman, "Celebrity Makeovers in Photoshop," *Step-by-Step Graphics*, 1993 (vol. 9, no. 4), p. 36

2 Herbert W. Franke, "Computer Graphics/Computer Film Metamorphoses," in Igildo G. Biesele,

Experiment Design, Zurich: ABC Verlag, 1986, p. 54

3 Char Davies, "Landscape, Earth, Body, Being, Space and Time in the Immersive Virtual Environment: Osmose and Ephemere," in Judy Malloy, ed., *Women in New Media*, Boston: MIT Press, 1998

4 David Joselit, "Planet Paik," *Art in America*, June 2000, p. 78

Chapter 9

1 Deborah Muirhead, personal communication, November 1993

2 Goethe, op. cit., p. 319

3 Rufino Tamayo, in Roger Toll, "An Artist's Mexico," *House and Garden*, November 1985, p. 150

4 J. M. W. Turner, Lecture V, 181, in John Gage, *Color in Turner*, New York: Praeger Publishers, 1969, p. 208

5 M. E. Chevreul, *The Laws of Contrast of Color*, trans. John Spanton, London: Routledge, Warner, and Routledge, 1859, p. 48

6 Rudolf Arnheim, "Progress in Color Composition," *Leonardo*, vol. 20, no. 2, p. 166

7 Henri Matisse, *Notes of a Painter*, in R. Goldwater and M. Treves, *Artists on Art*, Pantheon Books, 1945, pp. 411–412

8 Goethe, op. cit., p. 317

9 Josef Albers, in Albers: *Josef Albers at the Metropolitan Museum of Art*,

undated, unpaginated exhibition catalog

10 Rood, op. cit., p. 231

11 Paul Signac, "The Color Contribution of Delacroix, the Impressionists, and the Neoimpressionists," Paris, 1899. Quoted in *Artists on Art*, Robert Goldwater and Marco Treves, eds., third edition, New York: Pantheon Books, Inc., (originally published 1945): J. Murray Ltd, 1976, p. 378

12 John Roy, from catalog for Springfield Museum of Fine Arts solo exhibit, 1999

13 Arthur Hoener, personal communication, November 1987

Chapter 10

1 Cited in Birren, *History of Color in Painting*, p. 238

2 Ibid., p. 83

3 Claude Monet, 1889 letter to a young American artist, in Hugh Honour and John Fleming, *The Visual Arts: A History*, fourth edition, New York: Prentice Hall, Inc., 1995, p. 660

4 Paul Gauguin, in Helen Gardner, *Art through the Ages*, seventh edition, New York: Harcourt Brace Jovanovich, Inc., 1976, p. 788

5 Paul Gauguin, 1885 letter quoted in Rene Huyghe, *Gauguin*, New York: Crown Publishers, Inc., 1959, p. 39

6 André Derain, quoted by Helen Dudar, "In turn-of-the-century Paris, an

explosion of brash new art," *Smithsonian*, October 1990, p. 65

7 Pierre Bonnard in Jean-Louis Ferrier, director, *Art of the Twentieth Century*, op. cit., p. 447

8 Helen Frankenthaler, in Barbara Rose. *Frankenthaler*, New York: Harry N. Abrams, Inc., 1970, pp. 61–2

9 Ron Lambert, personal communication, July 2001

10 David Em, *The Art of David Em*, by O. David Ross and David Em, New York: Harry N. Abrams, Inc.

Chapter 11

1 Ed. Newman, "Color in Textiles," *American Fashion and Fabric magazine*, September/October 1986, p. 53

2 Leatrice Eiseman, "Results of the Roper/Pantone Consumer Color Preference Study," www.pantone.com/allaboutcolor, 2001

3 Ibid.

4 Kevin Grady, in Jennifer Mattson, "Color Therapy: How Color Works in Design," *Desktop Publishers*, June 1997, p. 64

5 Dr. Russell Ferstandig, quoted in Trish Hall, "The Quest for Colors that Make Lips Smack," *New York Times*, November 4, 1992, p. C1

6 Jeffrey B. Hirsch, quoted in Trish Hall, op. cit.

INDEX